*in*Print
Text and Type

*in*Print
Text and Type

Alex Brown

Watson-Guptill Publications / New York

Copyright © 1989 by Alex Brown
First published in 1989 by
Watson-Guptill Publications,
a division of BPI Communications, Inc.
1515 Broadway, New York, NY 10036

Library of Congress Cataloging-in-Publication Data

 Brown. Alex. 1952–
 In print: text and type/Alex Brown
 p. cm.
 Bibliography: p.
 Includes index.
 1. Type and typefounding. 2. Printing, Practical—Style
 manuals. 3. Typesetting. 4. Desktop publishing. I. Title.
Z250.B868 1989
686.2' 2544416—dc20
ISBN 0-8230-2544-6

Distributed in the United Kingdom by Phaidon Press, Ltd.,
Musterlin House, Jordan Hill Road, Oxford, OX2 8DP

Manufactured in U.S.A.

First printing, 1989.
1 2 3 4 5 6 7 8 9 10/93 92 91 90 89

Apple, LaserWriter, LaserWriter Plus, and Macintosh are registered trademarks of
 Apple Computer Inc.
Bitstream is a registered trademark and Fontware is a trademark of Bitstream Inc.
Compugraphic is a registered trademark of Agfa Corporation
Hercules is a trademark of Hercules
IBM is a trademark of International Business Machines Corp.
Interleaf is a trademark of Interleaf Inc.
Letraset is a trademark of Esselte Pendaflex Corporation
Linotronic is a trademark of Linotype
MagnaType is a trademark of Magna Computer Systems Inc.
Microsoft and MS-DOS are registered trademarks of Microsoft Corporation
NeXT is a trademark of NeXT, Inc.
PageMaker is a trademark of Aldus Corporation
PostScript is a registered trademark of Adobe Systems Inc.
Quark, and Quark XPress are trademarks of Quark, Inc.
Ready, Set, Go! is a trademark of Manhattan Graphics Corporation
Sun is a registered trademark of Sun Microsystems, Inc.
Superpage and Wave4 are registered trademarks of Bestinfo, Inc.
UNIX is a registered trademark of AT&T
Varityper is a registered trademark of Tegra, Inc.
Ventura Publisher is a trademark of Ventura Software Inc.
WordPerfect is a trademark of Word Perfect Corp.

Acknowledgments

Most people can tell you about what they do for a living, but only a few can fire your interest by their enthusiasm for what they do. At one time or another, the following people inspired me, taught me, and generally made me see the graphic arts as the rewarding craft that it is. I doubt they always knew they were teaching me because their commitment to their work compelled them to spark my engagement with the field. I want to thank Eileen Bradley, Don Estes, Kat Farnham, Charlie Foell, Dick Jones, Mike Hardy, Carol Hill, Bill Hoyt, Adelaide Jaquith, Michael Levins, Debbie McIlrevey, Kathy Miottke, Ed Monniere, Rob Randall, Alan Schillhammer, and Carol Wigger for adding immeasurably to my knowledge of this field.

This book was shaped in part by seminars and college courses I've taught. Some of my students were particularly outspoken and perceptive in their demand that I stop leading them through a labyrinth to make my point. I have Mike Joyce and Michael Lewis to thank for motivating me to bring this text down to the earth; I have Christine Mattke to thank for insisting that I do so and for showing some faith in my chances of pulling it off.

I'd like to thank Terry Ehrich for having so much confidence in me as a production manager that I had to get good at the job and to thank Terry Driscoll for giving me the best production problems to solve and the most stimulating conditions for solving them.

I'm grateful to Frank Austin, Sheldon Baker, Dick Beane, Nancy Bianco, Paul Claussen, Margetty Coe, Ed Contini, Tom Bentkowski, Fred Dempsey, Tom Easley, Win Firkey, Dave Flanagan, Al Goddard, Debbie and Jon Hall, Robert Hearne, Carl Hess, Noreen Kimball, Fred Miers, David J. Moore, Dave Norton, Roger Parker, Suzi Romanik, John Schillhammer, Dan Segal, Betta Stothart, George Taylor, Clark Vialle, and Bobby Ward. Each of them placed a brick or two in the road this book paves through the graphic arts.

Matthew Carter set me straight more than once regarding the practicalities and aesthetics of type design. I'm grateful not only for his insights but for his generosity as a teacher and critic.

Jeff Scott and Jean Kristinat encouraged me while writing this book, and also read and evaluated the manuscript from time to time. I have a special debt to them, and to Heidi Holman, for renewing my hope for this book, and for other books to follow.

Finally, I want to thank the newspaper paste-up artist who, when I ignorantly asked for a type correction to change a comma into a period, gave me the clearheaded reply that has served me in many a crisis: "Use your blade."

Contents

Preface

It's rare for someone to need information about the graphic arts and not already know something about the subject. Even if your professional connection with printing and publishing is a recent one, the graphic arts have such a central place in society that it's hard to avoid a basic understanding of printing, type, and paper. This book attempts to anticipate your need for both a reference book and a practical guide, but it also presumes you have some prior knowledge of the field. Whenever appropriate, the text goes beyond the basics. Accordingly, the book is suited to readers with curiosity about the principles of typography, typesetting, and text preparation. It's particularly designed for those who seek to enlarge their professional expertise, but because it progresses step by step, the book welcomes newcomers as well.

This book attempts to provide you with practical information by two tactics: using concrete, illustrated examples and identifying topics clearly enough to allow you to page through for isolated answers. In addition to the applicable information, background ideas and processes are also presented to outline the development of typography and technology. These detailed descriptions are pulled out from the text in sidebars so as not to interrupt the flow of pertinent material.

One of the unusual aspects of the graphic arts field is the great distance that often arises between the people who use its end products (print buyers, ad agencies, magazine publishers, graphic designers, and in fact every organization that communicates in print) and the people who produce this material (typesetters, printers, film strippers, paper manufacturers, color separators, and the rest). The gap between these two groups is largely bridged by salesmen and customer service representatives, and for the most part they bridge it well. They do, however, come from the production side of the equation, and the customer is slightly at their mercy. Unasked questions don't get answered. Unavailable procedures aren't suggested. Alternative specifications can't be considered. The people who originate the material that gets into print can make better use of the vast resources of the graphic arts industry simply by understanding it better. With this book, some active curiosity, and an interest in working with your suppliers to produce good printed work, you can utilize the craftsmanship and technology of the industry to its fullest.

Communication

Our eastern country lies beyond the seas, and the number of books reaching us from China is small. The books printed on blocks are often imperfect, and moreover it is difficult to print in their entirety all the books that exist. *I ordain therefore that characters be formed of bronze,* and that everything without exception upon which I can lay my hands be printed in order to pass on the tradition of what these works contain. ❦

Korean Emperor
T'ai Tsung
1403

Computer software is a simple product in its physical form: a couple of floppy disks holding the program, perhaps a binder or box, and that long, clunky document that most users wish could be magically imprinted on their minds instantly, the manual. The software buyer wants to act, not read, and he pages through the manual to find only what he needs to solve a problem and get underway. The same impatient reader might have selected that software because he examined a review of the program in a computer magazine and later saw the company's ad. He ordered the program from a mail-order supplier with another ad in the same magazine, whose prices he could study in print before picking up the phone. Later, the manual became an indispensable reference and helped remind the buyer how to employ little-used features in the program.

Software is rarely purchased or used without reference to the process it's often purported to replace: print communication. Words and pictures on paper still do something other media can't.

It's unnecessary to list any of the hundreds of ways we obtain information from print, but it is important to note that we take them for granted. It's likely that we'll continue to change the way we get at this information, by relying further on the retrieval, sorting, and indexing capacities of computers. But no matter how much paper we do away with in circulating ideas through other media, there are uses for print that will never change.

This is a book about type and text. The remainder of this chapter provides some context and is more abstract than practical. What follows is a discussion of the essence of print, the scope of the industry, and the basic stages of print production. To give you some background, this section also defines the various printing processes and their applications. Running throughout this chapter is a time line charting major events in printing and publishing history. In this chapter, you're invited to consider the nature of printed messages before reading about giving them form in type.

The alphabet and type

Writing is a method for storing thoughts until they can be spoken again, or preserving ideas until they can be acted upon. Because the ideas themselves are generally what we examine when we read, printing and type itself often go unnoticed. The type designer W.A. Dwiggins pointed out, "The graphic signs called letters are so completely blended with the stream of written thought that their presence therein is as unperceived as the ticking of a clock in the measurement of time. Only by an effort of attention does the layman discover that they exist at all." Consider this virtually invisible alphabet for a moment.

The alphabet is an idea so transforming to a culture that once in place it is never abandoned. Somewhat serendipitous in origin, it can properly be said to have been invented only once, and only modified in its appearance to yield all the alphabets in use today. The Egyptians were the first to use letters to symbolize oral sounds, but they integrated these signs with symbols based on ideas, and never developed a complete alphabet. It was the Phoenicians who borrowed the concept and created the first alphabet. To facilitate their trading interests, the Phoenicians delivered the alphabet throughout the Middle East. This collection of letters branched off into an Aramaic alphabet that evolved into the Hebrew, Arabic, and Indian alphabets. A form that took root in Greece flourished into the alphabet that most closely resembles that used in the Western world.

The concept of movable type is almost as significant to the dissemination of ideas as the alphabet itself. The first printed works were carved in wood or clay as complete pages. An alphabet is by nature far more utilitarian, since its individual letters may be combined and recombined. In 1401, Pi Sheng of China produced movable type fired in clay. Though they were fragile, these characters could be used repeatedly to make new pages. It was all the more remarkable that Pi Sheng invented the idea, since the Chinese ideographic writing system consisted of thousands of discrete characters. Movable type is better suited to the compact set of letters in an alphabet, so his invention was little used in China at that time.

About 50 years after the Chinese began using type fired in clay, Johann Gutenberg perfected a method for casting type in metal. Though historians are at pains to qualify the credit that must go to Gutenberg as the inventor of movable type, we can certainly grant him the distinction of establishing an efficient and accurate method for casting characters. His formula for a blend of lead, tin, and other metals was so appropriate that it was changed little through the nineteenth century. His design for a casting apparatus ensured consistency in the type and permitted production in large quantities.

Above all, movable type advanced the art of printing by harnessing the essence of the alphabet itself. From discrete characters, we can swiftly assemble any sentence from an alphabet or from the type that puts the alphabet into our hands. Printing fixes ideas in place, but it serves society first by being efficient enough to capture those ideas. It enables us to make permanent what would be fleeting, and to spread what would be isolated.

Print in context

When print is used to communicate, it permits the audience to read, look, reflect, and look again. A message in print can inform, persuade, verify, or stimulate. It encourages comparisons and combines vivid illustration with text, yet gives us all the time we'd like to examine and respond. This is a particular way of communicating, and it isn't the best way for all messages. But it is a way that we won't outgrow, even if some types of messages must be communicated by different means.

Computers both threaten and animate print. Every indicator, from the tons of paper made to the number of impressions printed, shows major increases in the quantity of printed materials in recent years, fueled in part by the expansion of information computers have triggered. Television subtracts two items from print's domain: advertising pages and the time an audience can spend with print at all. Today, television tends to affect the way a print message is constructed. Everything from look-alike, fast-reading romance novels to an emphasis on striking, eccentric photojournalism indicates the struggle to tell a story so swiftly or remarkably that TV's hold is momentarily broken.

If print is old news, it became old only recently. Reading has always been slower than thinking, but only recently has this appeared to be a problem. Computers beg us to compare reading with thinking, having given us a model of near instantaneous calculation and organization of data. The amount of information in the world is now doubling every five years, according to librarians. It almost appears that our capacity to read isn't vigorous enough to keep up with it.

There's an oblique pressure on us to either read faster or read differently. There's even a pressure not to read at all: to learn about the world through television. These pressures are inevitable, but they're also not much of a threat to what print communication can do best. Be-

Printing history

	Stamp seals used to record owner's mark in clay	Earliest writing, the Sumerian cuneiform	Egyptians introduce papyrus, precursor of paper	Phoenicians use an alphabet of 22 signs	First Chinese dictionary includes 40,000 characters
35,000 BC	**4500 BC**	**3500 BC**	**3200 BC**	**2000 BC**	**1400 BC**
Pictographs used to record hunting, daily life, nature	**4000 BC** Sumerians use pictographs on clay tablets	**3300 BC** Egyptians develop hieroglyphics, combining pictographs, ideograms, and syllabary elements	**2500 BC** First libraries are established in Egypt	**1500 BC** The Phaistos disk is imprinted with movable type	**1000 BC** Greeks adapt the Phoenician alphabet and add vowels

α Ω

cause you're reading this book, you already have some uses for print communication. No one needs to tell you that it's necessary and that it works. What you might like to be reminded of is that because print isn't the only way of communicating, it can be used when it's the best way. Every medium elbowing it aside gives print a chance to refine its potential. A core of uses remain, even after TV, radio, records, movies, and computer video tutorials subtract their logical applications. And it's a core so large and so longstanding that technology, entertainment, culture, and commerce all depend on it.

The idea of print

When printing is separated from the written expression it serves, we can notice print's three powerful properties: uniformity, continuity, and repeatability. Marshall McLuhan observed that the printed word makes personal memory inadequate. McLuhan did not, by the way, advocate consigning print to the dustbin but encouraged a new perspective on its cultural role; a different dustbin, by far. The printed book makes ideas visual and repeatable. They are visual because an alphabet embodies them and repeatable because a book can be a commodity, mass produced.

Printing is such a fundamental activity in our culture that we have to work at imagining what its consequences really are. Margaret Mead tells of bringing several copies of one book to the Pacific island natives she was studying. They had seen books before, but their surprise at these came from a new recognition. Because they'd encountered previous books as single copies, they had assumed each was unique. Identical books astonished them.

The uniformity of printing unifies readers, linking people through time and space. This is not without disturbing consequences, for the ability to influence others at an authoritative remove is the foundation

Homer writes *the Iliad* and *the Odyssey*	Ts'ai Lun of China invents paper-making	Wood block printing in China; lamp-black ink perfected	Charlemagne appoints Alcuin of York to develop a new manuscript copying style which will become lowercase letters	Pi-Sheng of Korea casts type in hardened clay	First known text printed from type, Korea	Intaglio printing process invented
c900 BC	105	400	789	1041	1397	1446
500 BC	**200**	**764**	**868**	**1200**	**1400**	
Romans adapt Greek alphabet, using 23 characters	Egyptians develop writing inks for papyrus	Japanese Empress Shotoku commissions first mass production printing: one million prayer sheets printed with wood blocks	First printed book, *The Diamond Sutra*, produced in China with wood blocks	Koreans cast type in bronze	Papermaking well established in Europe The letter *I* is added to the English alphabet	

SPQR

for a whole catalog of abuses. On the other hand, our most ingrained perception of culture as an additive progression is based on the fact that nothing people have achieved is lessened by time, distance, or individual memory.

Print's uniformity has done everything from fixing the spelling of hundreds of English words into their truly exasperating forms to acquainting Renaissance scholars with Greek mathematicians and philosophers. Printing a book first meant standardizing its language, and when the English spoken word was written, bold decisions were made concerning spelling and grammar. These choices govern our syntax because books froze them in place. Ideas, by the same token, accumulated in print to influence readers. A printed idea cannot be ignored and demands that thinkers build on it, utilize it, and share it.

The continuity of print unifies a culture because we can share and participate in the entire procession of literature, science, and philosophy that precedes us. Anyone at any time will be able to hear John Coltrane play the saxophone on record; no one will ever hear Bach play the organ. What sound reproduction has accomplished so recently, printing technology achieved centuries ago.

Tape recording has ensured Coltrane's immortality as a musician, but printing preserved Bach's as a composer. Print is always a force for defying time, and the immortality it implies can spur artistic triumphs, idiosyncratic outbursts, unquenchable palaver, and revolutionary ideas. There is little to keep us silent, little to impede our connection with each other. We now assume of print a staggering permanence. The least of our worries today is getting a copy of Chaucer's *Canterbury Tales* or finding out who holds a particular Olympic record or seeing what the Palace of Versailles looks like.

Print provides not only permanence but also permanent accessibility. Any desire we nurture to watch an old episode of "Leave It to

Gutenberg prints the 42-line Bible from movable type

William Caxton publishes Chaucer's *Canterbury Tales*, determines first spelling of spoken English

Aldus Manutius designs first italic type

italic

Christopher Plantin founds a press in Antwerp that will become the most progressive in Europe

Stephen Daye establishes first print shop in America, in Cambridge, Massachusetts

1456	1478	1501	1555	1638

1470 Nicholas Jensen cuts first type in roman style

1495 Francesco Griffo designs the type now known as Bembo

Bembo

1545 Claude Garamond establishes a typefoundry and begins casting types

Garamond

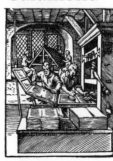

1585 The Oxford University Press, now the oldest continuously operating press, commences publishing

1690 William Rittenhouse manufactures first paper in America

1732 Benjamin Franklin begins publishing the *Pennsylvania Gazette*

Beaver" is tempered by the programming whims of local television stations. "Leave It to Beaver" is doubtless preserved, but individuals lack the apparatus to view it. Video cassettes have recently changed this for films and some television programs, but the impulse to publish on video a particular TV sitcom is starkly different from a library's inclination to maintain copies of perhaps equally trivial books.

Print's repeatability is the key to its authority and simplicity. If a coupon will increase sales of a shampoo, everyone's got to have that coupon. If there's only one correct way to operate a particular drill press, every owner has got to have the manual. Individuals need individual copies of material directed to many people at the same time.

Repeatability also gives print a special authority. We know that each copy is identical and that we're reading exactly what everyone else is reading. Each of us can develop his own opinion of a particular novel, but there's no question we all started from the same text. In contrast, can the witnesses to an accident really claim to have seen the same thing? In the same vein, one is more confident drawing conclusions after reading the text of the President's State of the Union Address than after hearing it.

A well-planned printed piece, in which the form supports its content, is hard for the right audience to ignore. If your message reaches the people who have a stake in reading it, print gives them the remarkable combination of a stimulating form that permits infinite reflection. Print is also an ideal medium for initiating the reader's response. In many cases, only a printed order form can actually obtain results, and direct mail specialists agree that the most important element in a mailing is the order card, not the letter. Print cannot assault the audience with anything like the arsenal of tricks that television has. But when someone volunteers to look, he can find more in a printed message than in any other medium.

William Caslon introduces his type

Caslon

John Baskerville introduces his type

Baskerville

Giambattista Bodoni introduces his type

Bodoni

The Fourdrinier brothers perfect a machine to make paper in a continuous roll

Jacob Perkins devises a method for duplicating plates, making steel plate engraving possible

Joseph Niepce etches a printing plate photographically

1734	1757	1788	1803	1815	1824

1735
Printer John Peter Zenger is acquitted of charges of seditious libel, establishing truth as a libel defense

1764
Pierre Simon Fournier publishes his *Manuel Typographique,* introducing the point system

1798
Alois Senefelder discovers lithography

1814
The *London Times* uses the first power-driven cylinder press; it produces over 1,000 sheets per hour

1822
William Church invents a keyboard-operated typesetting machine of limited practicality

1833
Benjamin Day founds the *New York Sun* and sells his newspaper for a penny instead of the usual six cents

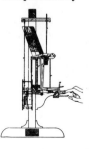

Scope of print communications

The graphic arts industry is growing, in bad times and good. A dismal economy may motivate price wars, sales, and increased advertising: print benefits. An expanding economy stimulates new businesses, new products, and increased advertising: print joins in. Regardless of the price of goods, the need to sell them in print continues. As commodities, books and magazines are not, as a rule, luxuries. They can promote dreams of goods a reader can't afford or tell how to use the ones he can. A newspaper's cost doesn't greatly influence its purchase, and after all, it includes help wanted ads.

This doesn't mean that the publishing industry has an easy time during poor economic periods. The price of paper has risen drastically in the last decade, reflecting in part the cost of energy required to produce it. Attracting subscribers becomes increasingly difficult as competing publications vie for attention. The glut of direct mail catalogs and promotions conspires to send many of them, unread, to the wastebasket. Advertisers find a type of efficiency in television and, having paid the higher price for it, have little budget left to allocate to print advertising. A book must stake out its position on a best-seller list swiftly or be consigned by the publisher to a failed experiment, unworthy of further promotion. But despite all these pressures on the businesses that communicate in print, the value of printed goods produced each year increases.

Printing, publishing, and related industries combined are among the top ten manufacturing endeavors in the United States in value of shipments. Printing itself is the most decentralized manufacturing activity by number of employees and value of products. Over 32,000 commercial printing concerns were in business in 1987, according to

A method for permanently fixing images made with blackened silver salts makes photography practical	First cylinder-to-cylinder press produced by the Hoe Company prints 2,000 impressions per hour	William Henry Fox Talbot discovers the halftone principle for rendering a photograph as tiny dots	William Bullock introduces the web-fed perfecting press which prints both sides of a continuous roll of paper	First rotary press produced by Hoe Company	Photoengraved prints, using the halftone process, begin replacing woodcuts in American books and magazines
1839	**1846**	**1852**	**1856**	**1871**	**1880**
1840 Papermaking from ground-wood pulp developed	**1848** The Associated Press is founded	**1854** Papermaking from chemical pulp perfected	**1861** *Harper's Weekly* magazine begins first-hand coverage of the Civil War, sending Mathew Brady, among others, to the battlefields	**1873** Publication begins of Leo Tolstoy's *Anna Karenina* in serial form	**1883** Mark Twain submits the manuscript of *Life on the Mississippi* to his publisher in typewritten form
	1850 George Gordon invents treadle-operated version of the platen press			**1878** Frederic Ives uses a halftone screen to reproduce a photograph as printed dots	

Key economic statistics: advertising, printing, and publishing

	1984	1982	1985	1985
	firms	employees	payroll (mil.)	shipments (mil.)
Advertising	15,600	185,000	$5,000	$17,343
Printing and publishing	53,406	1,360,000	$28,169	$111,885
Newspapers	8,846	411,000	$7,905	$27,015
Periodicals	3,328	96,000	$2,555	$15,246
Books	2,811	114,000	$2,559	$13,116
Miscellaneous publishing	2,057	52,000	$1,047	$4,437
Commercial printing	29,735	492,000	$10,057	$36,197
Business forms	810	54,000	$1,200	$6,669
Greeting card printing	154	20,000	$398	$2,598
Blankbooks, bookbinding	1,487	61,000	$1,074	$3,354
Printing trade services	4,178	60,000	$1,376	$3,254

source: U.S. Bureau of the Census, Annual Survey of Manufactures.

In the aggregate, printing and publishing firms combine to rank as the sixth largest U.S. employer in manufacturing.

the *U.S. Industrial Outlook.* Approximately 80 percent of these commercial printers employ twenty people or fewer.

Publishers of newspapers, magazines, and books numbered 21,000 in the same year. Altogether, these businesses produced about $54.4 billion in shipments, accounting for 1.3 percent of the gross national product.

The decentralization of printing and publishing has many consequences, but one is particularly significant for print buyers. Small print shops abound since many printed products must be produced on a strictly local level. The employees of these small shops rely for their sense of craft and technological insight on the fairly fragile network of trade publications and handed-down experience. This puts a burden on

Ottmar Mergenthaler perfects the Linotype linecasting machine

George Eastman introduces the first film on a flexible base and the Kodak camera that utilizes it

Nine out of ten Americans can read

Intertype introduces a linecasting machine modeled on the Linotype

The New York Times begins publishing important documents and speeches in their entirety

Kodak begins making high contrast film called Kodalith

1886 **1889** **1900** **1911** **1914** **1929**

1887
Tolbert Lanston invents the Monotype typesetting machine which makes keyboarding independent of casting

1893
First color images printed with photoengraved halftones

1898
Karl Klisch develops rotogravure printing, using the intaglio process with an etched copper cylinder

1905
Ira Rubel develops offset lithography, using a rubber blanket to transfer the image from plate to paper

1907
Louis and Auguste Lumiere introduce Autochrome, an early color photography process

The Saturday Evening Post tops $1 million in advertising revenue

c 1925
"Somewhere West of Laramie" car ad appears, first example of enigmatic copywriting that seeks to trigger an emotional response

Newspapers have a commanding lead in advertising revenues since they publish thousands more ad pages per year than magazines. The value of magazines as investments was underscored by Rupert Murdoch's purchase of Triangle Publications, publishers of TV Guide, *for $3 billion in the fall of 1988.*

Publishing industry statistics, 1985

	newspapers	periodicals	books
Number of establishments (1982)	8,846	3,328	2,130
with 20 or more employees (1982)	2,555	690	420
Employees	411,000	96,000	71,000
Payroll (millions)	$7,905	$2,555	$1,672
Value of receipts (millions)	$27,015	$15,246	$10,196
cost of materials	$6,585	$5,580	$3,021
value added by manufacturing	$20,426	$9,678	$7,396

source: U.S. Bureau of the Census, 1982 Census of Manufactures and 1985 Annual Survey of Manufactures.

the customer to evaluate quality and establish proper specifications. It is not impossible for a graphic designer to know more about type than a print shop's typesetter, and the printer's role as adviser to the client is changing. Still, many trade typesetters and printers represent the only source of specialized graphic arts knowledge, and some of them are exceptionally skilled. At minimum, it makes sense to know enough about type to appreciate their work; at worst, it may be necessary to know a good deal to obtain work of high caliber.

Stanley Morison's type design for the *Times* of London, Times New Roman, appears in the newspaper

Times Roman

Life magazine launched

Herman Freund invents the Fotosetter, the first typesetting machine using photographic type masters

First commercial electronic color scanner introduced by Publishers Developments, Inc., then a Time, Inc. subsidiary

Bob Woodward and Carl Bernstein report the Watergate scandal in *The Washington Post*

Gannett launches *USA Today*, transmitting copy by satellite to remote printing plants

Adobe develops Display PostScript

| 1932 | 1936 | 1946 | 1955 | 1972 | 1982 | 1988 |

1936
Kodachrome film introduced, the first multi-layer film using the subtractive color process

1938
Chester Carlson invents xerography

1948
TV Guide launched as regional magazine for New York viewers

1958
The Marlboro Man ad campaign begins (it continues virtually unchanged to this day)

1974
TV Guide passes *Reader's Digest* in circulation

1985
John Warnock and Charles Geschke develop the Postscript page description language; Apple introduces the PostScript-equipped Laserwriter and desktop publishing becomes possible on the Macintosh

Print production stages

If you write a memo, type it, duplicate it on a photocopier, and circulate it yourself, you've completed a print production sequence by yourself, but beyond this it's rare that a single individual directly produces a printed piece. A good part of what makes the process difficult is the need to coordinate many individuals and technologies and to specify, not execute, the results. Some production stages are performed by a company's employees on its own equipment but somewhere along the journey to print, most communicators use outside vendors.

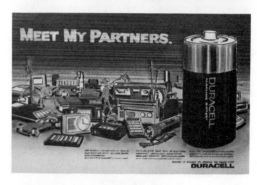

Most printed pieces require these elements:

- a dummy or rough layout
- copy for text, headlines, and captions
- photographs and other art
- typesetting
- a mechanical
- halftone and line camera work
- film assembly or stripping
- platemaking
- printing
- trimming, folding, gathering, and binding
- distribution

This book covers the stages of text preparation and typesetting and occasionally hints at the requirements that lie ahead for production of mechanicals and printing.

The steps on the following page chronicle a basic print production cycle for a typical project.

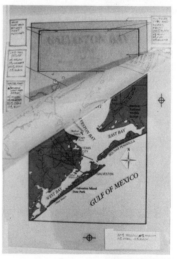

Design

Graphic design stages proceed from rough plans to precise renderings. The number of design phases increases when client approval depends on previsualizing the exact graphic image, reaching an apogee in ad comps. These are, essentially, drawings of the photographs that would be made for an ad, along with fastidious renderings of type. At minimum, the designer needs to produce a dummy that shows how type and art will be positioned and how color will be used.

Copy

Copy preparation, for text, involves resolving conflicts of style and usage, proofreading and correction of a manuscript, and finally markup of copy for typesetting. Markup specifications direct a compositor's work and define typesetting parameters. With electronic manuscripts, it's possible to include these commands directly in text that a typesetting machine can decode. Writers and reporters may end up doing some of their own coding by using the text they've written on a computer to drive a typesetting machine. Finally, desktop publishing (DTP) brings control of type directly into the author's hands. Writing, copy preparation, and typesetting are virtually merged, taking place on the same equipment, often executed by a single person.

At top, the rough thumbnails quickly sketched to develop an ad. One of them is carried forward into a full color comp, drawn to size. Above, the mechanical from which a color map is to be printed. The overlay tissue includes instructions to the film stripper, specifying the percentages of process colors that are to be combined to produce color tints. The dark area is a rubylith overlay that will constitute a tint distinct from the drawing and type below it. These three stages, from thumbnails to mechanicals, represent the production stages prior to printing.

Overview of print production stages

The print production process, showing typical tasks for each participant. The principal shown here may actually be several different people on a particular project. To schedule a print project, accommodate all the relevant steps shown here and include ample time for corrections and revisions, for few jobs move neatly through only these ideal stages.

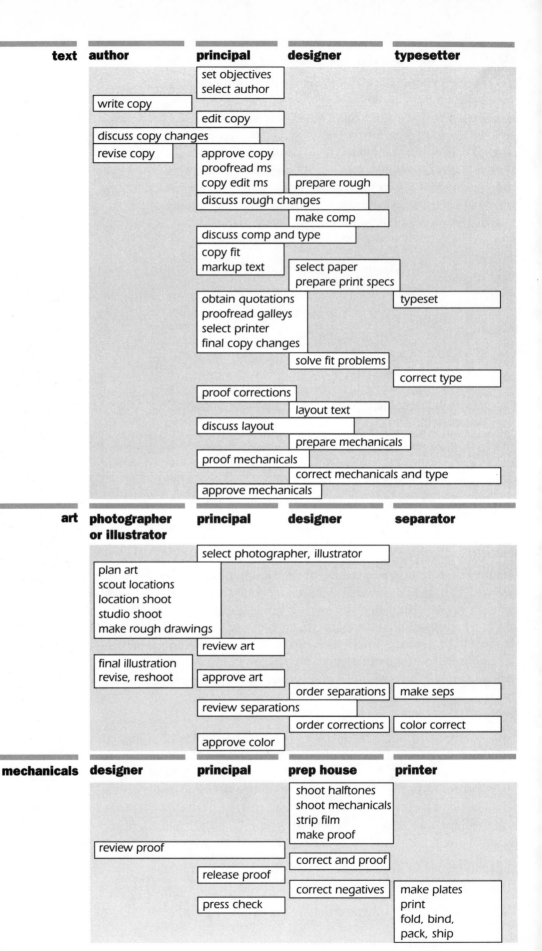

text	author	principal	designer	typesetter
		set objectives		
		select author		
	write copy			
		edit copy		
	discuss copy changes			
	revise copy			
		approve copy		
		proofread ms		
		copy edit ms	prepare rough	
		discuss rough changes		
			make comp	
		discuss comp and type		
		copy fit		
		markup text	select paper	
			prepare print specs	
		obtain quotations		typeset
		proofread galleys		
		select printer		
		final copy changes		
			solve fit problems	
				correct type
		proof corrections		
			layout text	
		discuss layout		
			prepare mechanicals	
		proof mechanicals		
			correct mechanicals and type	
		approve mechanicals		

art	photographer or illustrator	principal	designer	separator
		select photographer, illustrator		
	plan art			
	scout locations			
	location shoot			
	studio shoot			
	make rough drawings			
		review art		
	final illustration	approve art		
	revise, reshoot			
			order separations	make seps
		review separations		
			order corrections	color correct
		approve color		

mechanicals	designer	principal	prep house	printer
			shoot halftones	
			shoot mechanicals	
			strip film	
			make proof	
	review proof			
			correct and proof	
		release proof		
			correct negatives	make plates
		press check		print
				fold, bind, pack, ship

Art

Art for the printed piece may follow a long journey, from concept to photography to editing. Once a particular illustration or photo is selected, the designer establishes its cropping, intended size, and position on the page. The art may be reproduced photographically, or it may be digitized for later photographic output. Designers may also color correct the art, calling for changes based on a proof of the image. Electronic color correction and image manipulation is one of the most rapidly changing technologies in the graphic arts.

All illustrations composed of lines, dots, or solids are reproduced as line art. A graphic arts camera photographs the material as a single tone, rendered as pure black or a pure color on the press. Examples of line art include type itself, hand lettering, a nineteenth-century engraving, and the shading created with cross-hatched lines.

Images with a range of tones from black to gray to white are reproduced using the halftone process. The camera photographs such originals with a screen that distributes small dots based on the intensity of the tones of the image. Because they appear in different sizes and patterns, the printed dots simulate a tone to the naked eye. A color photograph is reproduced by four different pieces of halftone film, one for each of the inks in the four color process: cyan, magenta, yellow, and black. To make this film, a color image is analyzed through color filters to break out the proper tones for each color, and the result is called a separation.

Scheduling production

Most production schedules begin after the idea for the piece has been conveyed to the designer, copywriter, illustrator, and photographer.

As the charts show, a printed piece travels in a zigzag, moving from execution to approval to another phase of execution. An in-house desktop publishing system may remove several outward loops, but the need to keep several people aware of the ongoing work isn't likely to diminish. When scheduling a project, bear in mind that you may need two correction loops instead of one at many stages. The complete production cycle for a catalog or magazine can easily take eight weeks, while a newsletter can usually be produced in four. Jobs that don't include as much text or represent as many different contributors can be completed in two or three weeks.

There's a tendency to build a schedule based on how long work ought to take. Even if you have a firm grasp of those ideal times, you'll probably make your schedule too tight. In the end, how quickly something ought to be done is often a poor projection of how fast it will be done. Include enough time for changes and revisions, even if you're attempting to set up a production system in which modifications are unacceptable. Finally, include enough time for quality work to emerge. People can't always get things right the first time, but if you give them time to correct an error or consider a design just a little longer, you'll have a better printed piece. Think about all the printing you worked on over two years ago—you can probably remember every job that ran with a typo in it, but you may not recall which ones were late and which were on time.

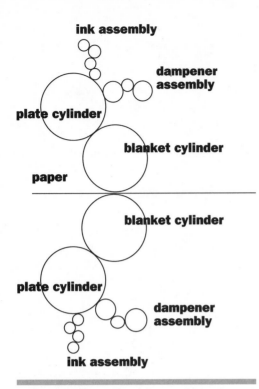

The perfecting press is a variation on the cylinder offset press design that sends the paper between two blanket cylinders, each acting as the impression cylinder for the other. This prints both sides of the paper simultaneously, requiring care in makeready but doubling the speed of single-sided printing. Both web and sheetfed perfecting presses are widely used.

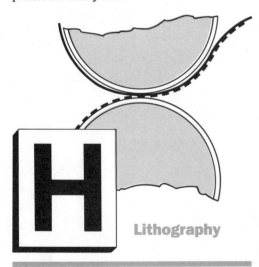

The lithographic process is based on the fact that oil and water do not mix. The plate is flat, but its photographic coating attracts oily ink where the printed image is developed. In this schematic drawing, the plate cylinder at bottom transfers ink to the paper on the impression cylinder at top.

Printing overview

The act of printing is almost instinctively clear: a plate is inked, put into contact with paper, and the plate's image can be copied indefinitely. There are four principal printing methods, each distinguished by the type of plate employed: letterpress, using a raised image to hold ink; gravure, using a recessed image to hold ink; screen, using a stencil to restrict ink; and lithography, using a chemically treated plate to attract ink. All four processes are based on selectively locating ink on a master plate for transfer to paper.

The majority of individual printing jobs are produced lithographically today. The number of net impressions from gravure is quite high because it best serves long print runs, but it accounts for roughly 20 percent of printed products. Letterpress, increasingly on the wane, is used for 10 percent of printing jobs, but its descendant, flexography, accounts for another 15 percent of printed work, chiefly in the packaging field. Screen printing and miscellaneous processes are behind 5 percent of current printing jobs. Lithography is the process of choice for about half of American presswork today. Why?

The reasons lie in the efforts needed to produce a plate, and the speed and fidelity with which the plate can transfer ink. Lithography requires numerous steps to create plates, but they are reasonably fast ones and they permit simple review and correction of material along the way.

Offset lithography

A lithographic plate is made photographically from a film negative or positive. It can easily include halftones (the reproduction form of photographs) because it's produced much like a film negative. The plate becomes a printing surface when its specially treated surface is exposed and developed. The areas that received light become receptive to ink and repellent to water. Lithography is called planographic printing because the plate is smooth; the image it contains is on the same plane as the nonimage area. On the press, the plate is bathed in water and alcohol. The exposed areas, which are to carry ink, repel this dampening solution. When ink is rolled across the entire plate, the watery areas accept no ink while the exposed areas readily absorb it.

This convenient platemaking technology doesn't account alone for lithography's prominence. Virtually all lithographic printing utilizes the offset method, and in fact it's more often called offset printing than lithography. The offset process calls for a two-step transfer of ink: from plate to blanket cylinder and from blanket to paper. Because of the double transfer, a plate is right-reading; it looks like the printed result rather than a mirror image.

Offset presses all use cylinders to hold plates and blankets. With each rotation, the plate passes through a water solution and against ink rollers. When it comes in contact with the rubber blanket, it deposits the ink it's attracted, which the blanket in turn delivers to paper. The paper fed through the press remains flat and is brought into contact with the blanket by an impression cylinder. The blanket's pliability allows it to conform to irregularities in the paper surface while still uni-

formly delivering ink. And because the plate only makes contact with the relatively soft blanket, plate life can be quite long. Offset, therefore, allows printers to get the most out of paper and plates.

There are two final advantages to the process. The amount and type of ink applied permits fast drying, either under heat or in the air. Offset printing is quickly ready for trimming or binding, and the fast impression speeds that the process allows mean that printing itself is completed rapidly. A typical offset web press produces 25,000 impressions an hour; high-speed presses can run up to 65,000 per hour. In addition, the impression cylinder's job of bringing paper into even contact with the blanket can be served by a second blanket cylinder instead of a blank one. Both sides of the sheet are printed simultaneously, and a press so equipped is called a perfecting press.

Finally, the offset process permits a great range of quality, suiting everything from low-budget printed products to prestigious publications and annual reports printed on the finest papers. Offset is capable of sharp, brilliant, faithful reproduction for both short and long pressruns, from one thousand copies to millions.

The virtues of offset are extensive enough to make it a likely choice for most jobs, from routine to fastidious printing. It's also omnipresent and may choose itself for you because of its wide availability. Familiarity with the other three processes, however, allows you to select them when appropriate.

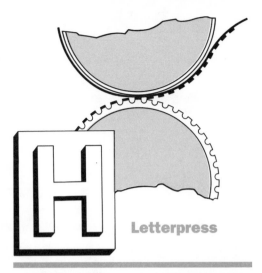

A letterpress plate has a raised image that picks up ink and transfers it to paper. The black marks in this stylized image represent the ink film. Letterpress is much like rubber stamping.

Letterpress

Letterpress is a relief printing process, equivalent to rubber stamping. Its plates must be cast, molded, or formed to produce a raised printing surface that draws ink from rollers. Letterpress can use type directly, in cast metal form, making it an appropriately fast process for newspapers. The plates themselves are mirror images of the printed result.

Gravure

Gravure is an intaglio process, similar to etching. A copper plate is etched and its minute depressions are filled with ink on press. The cylinder revolves against a flexible blade that wipes the surface of the plate clear, and when paper is brought into contact, surface tension and pressure draw the ink out. Gravure inks have a different body and gloss than lithographic inks. They're deeper in saturation and richness, and duller in gloss. Because of the higher costs and longer times required to make gravure plates, the process is rarely used for pressruns below one million, but plate etching technology is changing rapidly here. Gravure may soon become economical for runs as short as 500,000.

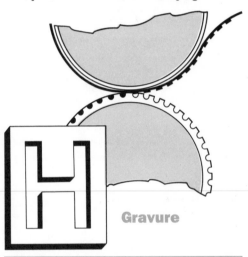

The depressions in a gravure printing plate hold ink, which is drawn out onto the paper by pressure and surface tension.

Screen

Screen printing is a stencilling process. A screen of nylon, silk, or other material carries a stencil that blocks ink selectively. The stencil might be created photomechanically or it might be cut by hand. With paper beneath the screen, a printer spreads ink across the screen with a squeegee. The ink is forced through the screen where the image permits, and the paper below receives a heavy, paint-like coating. This

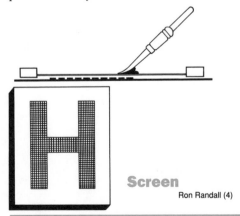

Ron Randall (4)

In screen printing, a squeegee forces ink through a screen that is open only where the printing image appears.

method is not confined to paper: printed T-shirts, decals, metal trim on car dashboards, billboard posters, and similar items are all candidates for screen printing. Glass, wood, plastic, and any other material unsuited for the apparatus and inks of the other printing processes can be printed with the screen process.

The four printing processes described here account for almost all the commercial printing done today. We might want to note that copying and duplicating processes are technically printing as well. A sophisticated fund-raising organization might use high-speed laser printing to produce letters with personalized salutations, feeding the data to the printer with a computer tape. At a smaller level, an office-grade laser printer might be used as the final printing process for a newsletter or in-house publication. The laser printer and the photocopier are closely related technologies. A bit different, and fading fast in prominence, are spirit duplicators and mimeograph machines. All these copying devices have limited capabilities for printing anything other than type, and generally are suited for production of under 500 copies at a time.

Type and printing

The printing process you use will have an effect on your choice of type, paper, and artwork. For example, gravure images are formed of tiny dots of ink drawn up from an intaglio plate. This means that fine lines and small type with thin hairlines will not reproduce sharply. In short, when you're planning a printed piece you'll need to consider its printing specifications as you determine its design and type selection.

In the 535 years since Johann Gutenberg perfected a method for casting type consistently and in quantity, the world's libraries have accumulated everything from Dante's *Divine Comedy* to Lee Iacocca's autobiography. Type, the medium, makes no distinctions about what it serves. It stands ready to animate any message, exhorting sales, exposing scandal, or sparking a reader's reflection on any topic at all. Type preserves and projects text into the future.

It is difficult to talk about type without some emotion when considering that letters have been the vehicle of thought for 4,000 years. Confronted with the papyrus on which Plato's *Republic* is written, or a page of the Coptic Gospel, or the medieval copies that preserved those works, the viewer must acknowledge the power of writing to defy time and distance. Because type gives form to ideas, it is simultaneously a simple conduit and a vital force.

Typography

The practice of typography, if it be followed faithfully, is hard work—full of detail, full of petty restrictions, full of drudgery, and not greatly rewarded as men now count rewards. There are times when we need to bring to it all the history and art and feeling that we can, to make it bearable. But in the light of history, and of art, and of knowledge and of man's achievement, it is as interesting a work as exists—a broad and humanizing employment which can indeed be followed merely as a trade, but which if perfected into an art, or even broadened into a profession, will perpetually open new horizons to our eyes and new opportunities to our hands.

Daniel Berkely Updike
Printing Types
1937

The twenty-six letters of our alphabet have probably been drawn more times than any other subject, and they are not likely to stop inspiring type designers any time soon. Graphic designers may choose from an array of typefaces so large that no one is confident of the number; the ways in which these fonts can be displayed are likewise nearly limitless. Typography concerns the selection and use of type, and the typographer's decisions are shaped by considerations of legibility and readability, and the search for effective, aesthetic methods of conveying ideas in print. Above all, typographers choose from an enormous set of possibilities, making graphic discrimination a typographer's most important skill.

Fine typography creates a perfect link between form and content in which the nature of the message and its presentation are ideally matched. Quite often, that flawless balance requires that the form go completely unnoticed, making beautiful typography the selfless, silent servant of content. In other applications, type conveys meaning and mood even before the message is read. But no matter how strong a force it is on the page, readers respond to typography subconsciously, almost always unaware of the intelligence and sensitivity necessary to make type communicate. In fact, the fine points of typography are often obscure even to those who examine yards of galleys a day, for computerized composition systems now handle many decisions editors or designers used to make.

Using type well requires sensitivity to shape, contrast, and form. It also demands an understanding of conventions of legibility and other technical matters. In this chapter, you'll read about the terms and ideas that support sensitivity to the graphic aspects of typography; in the typesetting chapter which follows, you'll learn about the technical aspects of setting type.

Type as raw material

A printed communication that relies on symbol or illustration alone is rare. Even highway signs lack complete confidence in the symbolic: the inverted triangle still gets "yield" written on it in case the shape alone fails to communicate to the driver. Type is the designer's constant concern, and though he may be forgiven for tiring of its demands, he must be prepared to commit himself to using type well. Often, that will mean working with the most subtle effect. The typographer Stanley Morison put it well when he said, "Typography is the efficient means to an essentially utilitarian and only accidentally aesthetic end, for enjoyment of patterns is rarely the reader's chief aim. Therefore, any disposition of printing material which, whatever the intention, has the effect of coming between author and reader is wrong." This doesn't diminish the designer's contribution, for he will shape and animate the message, but he must let the message come first.

The alphabet

Everyone is in agreement on what the alphabet looks like, yet there are a surprising number of variations in its letterforms that are read with equal understanding. The capital *A* can be everything from a simple triangle to an elaborately constructed set of lines and swashes. What we agree on is a theoretical, skeletal alphabet design, in which a *W*, for example, is two inverted triangles that may be joined together in a variety of ways, and in which a lowercase *g* can take one of two wholly different structures. Our certainty about the appearance of this core alphabet has to do with both the features individual characters possess and the relationship among characters in a set comprising an alphabet.

If the typographic equivalent of Esperanto were created, it's likely that still larger differences among letters would be built into it. The similarity between *cl* and *d* can make *clean* look like *dean*, and it takes just a little over-tight spacing to make *modern* read as *modem*. In the sections on legibility and readability, you'll read about the efforts both type designers and typographers must make to overcome these inherent shortcomings of the alphabet.

To notice the shapes we use to identify letters and read, look at the sentence below, printed with the upper half of the characters masked. Now turn the page and examine the same sentence with the lower half missing. The tops of characters tend to be more crucial to recognition.

Whether I shall turn out to be the
hero of my own life, or whether that
station will be held by anybody else,
these pages must show.

olive
modem modem
Torn Mix

Is it Tom Mix or Torn Mix? Many letter combinations pose legibility problems for type designers and typographers.

The tops of characters are more crucial to recognition than the bottoms. Try reading this sentence, and compare it to the version on the next page.

Axphot

ascender line
cap line
mean line
x-height
baseline
descender line
shoulder

Type measurement is based on the five lines shown above. Point size includes the shoulder area, and extends from the cap line to the bottom of the shoulder line.

Recognition

It's remarkable how much our powers of visual discrimination depend on the terminology we possess. Some people look out their windows and see only birds in the trees; others have learned to classify and recognize chickadees, sparrows, and finches. No chickadee looks like a sparrow, but until we have an idea of where to look for the differences and what to call them, we can't easily distinguish birds.

Recognizing type is a similar matter. It's probably not possible to count the number of different type styles available today, but a well-trained eye will allow you to identify hundreds of widely used typefaces and to recognize the distinctions of thousands more. Central to this recognition process are the terms for the elements of characters.

Elements of a character

The names for the lines and spaces in letterforms provide a solid footing for discussing and classifying type designs. The terms themselves tend to have obvious definitions, and you don't need to know them for themselves but for the differences among designs they help reveal.

The list that follows defines each term and gives examples of typical variations in these elements. A type design can be characterized overall by features these terms illuminate. You'll note that a disproportionate number of terms are used for the *g*. It's by far the most distinctive character in type and is often the best letter to examine to identify a face. The other consistently distinctive letters are the *a, e*, and *t*.

The tops of characters tend to be more crucial to recognition. This sentence is legible, but the version on the previous page is not.

Whether I shall turn out to be the
hero of my own life, or whether that
station will be held by anybody else
these pages must show

apex

AM

Triangular point at the top of a character, including its serif.

pointed A	M *flat*	
Times Roman	Bembo	
round **M**	M *serif*	
Cooper Black	Italia	
left serif A	A *scalloped*	
Beton	Caslon 540	

arm

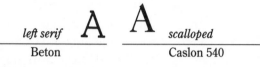

YLE

Horizontal or diagonal stroke extending from a vertical stem.

wide span L	L *narrow span*	
Newtext	Palatino	
even length E	E *uneven length*	
Copperplate	Baskerville	

ascender

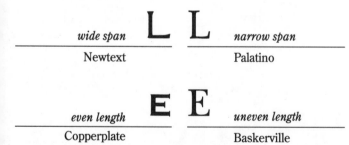

bdfhklt

Portion of the lowercase letters shown above that extends above the height of the lowercase *x*. Variations are discussed under *x-height*.

bar

AHe

Horizontal line within verticals, diagonals, or curves.

angle **e**	A *stroke*	
Avant Garde	Benguiat	
low placement H	**H** *high placement*	
Kabel	Broadway	

bowl

cRdaP

Curved line forming a loop, oval, or circle.

closed P	R *open*	
Modern No. 20	Palatino	
large size **R**	R *small size*	
Windsor	Benguiat	

bracket

mwxCA

Connection between a serif and a stroke.

no bracket M		
Rockwell		
light M	**M** *heavy*	
Baskerville	Clarendon	

counter

aenpOP

Enclosed or partially enclosed shape defined by a line.

small e	e *large*	
Bembo	Serif Gothic	

cross stroke

f t

Roughly horizontal line extending outside primary vertical line of a character.

angle	t f	*bracket*
Italia		Weiss
centered	f t	*uncentered*
Scotch Roman		Quorum

descender

gjpqy

Portion of the letters shown above extending below the baseline.

absence	g	
Broadway		
deep	ty ij	*shallow*
Bembo		Beton

ear

Line projecting from the bowl of the lowercase *g*.

left	g g	*straight*
Artcraft		Friz Quadrata
up	g g	*down*
Goudy		Clarendon
ball terminal	g g	*pointed terminal*
Bodoni		Cooper Black
straight terminal	g g	*small*
Weiss		Caslon 540
large	g g	*absence*
Clearface		Centaur

link

g

Line connecting upper and lower bowls of a lowercase *g*.

length	g g	*turn*
Gill Sans		Fenice
absence	g	
Kabel		

lower bowl

g

Line forming the loop in the lower part of a two-story character.

small	g g	*large*
Belwe		Baskerville
open	g	
Kabel		
oblong	g g	*round*
Sabon		Caslon Antique

serif

TEnk

Short, terminating strokes, roughly perpendicular to main strokes of a character.

angle	E m	*equal to stroke*
Bookman		American Typewriter
light	M d	*heavy*
Bodoni		Plantin
short	L F	*long*
Cheltenham		Modern No. 20
barb bracket	G G	*spur serif*
Fenice		Beton
ball bracket	k m	*right foot only*
Clearface		Zapf Book

shoulder

hmnr

Curved stroke emerging from a stem. Contrasting variations are shown in *overall properties*.

spine

S

Principal curved stroke of capital and lowercase *S*.

symmetrical	S	S	*asymmetrical*
Helvetica			Cheltenham
deep curve	S	S	*shallow curve*
Clarendon			Beton

spur

G

Small projection from a stroke.

absence	G	G	*presence*
Optima			Bookman
delicate	G	G	*pronounced*
Century Old Style			Cheltenham

stem

RHhY

Prominent vertical or diagonal stroke.

stress

dObC

Direction in which a curved stroke thickens.

backward	d	d	*vertical*
Caslon 540			Bodoni

tail

QRKjy

Short stroke at an angle to the main stroke.

cuts counter	Q	Q	*doesn't cut*
Century Old Style			Berling
swashes	Q	R	*sweep*
Cooper Black			Bulmer

terminal

awr

End of a stroke not concluding in a serif.

prominent	a	a	*delicate*
Helvetica			Cheltenham
ball shape	W		
Clearface			

upper bowl

g

Line forming the loop in the upper part of a two-story character.

large relative to lower bowl	g		*small relative to lower bowl*
Century Old Style			American Typewriter
similar to lower bowl	g		
Gill Sans			

vertex

MWvwV

Triangular point at the base of a character.

angle	V	M	flat
Friz Quadrata			Eras
non-intersecting	W		
Clearface			

x-height

ataraxy

Height of lowercase letters without ascenders or descenders.

small	extrapolate
Bembo	
large	extrapolate
Avant Garde	
moderate	extrapolate
Century Old Style	

overall properties

Some characteristics describe a type design in general ways.

narrow	abcdefghijk
Fenice	
wide	abcdefghijk
Optima	
no contrast	abcdefghijk
Helvetica	
little contrast	abcdefghijk
Garamond	
moderate contrast	abcdefghijk
Times Roman	
extreme contrast	abcdefghijk
Bodoni	
italic	*abcdefghijk*
Galliard	
demi weight	abcdefghijk
Eras	
bold weight	abcdefghijk
Eras	
ultra bold weight	abcdefghijk
Eras	

Classifying type

For all the precision required to design and specify type, typographers remain remarkably inexact in classifying type designs, settling on no single identification system. A classic division of types, based on the evolution of design through the eighteenth century, has proven incapable of sorting out styles that combine old influences or stake out new visual territory. Systems that include enough nuance to accommodate all unique properties tend to be so large as to defy natural use, while simpler classifications easily blur useful distinctions by identifying designs too superficially.

A classification system should enable graphic designers to select and relate type designs based on common properties, and these may range from x-height to thick/thin contrast to angle of stress. There is no single aspect of type that accounts for its appearance or guarantees its appropriateness in an application.

A secondary goal of a classification system is the organization of type to facilitate historical cataloging. In many ways, these projects are incompatible. A designer may be looking for a type that conveys a mood, like power or friendliness, while a type historian may want to underscore a single common element in design.

In the end, you'll forge distinctions of your own to relate typefaces. An overall classification system can help you notice common elements in type design, but it's useful only as a point of orientation. This is no

small benefit, of course, and whether you're familiar with hundreds of faces or only a few, you can sharpen your sensitivity by searching for the shared properties that categorize type. You may want to develop your own classification system, and the good news is that you're not constrained by a perfect, accepted model. The bad news is that it's difficult to organize type definitively. There are very few qualities that several types don't share, and the very aspects we'd like to use as a basis of classification tend to arise in contradictory patterns.

The model presented here will serve many purposes and can be the foundation of a system of your own. There are four major categories, each with subdivisions. The distinctions aren't posed to complicate matters, but rather to help you see type fully. The groups here highlight properties of type that most significantly influence its choice and application. That makes some boundaries fuzzy still, and allows you to debate the correctness of this particular arrangement. It's that very contentiousness that will heighten your perception of type and make you admire it more than any system for organizing it.

Serif

The serif category contains such a diversity of typefaces that anyone would hasten to subdivide it. In general, serif types show the influence of handwriting, particularly the humanist hand of the Renaissance. Though compasses and rulers define many of the lines, a roman type is not geometric. On close inspection, you'll find that many shapes are quite free and loose, even when they suggest straight lines or uniform curves.

oldstyle
calligraphic
soft serifs
sharp serifs
heavy serifs
transitional
modern
fat face
Egyptian
square serifs

Each typeface can be examined based on its treatment of four major characteristics:

■ *Serif styles* may be simple or embody prominent traits, such as hairline, angled, square, round, or sharp treatments.

■ *Brackets* connect stems to serifs and may be eliminated or thickened into prominence.

■ *Contrast* is the stroke range from thick to thin and gives the typeface its relative change in density within a letter.

■ *Angle of stress* describes the line between two points at which a curve is thinnest, which gives a curved stroke its overall slant.

KT KT hm hm

Serifs are small but telling strokes that distinguish type designs. Garamond is on the left and Bookman is on the right.

Contrast variations. A high contrast design, like Bodoni at left, has extreme changes in line weight. Goudy is at right.

Hb Hb db db

Bracket variations. Note the difference in thickness and shape between Clarendon, on the left, and Trump Medieval, on the right.

Stress concerns the angle in a curve. Some fonts show pronounced angles, like Palatino on the left, and others have curves parallel to stems, like Bodoni on the right.

Oldstyle

E

- modest serifs
- full brackets
- limited contrast
- angled stress

It's useful to think of oldstyle as the design root for all typefaces. The characteristics of type in other categories are often variations on oldstyle themes. The main attributes (angle of stress and moderate thick/thin contrast) link these types with the handwriting style called Littera Antiqua. Designers have consistently been inspired by oldstyle principles, and though the first of these faces dates from 1500, we won't soon see the last: Galliard was issued in 1978.

Bembo
Caslon
Century Oldstyle
Galliard
Garamond
Goudy
Janson
Sabon
Times Roman

Calligraphic

E

- restrained serifs
- light, sharp brackets
- moderate contrast emphasized by calligraphic quality of line
- angled stress

This subdivision calls attention to a particular way of treating line contrast. Here, the thick to thin relationship has a three-dimensional quality reminiscent of changing pen angles. Because these types mesh completely with oldstyles, the distinction may appear a small one, but the weight of such types in full text blocks is unique. Both the sample types were drawn in the last part of this century.

Palatino
Trump Medieval

Soft serifs

E

- rounded serifs
- brackets swell, blot, or curve into serifs
- limited contrast
- angle of stress varies

Some of these typefaces may have a vertical angle of stress and wouldn't properly qualify as oldstyles, but their serif treatment is so conspicuous that they deserve individual note. Exaggerations like these serifs are typical of the advertising types designed in the last hundred years.

American
Typewriter
Cooper Black
Souvenir

Sharp serifs

E

- small, sharp strokes for serifs
- light, short brackets
- contrast varies
- angle of stress varies

Most sharp serif types have a slight corona about them, due to their short, spiked edges. A face like Copperplate Gothic has just enough points to look crisp and neat, while an assertive style like Tiffany makes something of a commotion. All of these are twentieth-century designs.

Benguiat
COPPERPLATE GOTHIC
Friz Quadrata
Korinna
Novarese
Perpetua
Quorum
Tiffany

Heavy serifs

E

- strong serifs
- robust bracket curves, giving type a heavy horizontal quality
- little contrast, generally due to a heavy line weight overall
- vertical stress

Types in this subdivision are sometimes called Book or Primer, due to a design emphasis on easy reading that's obtained with subtle contrast, large counters, and distinct brackets. The strong horizontal motion of these types is due to their powerful serifs and brackets. They can appear either soothing or ponderous, depending on the typographer's skill.

Bookman
Century Schoolbook
Clearface

Transitional

E

- *modest serifs*
- *thin brackets*
- *moderate contrast*
- *vertical stress*

As the term suggests, transitional types represent a shift from oldstyle to modern characteristics and are typified by vertical stress coupled with definite contrast. Brackets are lightweight, on the brink of the hairlines that will distinguish moderns. Baskerville, the first transitional, appeared in 1758. The types embody a balance of extremes that suit them for many applications.

Baskerville

Bulmer

Caledonia

Electra

Modern

E

- *hairline serifs*
- *no brackets, or very weak brackets*
- *extreme contrast*
- *vertical stress*

Modern types have been modern for 200 years, surely setting a record for terminological stubbornness. In fact, the term for these types with powerful contrast arose in the 1770s when they must indeed have dazzled readers and printers alike. A desire to make letters more crisp and severe made perfect sense in the Age of Reason and rather parallels the efforts in this century to create ideal sans serif faces.

Bodoni

Fenice

Firenze

Firmin Didot

Modern No. 20

Walbaum

Fat face

- *hairline serifs*
- *no brackets*
- *drastic contrast*
- *vertical stress*

Bodoni himself might have been surprised to learn that there was a further extreme to which the modern style could be carried, but advertisers of the nineteenth century created a demand for eye-popping poster headlines, and designers met the need. Ultra Bodoni appeared in 1929, postdating its namesake by 160 years. These styles have great drama and power.

Metropolis Bold

Nubian

Thorowgood

Ultra Bodoni

Egyptian

E

- *rectangular slab serifs*
- *no brackets*
- *virtually no contrast*
- *no angle of stress*

Because these types dispense with every quality of oldstyle designs, they have far more in common with sans serif faces. In fact, sans serifs are often classified as Abstract or Structural in order to include the Egyptian faces. The term arose because these faces suggested the rigid power of hieroglyphs, but they originated on the heels of the Industrial Revolution and served advertising interests.

Beton

City

Egyptienne

Lubalin Graph

Memphis

Rockwell

Stymie

Square serifs

- *blunted serifs without tapered ends*
- *minimal brackets*
- *limited contrast*

The square serif type is another design range developed to satisfy novelty-hungry advertisers of the nineteenth century. Some have distinct circus poster qualities, but the more versatile of them can handle typographic duties today without a whisper of nostalgia. Melior is a recent, all-purpose font that uses the square serif unobtrusively.

Clarendon

Melior

Playbill

Sans serif

monoweight
gothic

Sans serif typefaces emphasize structural ideas of abstraction and give little or no hint of any handwriting influence. As geometric exercises, they are best divided by the purity of line thickness. Monoweight styles have little or no apparent change in line weight, while gothic styles allow lines to taper at stroke intersections. This difference is ultimately quite visible in a mass of type, even though its cause may be so subtle as to be overlooked.

The distinction between serif and sans serif ought to be a clear watershed, but it actually permits some confusion. Optima, for example, has tapered finishing strokes, but these terminals are gentle swells and can't be called serifs because they fail the test of resting perpendicular to main strokes.

Monoweight

E

- *uniform stroke weight*
- *no apparent contrast*

Most of these types are not only useful in themselves, but also for their vast array of weights and treatments. The invention of photocomposition in the 1950s made such ranges relatively simple to produce, but Futura, a design of the 1930s, was launched with an ambitious palette of weights in the era of metal linecasting, and Univers was conceived for typecasting as well as photocomposition in the 1950s. A type designer can develop weight variants rather easily in sans serif styles because the curves and stroke weight changes are limited.

Avant Garde
Eras
Futura
Helvetica
Kabel
Univers

Gothic

- *few variations in stroke weight*
- *limited contrast*

When sans serif types first appeared in the nineteenth century, Europeans called them grotesques and Americans labeled them gothics. Both terms strove to suggest the shock value of big ad lettering, with *gothic* used for its barbarous connotation. The gothic sans serifs have some degree of line contrast, generally most visible at stroke intersections and curves. Some gothics, like Gill Sans, use oldstyle proportions but eliminate serifs while others are purely abstract creations.

Franklin Gothic
Gill Sans
News Gothic
Optima

Lettered

Metal type's first mission was to duplicate the handwritten manuscripts it was to replace, and these fonts show the continuing efforts on this front. However, the models for most lettered typefaces are so remote from contemporary handwriting that these faces serve a very different purpose from early movable type.

All lettered types make a clear statement about the writing tool used to create them. Unlike other serif or sans serif designs, these types imply a human hand, often drawing rather freely, using anything from a brush to a steel quill.

This category benefits from four clear subdivisions, based on these elements:

- Letters may be slanted right to mimic handwriting or stand upright like roman type.
- Strokes may be rounded and free-flowing or built up in varying thicknesses by several strokes.
- Letters may have provisions for connection, like written script, or may be discrete shapes.

calligraphic
text
script
cursive

Calligraphic

- *no slant*
- *free-flowing strokes*
- *may or may not include letter connections*

A large number of handwriting styles were perfected in Europe from the first to the fourteenth centuries, but only two of them were visible influences on the Roman alphabet. Others, like the uncial hand, survive as typefaces that suggest their origins in penmanship. Calligraphic types lack the clear, structural verticals of roman letter and generally indicate the movement of a pen nib across the page.

american uncial

ITC Zapf Chancery

Script

- *strong slant to right*
- *free-flowing strokes*
- *complete letter connections*

Script types have a way of sparking brief fads and then retreating in disgrace. It is safe to say that few of them fool the viewer into believing custom calligraphy has been used, but when a handwritten quality is sought, these types stand ready. Some are loose, breezy affairs, but even at their most casual they labor a bit. Others preserve classics of penmanship, like the Spencerian style. Note that a wide range of writing tools are simulated.

Brush

Kaufmann Bold

Commercial Script

Text

- *no slant*
- *characters built of many strokes*
- *no letter connections*

Because these typefaces are more often used as monograms or in short lines for invitations and diplomas, it seems odd to call them text, but the term arose when German handwriting aspired to a dramatically woven appearance and earned the name Textura. The extreme emphasis on verticals gives these types a condensed appearance, and they are effectively a lesson in illegibility to our eyes. Black letter, the alternate term for these types, hints at their appearance in text blocks.

Fraktur

Old English

Wedding Text

Cursive

- *some slant*
- *free-flowing strokes*
- *no letter connections*

Social announcements, long a printing mainstay, were generally set in black letter until the 1930s, when the funereal quality of those types was finally judged too depressing for wedding invitations. Cursive types, distinguished by their handwritten but unconnected letters, may be used when more formal scripts are inappropriate. Some cursives slant only slightly, but in all cases they are distinct from roman italics because they lack serifs.

BALLOON

Murray Hill Bold

Park Avenue

Specialty

novelty
period
ornamental

Type has been drawn to produce so many effects that trying to make rigid subdivisions of the specialty fonts is amusing but nearly futile. Novelty is the watchword here, and few of these types can sustain more than brief text. For embellishment, emphasis, and just plain diversion, the specialty types provide everything from letters made of tree limbs to simulated neon signs.

In this category, you tend to know it when you see it, for it's unlikely you'll begin a design project certain that type constructed of bent paper clips will be perfect for a given headline. In fact, the hardest thing about using specialty type well is visualizing its effect on particular words in particular sizes.

To give you some orientation in a category populated with type that simply won't fit elsewhere, three subdivisions are staked out, but as you'll find when perusing any presstype catalog, there are no definitive organizing principles for these diverse types.

Novelty

No description will gather these types in useful categories, for they are idiosyncratic by definition. There are many types that make a point of assembling letters out of odd raw material, and it's safe to say that these usually startle readers into thinking twice about the shapes of letters. Designs using tonal effects or unusual lines and strokes can serve as the foundation for logotypes, and many a small business has found its identity from a novelty typeface in a presstype catalog. These types are fun to use, but can present legibility problems.

Croissant

GLASER STENCIL

Kalligraphia

ITC NEON

PROFIL

Shatter

SINALOA

Period

Some types were designed to suggest another era at the outset, and others perpetually capture the age in which they first appeared. Broadway, for example, is unselfconsciously a product of the 1920s, but Caslon Antique's distress marks were drawn in the late nineteenth century to simulate the rough printing of colonial times, and the face has no relationship to its eighteenth-century namesake. Used with care, period types can convey historical ambience, but remember that such an effect hinges on much more than a genre font.

Arnold Bocklin

Broadway

Caslon Antique

Peignot

Ornamental

Descended from the illuminated letters that were painstakingly hand drawn in manuscripts and printed books, ornamental types are still best parceled out a character at a time. Victorian designers had a rousing time with such types and never tired of dressing up letters. Judicious applications of these types can be delightful, but they call such attention to themselves that the designer must be cautious in his gambit.

Pamela

ROMANTIQUES

RUSTIC

SAPPHIRE

Type vocabulary

The process of selecting a typeface for any application begins with the designer's typographic memory. Though it's possible to form an idea about a message and then page through type specimen books looking for an appropriate typeface, the designer generally starts by connecting the idea with general or specific type possibilities even before he reaches for the typesetter's catalog of fonts. The big choices—between serif and sans serif, between soft serifs or hard, between extreme thick/thin contrast and gentle contrast—are usually played out in the designer's mind.

To use type well means going beyond copying the latest typographic fad. It's easy to select a type by reacting to what you see around you, but that kind of choice means that you're neglecting to build your solution from the application at hand. At the moment, Futura Extra Bold happens to be a hot font, and it's nice to see so much of it that we're all reminded how it works on the page. Unfortunately, some designers are calling for Futura because it's in fashion, not because they know what it can do for a particular job. If you react to trends, you'll never start one of your own. An inspired typographer looks at what type does to a message and lets the essence of a typeface play its part in the design. That means he must know a type very well, anticipating its rhythm on the page.

Designers must acquire a typographic vocabulary large enough to suit the range of messages and applications they'll encounter. Your control of type is not based on the number of samples in your library but on your ability to see the differences among them and to recall an array of faces. Accordingly, you'll want to have a vivid mental picture of a few typefaces whose characteristics you know so well that you can easily construct many design solutions from them, just as you would sentences from your English vocabulary. These typefaces will also form the basis for categorizing the traits of faces you use less frequently.

To guide you in developing a typographic vocabulary, the following fifteen pages present twenty-two serif and eight sans serif faces. The comments on each face provide some historical information, aids to identification, and guidelines for typographic use. When asked to select a single typeface for the equivalent of graphic design on a desert island, typographers tend to nominate Caslon, Garamond, Goudy, Helvetica, or Times Roman. In fact, those five faces are adequate for an enormous range of jobs and remind us that a basic foundation of typographic judgment begins with knowing a few faces very well.

contemplating
contemplating
contemplating
contemplating
contemplating
contemplating
contemplating
contemplating

Part of knowing a typeface well is visualizing the effect of its set width and density. Notice how much wider some of these set, and the range in contrast. Top to bottom: Bookman, Century Oldstyle, Franklin Gothic Heavy, Times Roman, Garamond, Goudy, Helvetica, Trump Medieval.

JeK
agB

Bembo

Bembo first appeared in a book printed in 1495 and was named for the author of the manuscript, not its designer. It was designed and cut by Francesco Griffo, who produced type for the Venetian scholar-printer Aldus Manutius. Griffo's work transformed type design, for his types were admired for their balanced, slightly heavier weight, and they influenced punchcutters throughout Europe. In a sense, Bembo is the root oldstyle design from which dozens of others branched. Bembo has an extremely shallow x-height, and its ascenders rise well above its capitals. Many aspects of Bembo are diminutive: the counters of the *a* and *e*, its overall set width, and its delicate serifs. But it also has some dramatic qualities in its tall ascenders, descending capital *J*, and the distinctive curved arm of the *K*. Bembo conserves space by its somewhat condensed style and its need for little or no leading.

ABCDEFGHIJKLMNOPQRSTUVWXYZ
abcdefghijklmnopqrstuvwxyz 1234567890
ABCDEFGHIJKLMNOPQRSTUVWXYZ
abcdefghijklmnopqrstuvwxyz 1234567890

ApC
tga

Caslon

William Caslon established a type foundry in 1720 in London and produced a line of type distinctly English and well suited to text in mass. Inspection of individual characters may dismay the viewer, for they abound in odd flaws, but somehow each isolated imperfection contributes to a steady, balanced look when the type is put to the real test of setting text. The bowl of the lowercase *p* threatens to crush the short descender, the *t* has a wedge serif that ought to place too much weight at a tiny intersection, and all the lefthand serifs on ascenders are stiff, triangular pennants. While these features may look awkward individually, Caslon sets with a bright, unaffected quality, and produces an even color despite its contrast. The style has been drawn many times, and is usually identified by a number; Caslon 540, shown here, seems quite true to William Caslon's specimen sheet of 1534, while Caslon 223 and LSC Caslon have much greater contrast. To identify any Caslon, look for upper and lower serifs on the *C*, the scalloped apex of the *A*, and the angular turn of the top of the *a*.

ABCDEFGHIJKLMNOPQRSTUVWXYZ
abcdefghijklmnopqrstuvwxyz 1234567890
ABCDEFGHIJKLMNOPQRSTUVWXYZ
abcdefghijklmnopqrstuvwxyz 1234567890

Century Oldstyle

During a decade beginning in 1906, Morris Benton designed the several weights and styles of this typeface. He named it for *Century Magazine*, and the design is based on the type his father produced for that publication. This face was created with legibility in mind, and for Benton that meant large serifs with strong brackets. Many serifs are sharply angled, giving the *S* something of a devil's tail and the *F*, *T*, and *E* prominent flourishes. All serifs are long, and while this helps distinguish characters, the treatment can backfire when tracking or kerning are too tight, for the serifs will touch. The typeface is sculptural enough to serve headlines, yet simple and legible enough for extensive text. Note the energetic lines forming the lower bowl of the *g* and the slight spur on the *G*.

GQg
dES

ABCDEFGHIJKLMNOPQRSTUVWXYZ
abcdefghijklmnopqrstuvwxyz 1234567890
ABCDEFGHIJKLMNOPQRSTUVWXYZ
abcdefghijklmnopqrstuvwxyz 1234567890

Galliard

Matthew Carter designed this type in 1978 and based the style on the much-admired sixteenth-century types of Robert Granjon. Carter's design is an inspired revival, suited to contemporary tastes but dramatically infused with the spirit and aesthetics of Granjon's French types. The style is crisp, authoritative, and bright. It has a large x-height and a distinctive set of italics. Note the italic *g*'s swooping, enclosed lower bowl, the splayed *Y*, and the overall cursive energy of the companion italic font. Galliard is lively, but can also appear brittle if misused. To recognize the face, look for the high crossbar on the *e* and the flat curve on the bowl of the *a*.

Ygi
Hpa

ABCDEFGHIJKLMNOPQRSTUVWXYZ
abcdefghijklmnopqrstuvwxyz 1234567890
ABCDEFGHIJKLMNOPQRSTUVWXYZ
abcdefghijklmnopqrstuvwxyz 1234567890

TcW
Agh

Garamond

Garamond represents more than a specific font, for it's a typographic vein that's been mined for four centuries. In the mid-sixteenth century, the French typographer Claude Garamond designed a type modeled on the Italian roman style, and it circulated widely throughout Europe, inspiring other type designers. The font has an elegance that defines French oldstyle type. Garamond proper has a shallow x-height, the better to accommodate the floating accent marks of French. In the International Typeface Corporation redesign shown here, it's been given the spacious x-height currently desirable, and in the process has become a rounder, sweeter type. Linotype's Garamond 3 is much more true to the original. To spot Garamond, look for the unmatched serifs on top of the *T*: the left one slants, the right one is vertical. Garamond's *W* has overlapping *V*s, its *c* has a very open counter, and its *A* is skinny, with a high crossbar.

ABCDEFGHIJKLMNOPQRSTUVWXYZ
abcdefghijklmnopqrstuvwxyz 1234567890
ABCDEFGHIJKLMNOPQRSTUVWXYZ
abcdefghijklmnopqrstuvwxyz 1234567890

Lij
mhE

Goudy

Frederic Goudy designed the book weight of this face in 1915 for the American Type Founders, but it was Morris Benton, the foundry's resident designer, who completed the range with bolds and variants. Goudy himself originally perceived the face's short ascenders and descenders as a design flaw, departing more than he wished from the Italian style he sought to emulate. However, this very characteristic suits the face to contemporary tastes. All characters have extremely open counters and the width of capitals is noticeably broad, giving the face a classical stature. Note the curve in the base of such characters as the *L* and *E* and the distinctive diamond used in punctuation and to dot the *i*.

ABCDEFGHIJKLMNOPQRSTUVWXYZ
abcdefghijklmnopqrstuvwxyz 1234567890
ABCDEFGHIJKLMNOPQRSTUVWXYZ
abcdefghijklmnopqrstuvwxyz 1234567890

Sabon

Commissioned in 1965 by several German typographers, Jan Tschichold designed Sabon, the last type design ordered for letterpress. It was released simultaneously for photocomposition, linecasting, and hand composition, and thus represents a watershed in type design history. Tschichold was a veteran of the Bauhaus movement, but he grew interested in typographic traditions and based Sabon on Garamond. The design had to fit the production idiosyncracies of linecasting and photocomposition, and it had to suit contemporary tastes. Tschichold succeeded in his mission and gave us a type with high x-height, moderate contrast, and a simple, rolling delicacy. Note the long bottom arm of the *E* and the overlapping diagonals of the *W*. In true oldstyle fashion, the counter of the *e* is small and the *a* has a small, slightly flattened bowl. The serifs on the *T* flick up above the arm and the *J* descends below the baseline. Sabon has a distinguishing mark that is more of a defect, for the ball terminal on the *y* is entirely out of keeping with the rest of the style. The type is very legible in lengthy text settings and looks rather majestic with extra leading.

ABCDEFGHIJKLMNOPQRSTUVWXYZ
abcdefghijklmnopqrstuvwxyz 1234567890
ABCDEFGHIJKLMNOPQRSTUVWXYZ
abcdefghijklmnopqrstuvwxyz 1234567890

Times Roman

It is not unusual for a type to be designed for a particular application, but when such a type proves to have nearly universal appeal, its creation is particularly fortuitous. Stanley Morison became the typographical advisor to *The Times* of London in 1929 and tackled every aspect of the newspaper's appearance, finally supervising the design of a new text type. In 1932, *The Times* was first set in Times New Roman, and shortly thereafter the face became commercially available. Morison's design was based on the oldstyle Dutch type Plantin and on the need to give the newspaper a type that conserved space yet appeared large, highly legible, and rather strong in weight—characteristics vital for newspaper printing and quite useful for other applications, too. It is always suitable as a text style, with good x-height, strongly angled stress, and almost miraculously high legibility in the smallest settings. This reputation as a text workhorse may lead you to overlook it for display work, but you'll be pleasantly surprised at the dignity and clarity of the font set large. Distinguishing features include the straight, tall stem of the *G*, the upward curve of the bowl of the *P*, the slightly condensed quality of all lowercase characters, and the strong swells and angles of the lowercase bowls. One unfortunate corollary of the face's somewhat heavy weight is that its bold font appears a clumsy, universal thickening of the roman, and loses the clarity in contrast and stress so handsome in the roman.

ABCDEFGHIJKLMNOPQRSTUVWXYZ
abcdefghijklmnopqrstuvwxyz 1234567890
ABCDEFGHIJKLMNOPQRSTUVWXYZ
abcdefghijklmnopqrstuvwxyz 1234567890

Pma
mhs

Palatino

The distinguished calligrapher and type designer Hermann Zapf designed this face in 1948, and Linotype issued it for linecasting in 1950. The Venetian influence is easily seen, and the face is suffused with calligraphic curves from thick to thin. Palatino combines serenity with a lively rhythm and has great warmth. The italic is significantly lighter in weight than the roman and can present some problems when used for emphasis. This face of moderate x-height is proof that characters need not be stretched upward for high legibility. The capitals range greatly in width and are reminiscent of Roman inscriptions. Note the open bowl of the *P*, the asymmetrical serifs on the right of the *h* and *m*, and the gentle outward taper of the stems. The spine of the *S* is distinctive: it appears like a snake coiled and ready to strike.

ABCDEFGHIJKLMNOPQRSTUVWXYZ
abcdefghijklmnopqrstuvwxyz 1234567890
ABCDEFGHIJKLMNOPQRSTUVWXYZ
abcdefghijklmnopqrstuvwxyz 1234567890

Rkn
fmn

Trump Medieval

The German typographer and teacher Georg Trump designed this face in 1954 as a handset type, and it was later purchased by Mergenthaler for linecasting. It has high x-height and the lowercase letters are visibly based on the rectangle, not the square. The open counters give text a spacious appearance, and this is not a deception, for it sets rather wide and is not to be used where space is at a premium. The tails of letters like the *R* and *K* have blunt ends, and in the bold weight this effect is quite extreme, giving certain stroke ends a somewhat pinched aspect. Note that many of the italics, such as *n* and *m*, are oblique romans, while others, like *a* and *f*, are true cursives. Overall, the face has a sharp, restless quality, adding just enough energy to enliven a textbook or brighten a magazine page. In Germany, the term *medieval* is used to refer to Venetian oldstyle designs.

ABCDEFGHIJKLMNOPQRSTUVWXYZ
abcdefghijklmnopqrstuvwxyz 1234567890
ABCDEFGHIJKLMNOPQRSTUVWXYZ
abcdefghijklmnopqrstuvwxyz 1234567890

American Typewriter

Joel Kadin and Tony Stan of ITC introduced this face in 1974, bringing the typewriter full circle from a machine that imitated type to a device that inspired it. Considerations of typographic legibility and contemporary design principles have been incorporated to produce a style that's remarkably useful for applications above and beyond the suggestion of the urgency of typewriting. The face is quite legible, even though it is designed to appear monospaced like its namesake. Only a few letters, like the *I, i,* and *f,* actually appear to be narrower than the others, though subtle changes in width are present throughout. Note the deep, strong curves in the *J, R,* and *Q,* and the overall quality of softly rounded serifs. The *r* and *c* both have terminals that curve backwards, and the tail of the *y* sweeps upward.

afr
JRQ

ABCDEFGHIJKLMNOPQRSTUVWXYZ
abcdefghijklmnopqrstuvwxyz 1234567890

Cooper Black

Oswald Cooper, a commercial letterer with several typefaces to his credit, introduced Cooper Black in 1920 to a grateful clientele of advertisers. It combines distinctiveness with boldness, ensuring that a headline is noticed. A softer serif would be hard to find— Cooper Black's are veritable pillows. This relaxed, puffy type also has some energy to it in the slant of the serifs and the oval dots above the *i* and *j.* As a display type, it sets a mood quickly, but it has a greater range of feeling than you might guess at first glance. The counters are too tiny to risk setting small, particularly if printing conditions are less than ideal. Note the angle in the counter of the *o,* the point in the ear of the *g,* and the rocking curve to the feet. The scallop within the *f* is particularly unusual.

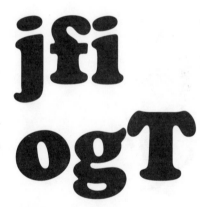

ABCDEFGHIJKLMNOPQRSTUVWXYZ
abcdefghijklmnopqrstuvwxyz 1234567890
ABCDEFGHIJKLMNOPQRSTUVWXYZ
abcdefghijklmnopqrstuvwxyz 1234567890

CgK
vNe

Korinna

Korinna was issued in 1904 by the Berthold foundry, but owes its later popularity to Ed Benguiat's redesign for ITC in the 1970s. Benguiat created the italic from scratch and called it Korinna Kursiv. The face's short serifs and monotone weight give way to the striking curves that distinguish the type. Many letters have peculiar bends and arcs (look at the *C* and the *g*, for starters), and the face gives the overall impression of collecting unusual counters and strokes into a cohesive pattern. Korinna has high x-height and is adaptable to many applications, though it is a bit busy in text blocks because of the variety of curves.

ABCDEFGHIJKLMNOPQRSTUVWXYZ
abcdefghijklmnopqrstuvwxyz 1234567890
ABCDEFGHIJKLMNOPQRSTUVWXYZ
abcdefghijklmnopqrstuvwxyz 1234567890

dbP
AQe

Perpetua

Eric Gill designed this face for a private press, and it was first used in 1928 for an edition of *The Passion of Perpetua and Felicity*. Gill's design for a companion italic was called Felicity, but this font is not the one paired with Perpetua today. Both Felicity and Perpetua italic are oblique romans. Gill was following Stanley Morison's conviction that greater harmony between roman and italic results from an oblique italic instead of a cursive one. Perpetua hints at Gill's background as a stonemason, for the face is strongly sculptured. Note the wave at the end of the *r*, the sharp point that begins the *a*, and the flat bowls at the baseline of the *b* and *d*. The style has long ascenders and descenders and gives text a spacious, dignified feeling.

ABCDEFGHIJKLMNOPQRSTUVWXYZ
abcdefghijklmnopqrstuvwxyz 1234567890
ABCDEFGHIJKLMNOPQRSTUVWXYZ
abcdefghijklmnopqrstuvwxyz 1234567890

Bookman

A typeface called Oldstyle Antique, issued in the 1850s, was so popular that several foundries produced their own versions. Bookman was the face released by American Type Founders when the merger of several foundries placed many versions under its control. This face is large and open, with a high x-height, open counters, and an overall wide stance. It's so monotone in weight that it can appear a little dreary, but it can just as easily be used to establish a sturdy and straightforward mood. The serifs on many capitals and the *m* and *n* are angled, and the *T* has gracefully splayed serifs. Because the type is rather heavy and very even in tone, avoid excessive tightening in text. The word "luggage," for example, looks like a mass of loops with tight tracking. Look for the *S*'s energetic, coiled curves.

ABCDEFGHIJKLMNOPQRSTUVWXYZ
abcdefghijklmnopqrstuvwxyz 1234567890
ABCDEFGHIJKLMNOPQRSTUVWXYZ
abcdefghijklmnopqrstuvwxyz 1234567890

Clearface

The boldface version of Morris Benton's Clearface appeared in the ATF catalog of 1909, and by 1912 the foundry had issued a roman style. This design of Benton's became quite popular for advertising work, but despite its hopeful name it is not the best choice for long blocks of small text. Clearface has a full collection of serif treatments. Several characters lack brackets, and the *M* has a bracketed serif on its thin stem but an unbracketed serif on the right. When a letter gets a bracket, it is a heavy, swooping piece of work, like the ones for the splayed serifs on the *E*. Finally, several lowercase letters end in ball terminals, and the *a* and *f* have a final upward point. Clearface is a strong type with large x-height and a fairly narrow aspect ratio that conserves space.

ABCDEFGHIJKLMNOPQRSTUVWXYZ
abcdefghijklmnopqrstuvwxyz 1234567890
ABCDEFGHIJKLMNOPQRSTUVWXYZ
abcdefghijklmnopqrstuvwxyz 1234567890

gEG
psa

Baskerville

In the 1750s, the English printer John Baskerville hired a punchcutter to produce a font whose design he had been perfecting for six years. He was attempting to create an ideal typeface and departed from the oldstyle principles of the day to give the font a light appearance with thin strokes. This delicacy in no way suited the printing methods of the time, but Baskerville boldly set about to eliminate those restrictions. He manufactured his own inks which were the envy of Europe for their luster and depth, developed the hot-pressing technique to smooth the surface of printed sheets, and established a small paper mill to develop the tighter printing surface called the wove finish. However, Baskerville's paragon was a personal one, and the font was roundly criticized at the time, though it is now one of the most popular types. It is a transitional design, lying between oldstyles and the more emphatic thick/thin extremes of modern types like Bodoni. The weight stress is vertical, a precursor of the moderns. It sets rather wide and has moderate x-height. Note the open lower bowl of the *g*, the spur serif of the *G*, and the long bottom arm of the *E*.

ABCDEFGHIJKLMNOPQRSTUVWXYZ
abcdefghijklmnopqrstuvwxyz 1234567890
ABCDEFGHIJKLMNOPQRSTUVWXYZ
abcdefghijklmnopqrstuvwxyz 1234567890

Rhn
mBD

Caledonia

W.A. Dwiggins, known for his book design as well as his types, created Caledonia in 1938. It's modeled on Bulmer, but the name Caledonia (Scotland) reminds us that Dwiggins originally intended to revise Scotch Roman. With average x-height and firm contrast, the type is well suited to text applications. You can identify Caledonia by the curved tail of the *R* and the sharp contrast in the shoulders of the *h*, *n*, and *m*. The serifs are unbracketed, like modern types, but its overall contrast is much lower. Dwiggins designed the type for linecasting and sought a balanced, collected style that would suit book production. He succeeded; Caledonia has been a mainstay of book publishing since its introduction. Word spacing should be tight, for the type has a handsome rhythm that shapes words well.

ABCDEFGHIJKLMNOPQRSTUVWXYZ
abcdefghijklmnopqrstuvwxyz 1234567890
ABCDEFGHIJKLMNOPQRSTUVWXYZ
abcdefghijklmnopqrstuvwxyz 1234567890

Bodoni

In the 1770s, great improvements in printing and paper made the reproduction of fine lines possible, and Giambattista Bodoni took advantage of this when he designed and cut the prototypical modern type. The face is an extreme one, and though it's spectacular in some applications, there are sharp limits on its potential uses. A page of Bodoni has almost as much vertical movement as horizontal, as the eye picks up the extreme contrast between thick stems and hairline serifs. This is a rigid face, ready to trip up the careless designer who ignores the high-contrast dazzle and self-conscious classicism of the face. It is also a brilliant type, full of exciting contrast and drama. Generous leading is wise, and extreme leading is quite interesting. Bodoni is a staple newspaper headline face, and it always looks dignified in large sizes. Text settings below 12 point run the risk of appearing more woven than written. Note that all serifs are unbracketed and that ascenders and descenders are long. The capital *C* is unusual in possessing serifs at the top and bottom, and the *M* is particularly narrow.

ABCDEFGHIJKLMNOPQRSTUVWXYZ
abcdefghijklmnopqrstuvwxyz 1234567890
ABCDEFGHIJKLMNOPQRSTUVWXYZ
abcdefghijklmnopqrstuvwxyz 1234567890

Fenice

In 1980, the Berthold foundry introduced this type from Aldo Novarese. It is now a licensed ITC design as well. Fenice extends the neoclassical tradition of Bodoni and combines the capacity of contemporary technology to reproduce fine lines with a powerful refinement in letterforms. Unlike other modern types, Fenice has a very high x-height and extremely short ascenders and descenders. It's somewhat condensed to conserve space, and the capitals are remarkably uniform in set width. All these characteristics make it useful in advertising applications and permit great latitude in letterspacing. Saving space is such a key principal here that the serifs on the *A*, *H*, and other capitals are longer on the inside than outside. Like other moderns, Fenice will produce a bright dazzle effect in text settings, but its condensed, rectangular stance helps balance the page. Whole characters, not stems alone, make up the powerful vertical strokes. Set letterspacing and leading with a careful relationship to the counters and you'll construct a handsome, stable page.

ABCDEFGHIJKLMNOPQRSTUVWXYZ
abcdefghijklmnopqrstuvwxyz 1234567890
ABCDEFGHIJKLMNOPQRSTUVWXYZ
abcdefghijklmnopqrstuvwxyz 1234567890

Egyptian

aQR
grt

Clarendon

This version of Clarendon was designed by Hermann Eidenbenz for the Haas type foundry in 1953, but it is based on a design of the 1840s first issued by the foundry R. Besley & Co. In 1955, ATF commissioned Freeman Craw to create a variation, Craw Clarendon, a design with somewhat less contrast and slightly richer curves. The name comes from the Clarendon Press at Oxford, and refers to a class of type as well as a particular design. Strictly speaking, square serif types are Egyptian, but those with a bracket connecting the serif to the stem are Clarendons. These are heavy types, clearly well suited to the bold advertising practices of the nineteenth century, and useful now for their weight and vigor. To recognize Clarendon, look for the playful swoop on the terminals of the *a* and the *R*, the large ball terminals on the *f, g,* and *r*, and overall mass of the horizontal serifs. Clarendon sets wide and is unapologetic about its density. Watch word spacing and letterspacing particularly, as any break in typographic color will disturb the dense pattern of this type. Use restraint when kerning to keep serifs from touching while exploiting the sharp contrast between thin intercharacter white space and thick serifs.

ABCDEFGHIJKLMNOPQRSTUVWXYZ
abcdefghijklmnopqrstuvwxyz 1234567890

mAG
tye

Stymie

The prolific type designer Morris Benton created Stymie for ATF in 1931. The Egyptian style of square serif types was then quite popular, and Benton contributed Stymie to the craze. Distinguishing different Egyptians is not an easy task, but to spot Stymie, look for the symmetrical serif atop the capital *A*, the spur serif on the *G*, the right angle serif at the base of the *t*, and the full serif on the descender of the *y*. Stymie is not difficult to use, and it presents an even typographic color. It has a certain fussiness due to the constant appearance of unbracketed serifs at every available point, but it is pleasing and rhythmic on the page.

ABCDEFGHIJKLMNOPQRSTUVWXYZ
abcdefghijklmnopqrstuvwxyz 1234567890
ABCDEFGHIJKLMNOPQRSTUVWXYZ
abcdefghijklmnopqrstuvwxyz 1234567890

Avant Garde

This face was designed in 1962 as a logotype for *Avant Garde* magazine by its art director, Herb Lubalin. After resisting many requests to create additional weights, Lubalin finally agreed to release the style in 1970 when ITC was established with Lubalin as vice president. He later added a major variant in Lubalin Graph, an Egyptian face that adds square serifs to the base Avant Garde design. The design lures novice designers, offering a large array of ligatures and alternate characters that the beginner may juggle dramatically but unsteadily. Lubalin actually regretted issuing the design, for he saw it abused so often. Nevertheless, the face can be used to brilliant effect. It's distinguished by its towering x-height (which requires generous leading) and its overall large size (which makes its 12 point look like 14 in another style).

THh
adV

ABCDEFGHIJKLMNOPQRSTUVWXYZ
abcdefghijklmnopqrstuvwxyz 1234567890
ABCDEFGHIJKLMNOPQRSTUVWXYZ
abcdefghijklmnopqrstuvwxyz 1234567890

Eras

Albert Boton and Albert Hollenstein collaborated to produce this design, and ITC released it in 1976. The face is based on a design of the mid-1960s offered by a French phototypesetter. Eras may be the most free-spirited sans serif type, combining a bold novelty and energy with serene, monotone letterforms. It has a contemporary high x-height and appears in a range of weights that offer the designer a full palette for emphasis and variety in color. Notice how short the ascenders are and the unusual shape to the bowls of almost all enclosed characters. Eras has a slight cant to the right, and a well-composed headline can appear to soar upward. There is little change in thickness at intersections, but at several points lines are kept from converging—note the open *P* and *R*. This type family can be used for text, headlines, and everything in-between. Leading should be somewhat loose, given the short ascenders.

aER
Psg

ABCDEFGHIJKLMNOPQRSTUVWXYZ
abcdefghijklmnopqrstuvwxyz 1234567890

jtd
OaH

Futura

Paul Renner designed Futura for the Bauer foundry in 1927 during a time when typographic values were particularly influenced by the Bauhaus dictum that form follow function. Futura is nothing short of a manifesto on powerful, geometric abstraction. The curves are crisp and doled out grudgingly: note the straight tail of the *j* and *t*. From the one-storied *a* to the style's monoweight lack of stress, Futura predicts a spartan, analytical future. Ironically, the function of reading is not well served by the form here, as readers tend to find type without weight changes tiring in long blocks of text. In small doses, Futura and its extensive array of variant weights and treatments can be used effectively with tight leading to balance its shallow x-height.

ABCDEFGHIJKLMNOPQRSTUVWXYZ
abcdefghijklmnopqrstuvwxyz 1234567890
ABCDEFGHIJKLMNOPQRSTUVWXYZ
abcdefghijklmnopqrstuvwxyz 1234567890

aiA
Rgn

Helvetica

Max Meidinger's 1957 design for the Haas type foundry was originally called New Haas Grotesque, but its name now honors Switzerland, its country of origin and not incidentally the location of an influential graphic design movement, the Swiss School. When seeking proof of the elegance possible in a letterform, one need only examine the exquisite curve of the bowl of Helvetica's *a* as it intersects the stem. Throughout the design, weight is delicately lightened at such intersections, suggesting the precise points at which compass and ruler must be surrendered by almost any type designer. Helvetica has been such a mainstay since its introduction that office laser printer manufacturers knew they must include the font as standard equipment. Its omnipresence may work against it from time to time, but it sets so well that it makes a wise choice for anything from headlines to price lists. Word spacing is particularly crucial, for the face's tight, simple verticals need small word spaces to preserve proper color and texture.

ABCDEFGHIJKLMNOPQRSTUVWXYZ
abcdefghijklmnopqrstuvwxyz 1234567890
ABCDEFGHIJKLMNOPQRSTUVWXYZ
abcdefghijklmnopqrstuvwxyz 1234567890

Univers

In 1956, Adrian Frutiger set about designing a family of over twenty variations on a sans serif face, establishing a range of weights with condensed and expanded variants. The project itself indicates the impact of photocomposition on design, for Univers entered the world as a fully planned type range, while roman faces from the metal era were launched and then extended in scope only when public acceptance warranted the manufacturing expense. Univers is called a grotesque, a nineteenth-century term for sans serif type that indicated not so much disrespect as the impact such designs produced as advertising headlines. To distinguish Univers from Helvetica, examine the *a* (in Univers the curve is flat and the vertical stroke doesn't curve at the end) and the *t* (the vertical stroke ends in a diagonal, while Helvetica's is square). To differentiate it from News Gothic, note the single bowl of the *g* and the style's overall smaller, tighter appearance.

gHn
eSa

ABCDEFGHIJKLMNOPQRSTUVWXYZ
abcdefghijklmnopqrstuvwxyz 1234567890
ABCDEFGHIJKLMNOPQRSTUVWXYZ
abcdefghijklmnopqrstuvwxyz 1234567890

Franklin Gothic

ATF issued the first font of Morris Benton's Franklin Gothic in 1905 and continued releasing condensed, extended, and other variants through 1913. This design carries on Benton's beautiful but practical contributions to sans serif type, including Alternate Gothic and News Gothic. There are several weights of the face, but by far the most useful is the heavy version that remarkably retains legibility and nuance in small settings. Franklin Gothic is valuable in forms design and in other applications that require distinctions of contrast, not size, to cue the reader. Note the tapered spur on the *G* and the great contrast in letters like *a, g,* and *p.* A more subtle change of weight appears in letters like the *w* and *s.* Be careful when combining several weights of Franklin Gothic, as they may be too close in density to be differentiated.

nsg
aBp

ABCDEFGHIJKLMNOPQRSTUVWXYZ
abcdefghijklmnopqrstuvwxyz 1234567890
ABCDEFGHIJKLMNOPQRSTUVWXYZ
abcdefghijklmnopqrstuvwxyz 1234567890

Mga
wrH

Gill Sans

Eric Gill's 1927 design for Monotype gave that foundry a foothold in the sans serif competition that was raging in Europe after the appearance of Futura. Although it's indisputably similar to a font designed by Edward Johnston for the London Underground, Gill dismissed that source as an influence. Unlike the geometric sans serif designs popular at the time, Gill Sans uses principles of proportion and shape from oldstyle roman designs but dispenses with the serifs. This combination makes it a highly readable face, striking an interesting balance between simple lines and intricate shapes. The x-height is rather shallow, and the counters of the *a* and *g* are distinctive and slightly pinched. The vertex of the capital *M* does not reach the baseline, giving the character a high, open quality.

ABCDEFGHIJKLMNOPQRSTUVWXYZ
abcdefghijklmnopqrstuvwxyz 1234567890
ABCDEFGHIJKLMNOPQRSTUVWXYZ
abcdefghijklmnopqrstuvwxyz 1234567890

mPS
gta

Optima

Hermann Zapf produced his first sketches of Optima in 1952 and the type was issued in 1958. It's a sans serif face, but there is nothing mechanical about it. In fact, the flared ends of each stroke have all the clarity of serifs with all the economy of Helvetica condensed, a remarkable combination. Your insurance policy is very likely set in Optima, but so are the logotypes for Comtrex and Wheat Chex, suggesting the great size range at which this face works. In the original design, Zapf gave the small sizes short descenders, but extended them in the larger range. This is the type of distinction lost in conventional phototypesetting when a single master produces all sizes. It's also defeated by some simplified digital versions, but that problem pales beside the difficulty of rendering such subtle swells at low resolution. Optima may be the hardest type to digitize. Note the large lower bowl of the *g*, the thin end of the *a* and *t* in contrast to the flared ends of other characters, and the varying width of capitals.

ABCDEFGHIJKLMNOPQRSTUVWXYZ
abcdefghijklmnopqrstuvwxyz 1234567890
ABCDEFGHIJKLMNOPQRSTUVWXYZ
abcdefghijklmnopqrstuvwxyz 1234567890

Type families

A type classification system sorts whole families of type into categories. A design family is an integrated group, with a general name like Helvetica or Garamond. The family includes numerous fonts that vary in weight and style, making Garamond Bold Italic a particular font within the family. Strictly speaking, fonts are also specific sizes, and the distinction is logical when you recall that metal type was cast in individual sizes. Now that photographic and digital scaling methods produce type, the size issue appears insignificant, but it's still correct to call 24-point Caslon one font and 28-point Caslon another.

Almost every type family includes at least two styles, roman and italic. Weight variations now range from ultra light to ultra bold. Some families include additional styles, such as condensed and expanded versions of both italic and roman. Finally, outline, inline, shadow, and reverse treatments may be offered. When the range of weights is added, the full complement of fonts becomes the array listed at right. It's easier to extend a sans serif through many weight variations than it is a serif face with stress and contrast.

Very few type families include all forty-nine of the possibilities listed, but several sans serif faces have vast font ranges, exceeding even the list here. A complete serif type has a range similar to ITC Garamond, shown below.

ITC Garamond Light

ITC Garamond Book

ITC Garamond Bold

ITC Garamond Ultra

ITC Garamond Light Italic

ITC Garamond Book Italic

ITC Garamond Bold Italic

ITC Garamond Ultra Italic

ITC Garamond Light Condensed

ITC Garamond Book Condensed

ITC Garamond Bold Condensed

ITC Garamond Ultra Condensed

ITC Garamond Light Condensed Italic

ITC Garamond Book Condensed Italic

ITC Garamond Bold Condensed Italic

ITC Garamond Ultra Condensed Italic

aha
aha

Italics, at top, utilize entirely different design principles than their companion romans, at bottom. The typeface is Century Oldstyle.

In the Renaissance, the Venetian scholar-printer Aldus Manutius published a series of compact, inexpensive editions of Greek classics, typeset in a cursive Greek type that conserved space. To produce a similar series of Latin works, he designed a space-saving type that became the basis for italic type. The term itself suggests the Italian origin. The example at right is from Virgil's Aeneid, *published by Aldus in 1501.*

Roman, true italics, and oblique type compared in Caslon 540. The oblique version is merely a modified roman, not the discrete design italics generally are.

Characters in a family

In addition to roman and bold, most type families include an italic.

italics and obliques

An italic style is somewhere between a design in its own right and a variation on a family parent. In fact, the notion of relating an italic to a roman did not arise until the sixteenth century, when coordinated families of capitals, small capitals, lowercase, italic, and bold types were created. Prior to these efforts, italics were discrete designs and were always used in lowercase, with upright capitals from another font.

Even within a family, an italic usually plays by different design rules than its roman counterpart. Most lefthand serifs are dropped, and many serifs are replaced by short tails. These adjustments suggest the influence of the chancery hand on italic designs, giving italics both the slope and cursive qualities of handwriting. Some italics preserve a hint of original typographic conventions by utilizing a stronger rightward slant in lowercase than in capitals; this evokes the use of a roman font for capitals. Most significant, italics generally are lighter in density and higher in contrast than their companion romans.

P abula parua legens, nidis´q; loquacibus escas,
E t nunc porticibus uacuis, nunc humida circum
S tagna sonat, similis medios Iuturna per hostes
F ertur equis, rapido´q; uolans obit omnia curru.
I am´q; hic germanum, iam´q; hic ostendit ouantem
N ec conferre manum patitur, uolat auia longe.

Though italics are immediately distinguished by their slant, a roman letter cannot easily be made into a successful italic merely by canting it to the right. Letters given a purely mechanical angle are called obliques. With digital type imaging or camera modification, such pseudoitalics are simple to produce, and are specified by degrees of slope. Though obliques satisfy the requirement that italics slant, they carry with them the baggage of their roman design nuances. Only in sans serif faces, as a rule, is such a coarse transformation successful, and even for those more geometric typefaces, the obliques fail some aesthetic tests.

Proper italics slope from 11 to 30 degrees. Though obliques can be defined at any slope, 12 degrees is usually adequate to create the effect and stops short of serious distortion.

Caslon
Caslon Italic
Caslon Oblique

Characters in a font

The complete character set of Baskerville available on Varityper's CompEdit phototypesetter is shown below. Note the small capitals, superscript numerals, and piece fractions. The latter are extremely valuable to have in a font, but can be constructed by changing the size and baseline of regular numerals.

abcdefghijklmnopqrstuvwxyz
ABCDEFGHIJKLMNOPQRSTUVWXYZ
ABCDEFGHIJKLMNOPQRSTUVWXYZ&
1234567890$¢£¹²³⁴⁵⁶⁷⁸⁹⁰⅛¼⅜½⅝¾⅞
().,-:;!?/''——-*%'''

small capitals

The convention of using small capitals in an initial line is an attractive one, but to produce the best effect, true small capitals are required. A genuine small cap is drawn to print with the same density as roman letters in its size. Substituting the regular capitals of a smaller size will result in type of weaker density, though the practice is fairly common.

A small capital is about 82 percent of the moderate x-height font's cap height, and about 87 percent of its set width. Therefore, when forced to select a smaller size to substitute for true small caps, a single point size adjustment will not work for all type designs. With trial and error or careful inspection of the text type's x-height, you can determine the appropriate size for makeshift small capitals. However, since true small caps are generally designed a bit narrower than capitals to match the set width of the romans in a particular size, a smaller point size capital cannot produce the full effect.

Small capitals have the great virtue of relieving the ponderous appearance of acronyms set in full caps. Not only do all caps look forbidding and marginally legible, type designers design capitals to stand adjacent to lower case letters, not each other. When designing a companion small capital, the designer plans for this very different relationship. If you examine a font's small capitals carefully, you'll note subtle differences. A small capital *c, o, s, u, v, w, x,* or *z* must do the trick of remaining distinct from both lowercase and uppercase characters in the same font. Like all small caps, those characters should be a bit darker and higher in x-height than the lowercase letters. When used to set off text, small caps should be letterspaced for an open, graceful look.

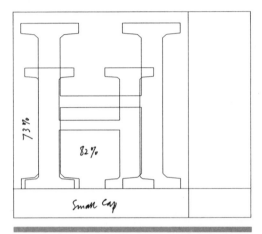

True small caps have the same stem weight as the parent capitals, and are not simply the caps from a smaller font. Shown here is a working drawing for Charter, designed by Matthew Carter.

Simulating small capitals by mixing a smaller font with a larger one yields type with the wrong x-height and stem weight. From left to right: true small caps, 9-point capitals with 12-point text, 10-point capitals with 12-point text.

CALL ME ISHMAEL. Some years ago—never mind how long precisely—having little or no money in my purse, and nothing particular to interest me on shore, I thought I would sail about a little and see the watery part of the world.

CALL ME ISHMAEL. Some years ago—never mind how long precisely—having little or no money in my purse, and nothing particular to interest me on shore, I thought I would sail about a little and see the watery part of the world.

CALL ME ISHMAEL. Some years ago—never mind how long precisely—having little or no money in my purse, and nothing particular to interest me on shore, I thought I would sail about a little and see the watery part of the world.

The letters a, e, r *in an eighth-century ligature, written in the Merovingian hand. Throughout medieval Europe, the National hands, unique to countries and regions, were the writing style of each culture, with differences somewhat equivalent to those in type design.*

ligatures

Four kinds of ligatures have arisen to cope with oddities of language and writing. A ligature is a fusion of two characters, and though the ones you'll find in type are at pains to clarify the two letters combined, the first ligatures were bold, space-saving contractions drawn by medieval scribes, and to our eyes are virtually brand new letterforms. These early ligatures followed few strict rules and were often spontaneous solutions to copy-fitting problems. Some ligatures, however, were the natural responses to certain letter combinations that deserved their own special and consistent aesthetic treatment.

The ligatures of cast type overcome a very different obstacle. The concept of using twenty-six discrete letters to form all possible words is a brilliant one, but many necessary letter combinations are unattractive. When type was made of metal, the isolated quality of each letter was very much a part of type itself. Each character had an allowance for spacing that was fixed on its metal body, and though we wouldn't want an *f* to crowd an *e*, we'd be disappointed to see the same useful space between the two *f*s of *offer*. Accordingly, typefounders cast many more than twenty-six letters, making up fonts of numerous ligatures in anticipation of key letter combinations.

With photocomposition, letterspacing can be adjusted by kerning, a selective space reduction between two characters. Still, there are some letter combinations type designers have deemed unsightly. Some of these aesthetic ligatures may appear archaic or odd now because they are rarely used, but the combinations below show some cherished design principles.

as fi ff fl fr ffi ffl ll ct st is us

Though the ligatures above may actually be quite distracting to a contemporary reader, type designers continue to propose special letter combinations for aesthetic reasons. In Avant Garde, shown below, the designer provided some unusual alternate letters, chiefly of interest to designers building logotypes or nameplates. None of these would be acceptable in a text setting.

CACOEAFAFRGAHTKALALNTRRASSSTTHUT

Æ æ AE æ

True diphthongs, at left, are unique letterforms. The pairs on the right are individual letters kerned vigorously. As you can see easily in the capitals, a diphthong can't be built if it isn't in the font's character set.

The diphthong, the fourth type of ligature, is the closest in spirit to the medieval scribe's consistent combinations. A diphthong is not truly a ligature, but a character in its own right. The dual vowel *ae* of medi*ae*val and encyclop*ae*dia is best shown as a fused character, for it represents a single sound. It is hard to tell which came first, the disappearance of the diphthong from type fonts or the modern reader's uncertainty about that odd shape, but in any case its use is on the wane. Attempts to produce it by vigorous kerning will be unsatisfactory in most fonts, and it is probably better to give up on indicating this Greek sound and use an *e* alone.

swashes and terminals

If this catalog of font components is beginning to sound unduly concerned with the norms of cast type, we come now to two kinds of special characters, one of which has been preserved and amplified in contemporary type, and the other virtually abandoned.

Swash letters are decorative characters, sporting dramatic flourishes that extend below baseline and sweep far to the left or right. Few fonts include swashes at all, and most stop at capitals, but some offer some lowercase alternatives. It is handy to have swash capitals available in a font for initial letters, and modern designers have built rather theatrical logotypes and headlines by using them within words as well.

MAER R ABDr w

If you want to embed a few swash letters within words, you will soon find yourself wishing for an even larger array from which to choose, for swashes lend themselves to limited combinations. For this reason, when your design cries out for extensive swash embellishments, you may be better off using a calligrapher to produce the effect.

Terminal letters are alternate lowercase characters with a simple, elongated closing stroke. They are effective, when used sparingly, to finish off text blocks with a firm yet quiet flourish. Early printers had recourse to them for practical as well as decorative effects, using them to diminish widows and to fill loose lines. A terminal's stroke falls right on the baseline, preventing any combination with a succeeding character and sometimes making even a period look like an intruder.

Illustrat splendore suo, noctemá, recentium
Arte noua pulsa penitus caligine nudat.
Iure igitur viuax, omniá, perennius ære
Maiestate sua stabit, nec firmius ullum
Olim cudit opus vapida fornacibus Ætna
Cyclopum lassata manus, ferroá, coacta
Sudantis rara sub veste Pyracmonis artes
Sentiscent aui cariem priùs, & solida spe
Fraudatus Steropes operam plorabit inertem.
O qua fama tuas olim sectabitur vmbras?
Venturi quantus populi memoraberis ore

Terminal and swash characters are still available in some fonts' foundry type and presstype. The useful but inflexible computer that forms the heart of most composing systems does not have an easy time making alternate characters available. Swashes, which are more widely used, are accessible in some photocomposition systems, but terminal characters have largely been discarded.

Swashes from Bookman, a type design so well endowed with alternate characters that it has the questionable distinction of being overused in book title design.

Terminal letters can fill out lines and balance a page, as well as adding the occasional flourish. This sample is type from the Plantin Office of the Netherlands, founded by the typographer and printer Christopher Plantin. It dates from 1616.

1234567890
1234567890

Oldstyle and lining numerals in Goudy. The oldstyle numerals, at top, have the equivalent of ascenders and descenders, and therefore have a smaller overall mass and defined x-height. Lining numerals are the norm, and very few type designs are available with oldstyle numerals today, even though they may once have used that style.

8
1
6

Numerals must align in columns, so the number 1 is always given a wide float space on each side. This built-in space, which appears around every letter, is called the side bearing.

numerals

Though the Romans designed beautiful characters for the alphabet, we were surely wise to look to another source for the design of numerals. The decision was not an aesthetic one; mathematicians in India created the all-important zero, a concept that rivals the alphabet in significance and makes Roman numerals inferior tools indeed for calculating. Arabs acquired the discovery and eventually developed the design of numbers that would take hold in Europe by the tenth century.

Type designs sometimes preserve oldstyle numerals, which effectively have ascenders and descenders. The *3, 4, 5, 7,* and *9* all extend below the baseline, while the *6* and *8* rise above the mean line. This convention may be used in type of any category, and the term "oldstyle" in this application does not refer to the alphabet's design.

Oldstyle numerals arguably are more legible for the same reason we rely on ascenders and descenders in text characters. However, they are now so rarely used that contemporary readers have lost the instinct for recognizing them easily. To create the variations in height, oldstyle numerals must have a shorter overall body that establishes x-height. This makes them smaller, and to many readers, confusing. Extolling their superior legibility is a little like suggesting conversion to the metric system: everyone agrees that it's better, but no one wants to learn to measure all over again. Typographers should feel free to choose oldstyle numerals, but they should recognize this problem and the fact that oldstyle numerals are a poor choice for numerical tables.

Lining numerals are by far more common. These are even in height, from the baseline to the ascender line, and while oldstyle numerals look like lowercase, these look like capitals. In most designs, this uniformity also extends to numeral width. Rather than allow an *8* to be wider than a *1* as its essential shape would suggest, numerals are monospaced to facilitate the composition of tables of figures. This is a valuable idea, for no one wants to read a column of numbers with any uncertainty about relative decimal places. A consistent width works well enough for all the numerals but the *1*, a shape of such powerful simplicity than any attempt to widen it is extremely artificial. That number aligns with the others by virtue of a fixed float space to each side.

Oldstyle numerals are also generally uniform in width, to provide the same benefit of vertical alignment. Needless to say, the typographer should not violate this spacing principle with kerning or radical letterspacing when numbers appear in tables.

Quality of type images

A guardian of tradition runs the risk of clinging to the old without recognizing the virtues of the new. Composition methods have presented some aesthetic dilemmas in the last half of this century that tend to pit tradition against technology. The traditionalists in this instance are justified in their complaints. The real issue is not whether new technology robbed us of type quality, but why we aren't busy trying to build quality back into the process. It is not easy to resolve these conflicts, and every designer must recognize their roots.

Master sizes

When type is cast metal, a master matrix is the source for each letter, and a new matrix is needed for each size. Even when maintaining all the qualities that will integrate a family of type, the punchcutter who makes the matrix is free to suit the design to the size. Foundry punches are based on master drawings, and though the casting process technically permits changes at each point size, there are usually only three master drawings, covering 6 to 9 point, 10 to 14 point, and 18 to 72 point. Among the many refinements this technique permits, the counters of lowercase letters in a small size may be enlarged, and the weight of strokes in larger sizes can be diminished. All of these adjustments attempt to deal with the problem of purely proportional resizing. Making a 6-point character from a 12-point master yields a letter 50 percent of the original, but a type designer would develop a 6-point character with counters about 70 percent the size of 12 point.

HHH

Each letter above is the master H from a different size range for Century Nova. Left to right, these are the 9-, 18-, and 36-point characters, enlarged here to a uniform size to highlight the differences. Imagine how crude a headline blown up from the 9-point master would appear, and how weak text would look if reduced from the largest master.

The first three lines below were enlarged from foundry type from the 8-point, 16-point, and 30-point fonts of Garamond. Each reflects a different master that's visible when comparing the type at a uniform size. The bottom three lines were enlarged from phototype set at 8 point, 16 point, and 36 point. By using the same master for all point sizes, phototype can't adjust fine details, like the counter of the e, to suit the reproduction size.

meridian AEQR abgesw

meridian AEQR adgesw

meridian AEQR abgesw

meridian AEQR abgesw

meridian AEQR abgesw

meridian AEQR abgesw

Part of the brilliance of the photocomposition technique is that a single photographic master provides a whole range of set sizes. Type is produced by a lens that projects the photo master at different magnifications, and therefore in different sizes. Because text composition accounts for the bulk of typesetting, photo masters are based on the 10- to 14-point version of the type design. Originally, some manufacturers offered photo masters in different size ranges, but it did not take long to see that customers were buying only one range. Given a choice of acquiring a different type or a different size range, almost everyone spent his money on broadening his font library instead of maintaining each master size range in the library he had.

Strictly proportional size changes rob a design of nuance and compromise the type designer's intentions for extremely large or extremely small settings. In the 1950s and '60s, when photocomposition first appeared, this was a hot topic, and the debate was acerbic and spirited. It has since virtually disappeared as an issue, proof that the considerable benefits of photocomposition outweigh this defect. The furor has died away, but not the problem. Anyone with a passion for type will continue to champion discrete designs for different size ranges, but the imperfections should not be exaggerated.

Digital imaging

Oddly enough, a subsequent aesthetic controversy had within it a method of resolving the first. Producing type from digital masters frees a composition system from dependence on a single, physical master. In digital type imaging, a character is projected onto photo paper in minute dots, strokes, or arcs. These marks are maintained as binary data, and the data can be manipulated mathematically to scale the master image in size, and also to alter its angle and width. There is no physical reason why several digital masters cannot be used, because the process relies on data selection, not the movement of a lens and master. Economic limitations continue to bear on the issue, however, for there is considerable extra expense involved in digitizing type and endowing a typesetting machine with multiple masters. Some digital composition systems make use of four or more masters, bringing subtle size distinctions back into typesetting. However, much equipment forges ahead with the same one-master-for-every-size principle that was accepted in photocomposition. Notably in this category are laser printers and typesetters using the Postscript page description language for desktop publishing. Postscript itself contains some algorithms, called sizing hints, that help scale digital type aesthetically at size extremes, which partly overcomes the master size problem.

Unfortunately, a new dilemma arises with digital imaging. To convert a shape into digital data, its curves and strokes must be scanned and defined as binary data. Though there are several methods for constructing type from digital masters, the conversion itself is analogous to placing a fine grid on a letter and recording either black or white data at each coordinate. No matter how precise the grid, the edge of a curve may fall within the position examined, and it will have to be converted to all black or all white, distorting the original. This problem of resolution is discussed more fully in the technical typeset-

Digitizing type requires that the curves, lines, and body of a character be converted to data that can later be used to plot or reconstruct the letter. You might think of the process as reducing a shape to tiny components, like the bits shown here. In order to make up a shape of entirely square bits, a curve must be reduced to a stair-step since each bit is either present or absent.

harmony harmony harmony

harmony harmony harmony

harmony harmony harmony

harmony harmony harmony

harmony harmony harmony

harmony harmony harmony

harmony harmony harmony

ting chapter. From an aesthetic viewpoint, digital data is inherently flawed. The principal defense against this drawback is raising resolution to such a high degree that the viewer's eye cannot detect an intrinsic defect.

Both size differentiation and resolution problems are serious matters for the typographer, but they should be placed in context. Readers are quite willing to accept digital type and do not examine letters closely enough in most instances to detect any flaws. The resolution issue only becomes important when the viewer can see the rough edge of digital type, or when the digitization process itself has distorted the type beyond its true design. The master size issue is more likely to haunt the typographer, for it restricts his use of a completely developed type design. In either instance, the typographer should understand these limits and plan his work so that these obstacles do not become larger than they naturally are.

An exaggerated demonstration of the effect of resolution on type integrity. From left to right, Garamond, Galliard, and Charter, first in their true, high-resolution forms, and then progressively coarsened in a simulation of reduced resolution. By the time we reach the final image, there is virtually no distinction among the three designs, suggesting what reduced resolution does to design nuances.

Type measurement

The principal variables in typesetting are set size, interline depth, and line measure. Only the last of these is a distance readily calculated in inches, but even here the inch is not the measure of choice. The inch system is necessarily abandoned for the expression of type and design dimensions, for the inch itself is simply too crude a measure. Because it must often be divided into fractions, the inch ceases to be accurate. Further, the fractional elements of the inch can make calculations difficult. We can clearly see increments as fine as 32nds of an inch, but multiplying and dividing such measures requires relatively cumbersome math. A measurement system with much finer increments is necessary, and the point and pica system fills this need.

Points and picas

As soon as we slice up an inch into smaller segments, we can work with whole numbers instead of fractions or decimals. In the graphic arts, the point is the building block of measurement. There are approximately 72 points in an inch, and most rulers can only display them in what amounts to summary form, marking them off in clusters.

Specifically, the point is .01384 inches, and from it the pica is derived. A pica equals 12 points, and that makes a single pica .166 inches, or about 5/32nds of an inch. There are about 6 picas in an inch. With this finer measurement, we can abandon the 32nd of an inch and its awkward cousins, and so we won't bother converting picas into inches for virtually any typesetting measurement.

With the inch as a reference, the graphic arts units of measure are:

	exactly	approximately	
1 point =	.01384 inch	$^1/72$ inch	
1 pica =	.01666 inch	$^1/6$ inch	or 12 points
6 picas =	.996 inch	1 inch	or 72 points
72 points =	.996 inch	1 inch	or 6 picas

Dimensions described in picas tend to be clearly distinct to the eye: a typeset line 20 picas wide is manifestly shorter than one of 22 picas. The pica is often divided into halves and quarters to describe type measures, but it's unusual to need to resort to smaller fractions. As a rule of thumb, we can say that the quarter-pica is about the smallest distance the eye can easily distinguish.

The finer the measuring increment, the longer we can use whole numbers to describe dimensions, and the more accurate our math will be. Though the quarter-pica may indeed be the smallest measure our eyes can detect, a typesetting machine can work with far smaller dimensions. Measurement in points delineates all the subtleties of type size and interline depth. With digital type, it's common to size type in half-point increments, discriminating between 9 point and 9½ point.

Points are used to measure only small distances, while picas describe the larger dimensions. Typically points express set size of type, interline spacing, and the thickness of rules. Picas are used to describe typeset line measure, depth of type columns, illustration sizes, and overall page areas.

The invention of the point system

The point system was developed in the eighteenth century for measuring type. Previously, type was sized in what can only be called highly idiosyncratic ways, but the establishment of the point system eventually brought order out of chaos.

With photocomposition, we're accustomed to assuming type of any point size is ours for the specifying, but when alphabets were cast of metal, the range of sizes was necessarily limited. Each foundry (and originally, each printer) made its own type in sizes of its choosing. Trying to match types from different sources in height, size, or alignment was troublesome to impossible. Further, similar type sizes were classified with names, not consistent measurements. What we call 48-point type was called canon type in England; the chart below shows a few of the rather evocative names by which foundry type was identified.

point size	English	French	German	Italian
48	Canon	Double Canon	Kleine Missal	Reale
36	2-line Great Primer	Trismegiste	Kleine Canon	Canone
24	2-line Pica	Palestine	Roman	Canoncino
18	Great Primer	Gros Romain	Tertia	Testo
12	Pica	Cicero	Cicero	Lettura
10	Long Primer	Petit Romain	Garamond	Garamone
9	Bourgeois	Gaillarde	Borgis	Garamoncino
6	Nonpariel	Nonpareille	Nonpareille	Nompariglia

The typographer Simon-Pierre Fournier proposed a standardized system of measurement in 1737. By the time he refined it in 1764, it was recognizable as the point system we use today, though the size of the point itself changed as the system evolved.

Fournier established the concept of point size with the division of the inch into 72 increments, but he presented the standard in 1737 by means of a printed scale. He acknowledged a problem in his 1764 tract entitled "Manuel Typographique": "After printing this same table…I perceived that the paper in drying had shrunk the proper dimensions of the scale a little, and in the present table I have forestalled this fault by adding what should be allowed for the shrinkage of the paper."

This solution was at best cavalier, for books at this time were printed on wet paper and shrinkage varied greatly. Typecasters could not use different copies of the scale as a standard measure. Fournier's other concession to this difficulty was the production of a metal gauge, which he called a prototype. It is likely, however, that manufacture of the gauge itself allowed considerable variation in its markings, limiting its accuracy.

In 1770, Francois Ambroise Didot, of the well-known French family of typographers, proposed an improvement on Fournier's system that prompted French type founders to accept it. He adopted a 72-increment division of the French inch, which is slightly larger than our American inch, and the result was a point of .01483 American inches. This Didot point is still the standard measure in France, Germany, and many other European countries, and therefore typesetting equipment and other graphic arts specifications must be modified if they are to match European measures.

Didot's other significant contribution was the wholesale abandonment of the charming but imprecise names for type sizes. Fournier had maintained all these, but assigned a point size to each, while Didot disposed of the nomenclature and relied on numeric identifications only.

While the French were embracing the consistency of the Didot point system, sizing anarchy continued in the U.S. and Britain through the nineteenth century. Many variations on the point system were proposed, but conversion would have entailed a foundry's comprehensive retooling. One foundry's nonpariel type might match the new 6-point standard but its pica wouldn't be a true 12 point, while another foundry might experience the reverse. The point system would have required that a great deal of type be discarded, and for decades American foundries implicitly agreed that chaos was preferable to financial hardship.

Economic self-interest prevented any one foundry from stepping forward to advance a standard point system, but a catastrophe nudged one of them into the vanguard. The great Chicago fire of 1871 destroyed the foundry of Marder, Luse & Co. When they rebuilt their molds and matrices from scratch, they used the point system developed by Nelson Hawks to size their type.

Hawks adapted Fournier's idea and anchored his point system around the pica type of the MacKellar, Smiths and Jordan foundry, which was then the largest in America. This type became 12 point, and nonpareil became exactly half its size. The five types in-between were each made a point apart. The mathematics were simple; convincing the other foundries to jettison types that didn't match was much harder. Hawks himself promoted the system with unstinting enthusiasm, and eventually the foundries all came to accept it.

The point was fixed at .013838 inch, which meant that 72 of them equalled an untidy .996 inch. The missing fraction fluttered away long before the point system took hold. The pica in common use, and the foundation for the MacKellar, Smiths and Jordan pica type, was a bit short of the true 1/6 inch. Casting equipment used in the very first American foundry (and in its European ancestors) was slightly off, and the deficient pica took hold among printers unconcerned with such minute measurements. The point system could have corrected matters, but only by consigning still more type to the scrap heap. It was enough of a revolution in typefounding without that additional corrective mission.

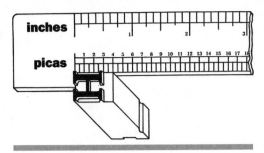

A 48-point type shown with a line gauge that reveals the difference between point size and actual depth. The character is three picas deep, but the body is four.

Specifying type

The three main elements of type specification are type size, interline depth, and line measure. Type size refers to the height of typeset characters, and because it is given in points it is frequently called point size. The interline spacing of type is called leading, and it has an important relationship to type size because it defines the open space between lines. Leading is also expressed in points, to complement the point size measure. Line measure, described in picas, defines the length of a line of type, or the width of a typeset column. These three dimensions are conveyed in the format:

$$9/10 \times 21$$

In this example, the 9 refers to point size, the 10 to the leading, and the 21 to line measure. This would be read out loud as "nine on ten by twenty-one."

The sample at right is set 9/10 x 24¼. Dimensions can be expressed in picas plus pica fractions, or as picas plus the appropriate number of points. Thus, the same typesetting line measure might be described as 24¼ picas, or 24 picas and 3 points.

When in disgrace with fortune and men's eyes, I all alone beweep my outcast state, and trouble deaf heaven with my bootless cries, and look upon myself, and curse my fate; wishing me like to one more rich in hope; featured like him, like him with friends possessed; desiring this man's art and that man's scope, with what I most enjoy contented least; yet in these thoughts myself almost despising, haply I think on thee—and then my state, like to the lark on break of day arising from sullen earth, sings hymns at heaven's gate; for thy sweet love remembered such wealth brings that then I scorn to change my state with kings.

em space

en space

one-third em, or three-to-the-em space

one-fourth em, or four-to-the-em space

one-fifth em, or five-to-the-em space

em space

Points and picas are used to convey type specifications, but another measure is useful when describing typographic spaces. The em space is a square that is as high and as wide as the point size of a type. Half of an em is called an en, and the names are logical even if they're hard to distinguish when spoken. For most type designs, the em is about the width of a lowercase *m* and the en is about as wide as an *n*. Indents and other tab positions are often specified in ems, while the space between words is usually defined as a fraction of an em. A typical word space is one-third of an em, called three-to-the-em space. The em space and all divisions of it remain relative to type size, a distinct benefit when gauging distances in a line, paragraph, or table.

point size

The illustration at left shows the dimensions of a character. Notice that point size includes a nonprinting area called the shoulder. A point ruler, therefore, won't enable you to determine the precise size of type you encounter since every type will be shorter than its point size designation. To determine the point size of set type, a clear plastic gauge with sample settings is used.

A character's point size includes this float space beneath the descender because conventions for measurement were developed for cast metal type. As the illustration shows, type bodies were measured from back to belly, and bodies were cast with an allowance for space between lines. In practice, a type specifier is working with an approximate point size. To fill a precise depth, the specifier must add a few points to compensate for the shoulder. A character one-half inch high

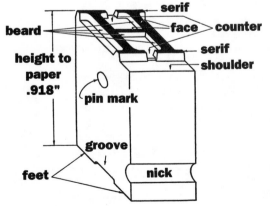

would be about 56 point, not the 36 you might guess. Approximate measurements are usually adequate to estimate point sizes.

x-height

Along with point size, there is another measure of the vertical dimension of type, and this one is relative to each type font or style. The illustration at right shows the x-height for three different fonts. This distance, between the baseline and the mean line, describes the height of lowercase letters without ascenders or descenders, such as the *x*. In text typesetting, lowercase characters predominate, and the reader actually sees three primary horizontal lines: the baseline, the clear mean line, and the slightly less well-defined ascender line. The space between the mean line and the baseline of the line above is the most visually significant distance in text type.

X-height is a dimension of its own, but the relative height of ascenders also influences the spatial effect. A type with moderate x-height and high ascenders appears almost as small and light on the page as one with shallow x-height.

spherical — *Bookman*

spherical — *Caledonia*

spherical — *Avant Garde*

Variations in x-height are easy to see with the mean line marked, and reveal that the space between the mean line and the baseline is the most visually significant distance in type.

leading

A point size specification is always combined with a measure for spacing between lines, called leading. The term is pronounced *ledding*, and stems from the use of strips of metal, principally lead, placed between lines of metal type. Leading strips were cast to the nonprinting height of characters and in varying thicknesses.

Leading specifications are given in points; the 9/10 x 21 example calls for 9-point type with 10 points of leading. These 10 points are not in addition to type points but are instead the expression of the total distance between two baselines. Approximately 9 points would be filled with type, and a single point of leading would be added to separate the lines.

Leading is provided by physical strips in metal typesetting, but it's produced by the movement of paper exposed to digital or photographic type masters in photocomposition. The paper advances after each line is set, and its movement can be finely controlled. When using photocomposition equipment, leading can be specified in fractions of points.

At your disposal as well is the option of setting solid, which means calling for type without any leading. This spec would be written 10/10 or 32/32. Some float space is guaranteed by the shoulder allowance in a solid leading specification. To eliminate that, and to bring lines of type so close together that overlaps can occur, you can use negative or minus leading, which would be written 10/8 or 32/28. A few points of negative leading will take away the shoulder and bring ascenders up to touch or nearly touch descenders. More negative leading can be used to close up lines of headline type in all caps in which no descenders appear, to fit ascenders up into unused space beneath baselines, or to overlap characters completely.

Chicago
Syracuse
Dubuque

The dark bars represent leading while the overall shading for each line is point size.

Journey to the
Center of the
Earth

JOURNEY
TO THE
CENTER
OF THE
EARTH

Negative leading tightens these text blocks. At top, 18/16; above, 18/14. More leading can be eliminated with capitals.

line measure

Line measure defines in picas the length of a single line to be typeset. Of all type specifications, line measure is the most affected by page size or general design. In most applications, the line measure decision is based on the number of columns of type that will appear on a page. On an 8½ x 11 inch page, for example, two columns of 21 picas each fit comfortably with outer margins and inner gutters to separate each column. To divide the page into three columns, you might select a line measure of 13 picas. Columns need not be equal, of course, but the design decision on margins and gutters precedes selection of a line measure.

Line measure choices may originate in the design decision to divide a page into text blocks, but there are practical limits to the freedom a designer has here. Type size, x-height, leading, and line measure must all be selected with readability in mind.

Some sample pages showing the significant connection between line measure and page design. Though these are book or magazine pages, the same structural choices apply to brochures or advertising pages that include illustration. The line measure provides a design grid, and need not be based on equal margins.

When in disgrace with fortune and men's eyes, I all alone beweep my outcast state, and trouble deaf heaven with my bootless cries, and look upon myself, and curse my fate; wishing me like to one more rich in hope; featured like him, like him with friends possessed; desiring this man's art and that man's scope, with what I most enjoy contented least; yet in these thoughts myself almost despising, hap-ly I think on thee—and then my state, like to the lark at break of day arising from sullen earth, sings hymns at heaven's gate; for thy sweet love remembered such wealth brings that then I scorn

When in disgrace with fortune and men's eyes, I all alone beweep my outcast state, and trouble deaf heaven with my bootless cries, and look upon myself, and curse my fate; wishing me like to one more rich in hope; featured like him, like him with friends possessed; desiring this man's art and that man's scope, with what I most enjoy contented least; yet in these thoughts myself almost despising, hap-ly I think on thee—and then my state, like to the lark at break of day arising from sullen earth, sings hymns at heaven's gate; for thy sweet love remembered such wealth brings that then I scorn

When in disgrace with fortune and men's eyes, I all alone beweep my outcast state, and trouble deaf heaven with my bootless cries, and look upon myself, and curse my fate; wishing me like to one more rich in hope; featured like him, like him with friends possessed; desiring this man's art and that man's scope, with what I most enjoy contented least; yet in these thoughts myself almost despising, ha-ply I think on thee—and then my state, like to the lark at break of day arising from sullen earth, sings hymns at heaven's gate;

When in disgrace with fortune and men's eyes, I all alone beweep my outcast state, and trouble deaf heaven with my bootless cries, and look upon myself, and curse my fate; wishing me like to one more rich in hope; featured like him, like him with friends possessed; desiring this man's art and that man's scope, with what I most enjoy contented least; yet in these thoughts myself almost despising, haply I think on thee—and then my state, like to the lark at break of day arising from sullen earth, sings hymns at heaven's gate; for thy sweet love remembered such wealth brings that then I scorn to change my fate with kings. No widows.

When in disgrace with fortune and men's eyes, I all alone beweep my outcast state, and trouble deaf heaven with my bootless cries, and look upon myself, and curse my fate; wishing me like to one more rich in hope; featured like him, like him with friends possessed; desiring this man's art and that

myself, and curse my fate; wishing me like to one more rich in hope; featured like him, like him with friends possessed; desiring this man's art and that man's scope, with what I most enjoy contented least; yet in these thoughts myself almost despising, haply I think on thee—and then my state, like to the lark at break of day arising from sullen earth, sings hymns at heaven's gate; for thy sweet love remembered such wealth brings that then I scorn to change my fate with kings. No widows.

man's scope, with what I most enjoy contented least; yet in these thoughts myself almost despising, haply I think on thee—and then my state, like to the lark at break of day arising from sullen earth, sings hymns at heaven's gate; for thy sweet love remembered such wealth brings that then I scorn to change my fate with kings.

When in disgrace with fortune and men's eyes, I all alone beweep my outcast state, and trouble deaf heaven with my bootless cries, and look upon myself, and curse my fate; wishing me like to one more rich in hope; featured like him, like him with friends possessed; desiring this man's art and that man's scope, with what I most enjoy contented least; yet in these thoughts myself almost despising, haply I think on thee—and then my state, like to the lark at break of day arising from sullen earth, sings hymns at heaven's gate; for thy sweet love remembered such wealth brings that then I scorn to change my fate with kings. Shakespeare.

When in disgrace with fortune and men's eyes, I all alone beweep my outcast state, and trouble deaf heaven with my bootless cries, and look upon myself, and curse my fate; wishing me like to one more rich in hope; featured like him, like him with friends possessed; desiring this man's art and that man's scope, with what I most enjoy contented least; yet in these thoughts myself almost despising, haply I think on thee—and then my state, like to the lark at break of day arising from sullen earth, sings hymns at heaven's gate; for thy sweet love remembered such wealth brings that then I scorn to change my fate with kings. Shakespeare.

When in disgrace with fortune and men's eyes, I all alone beweep my outcast state, and trouble deaf heaven with my bootless to cries, and look upon myself, and curse my fate; wish-

ing me like to one more Chj rich in hope; ab featured like him, like him with friends possessed; desiring this man's art and that man's scope, with what I most enjoy contented least; yet in these thoughts myself almost despising, haply I think on thee—and then my state, like to the lark at break of day arising from sullen earth, sings hymns at heaven's gate; for thy Cgj sweet love remembered such Chj wealth brings that then I scorn to change

my Srmj fate with kings and kings.

When in disgrace with fortune and men's eyes, I all alone beweep my outcast state, and trouble deaf heaven with my bootless hats Cgj cries, and look upon myself, and curse my fate; wishing me like to one more rich in hope; featured like him, like him ast with friends possessed; desiring this man's art and that man's scope, with what I most enjoy contented least; yet Crj in these thoughts myself almost despising, haply I think on thee—and

alone beweep my outcast state, and trouble deaf heaven with my bootless cries, and look upon myself, and curse my fate; wishing me like to one more rich in hope; featured like him, like him with friends possessed; desiring this man's art and that man's scope, with what I most enjoy contented least; yet in these thoughts myself almost despising, haply I think on thee—and then my state, like to the lark at break of day arising from sullen earth, sings hymns at heaven's gate; for thy sweet love remembered such wealth brings that then I scorn to change my fate with kings. Phoenix Reed.

When in disgrace with fortune and men's eyes, I all alone beweep my outcast state, and trouble deaf heaven with my bootless cries, and look upon

When in disgrace with fortune and men's eyes, I all alone beweep my outcast state, and trouble deaf heaven with my bootless cries, and look upon myself, and curse my fate; wishing me like to one more rich in hope; featured like him, like him with friends possessed; desiring this man's art and that man's scope, with what I most enjoy contented least; yet in these thoughts myself almost despising, haply I think on thee—and then my state, like to the lark at break of day arising from sullen earth, sings hymns at heaven's gate; for thy sweet love remembered such wealth brings that then I scorn to change my fate with kings. Phoenix Reed.

When in disgrace with fortune and men's eyes, I all alone beweep my outcast state, and trouble deaf heaven with my

Typesetting modes

The next type specification concerns the general appearance of a text block or headline. The line measure fixes the width of a single line, and the typesetting mode determines how a series of lines will be handled. Typeset text can be presented in five modes and many position specs. A mode dictates the way characters will be spaced to fill a line measure, while a position spec establishes an occasional standard for spacing.

Compositors generally assume text is to be justified, but all copy should include a mode spec, even if justification is desired. The nonjustified modes are ragged right, ragged left, and ragged center. Nonjustified type follows a line measure but does not fill out each line to an identical width. Ragged right, for example, has a fixed left margin and a variable right margin. The line endings in a long text block will be calculated by the typesetting machine, and the proper term for nonjustified setting is ragged right, ragged left, and so forth. But when preparing specs for headlines, the designer or copywriter may determine the line-ending points, and the copy is marked accordingly. This spec would be called flush left or flush right. Many typographers use the term quad instead of flush, harking back to the time when a line of foundry type was filled out with nonprinting em quads.

Position specs apply to selective points in typeset text. Most of them require a second specification for either justified or nonjustified mode.

runarounds

A runaround is type that follows a shape that appears mortised into the page. It's typically used around a photograph or drawing, and appears as a temporary change in line measure. When a runaround follows an irregular shape, it's called a contour. To specify it, you tell the compositor the amount of indent, whether the indent is left or right, and the number of lines or typeset depth the indent is in effect. A typical spec would read, "indent left five picas, eight lines."

contours

A contour makes type appear to flow around an irregular boundary. With traditional markup, a contour requires considerable planning. You specify the lengths of individual lines, and then modify the results after examining the type. A spec might read: first seven lines 9/10 x 21 justified; eighth line indent 14 picas; ninth line indent 13; tenth line indent 13 and one-half; and so forth. To prepare such a spec, you must use a type gauge and mark off lines on a dummy or stat of the art at the desired size, but even at that you will probably have to examine the set type and make modifications to improve the fit. With some typesetting systems, including most desktop applications, you can examine the type on the screen and push and pull the line measures to fit around artwork that is represented at size on the screen.

Contours can be loose or tight, and they differ in two respects. The distance from type to art may be as tight as a quarter pica or as loose as one or two picas, and the sharp sculpturing of the contour may be so tight as to echo the shape of the art precisely or so loose as to roughly indicate the art's edge. Tight contours are generally done on display terminals that allow copy to flow around art that's shown on the screen.

At top, a runaround; above, a tight contour around an irregular shape. Both of these typesetting modes require you to specify the distance maintained between type and the mortised graphic.

indents

Indents are used in single lines to introduce paragraphs and for a series of lines to set off a block of text. The specification for the amount of indent is almost always given in ems, but many desktop publishing applications use points and picas instead. When marking up an indented block of copy, you need to specify whether the indent is to appear on each side, centering the copy inside the regular line measure, or if only one side should be indented.

A hanging indent is the reverse of a regular indent and allows one line or more to extend beyond the margin. A paragraph set with a hanging indent juts out over the margin for the first line. In some ways, this is a clearer signal that a new paragraph has begun than the traditional indent. A hanging indent is specified as a negative indent value. To set a hanging indent out 1 pica in a 13-pica measure, you'd write, "first line outdent 14 picas" or "first line -1 pica hanging indent."

initial caps

Initial caps can be mortised into text in a variety of ways. An up cap is a large initial letter that uses the same baseline as the smaller text type to follow and therefore pops up. You specify this just by calling for a point size change. A drop cap fits downward into a text block, matching the depth of two, three, or more lines. To specify these, you need to know the point size that will equal the depth you want to fill, for it's important that the drop cap land on a baseline in common with the text. A 42-point cap, for example, is about 3 lines deep at 10-point leading. Finally, you can contour the text around the shape of the drop cap. To produce this effect, you'll need a cooperative compositor or a desktop publishing system that allows you to see the position of each line fitting around the cap.

split quad

In a split quad setting, some copy is pushed flush left and some is flush right, with the amount of open space between determined by the remainder of each line. This spec is used for headlines, tables, or other material in which line breaks are predetermined.

Often text is set split quad with leader characters. Leader is usually small dots to help the eye connect the two sides in a listing. A typesetting machine fills the split quad area with leader and adjusts the amount of leader to fill each line. Most typesetting systems allow you to specify a range of different leader characters, such as dashes, underscores, or even letters.

tabular

Tabular material involves multiple line measures on one line. Each tabular column can have its own specifications, such as ragged right or justified. You may center or justify material within a tabbed column, but with numbers it's common to use decimal alignment. This spec maintains the columnar position of figures and frees the compositor from manually inserting spaces to align numbers. To specify a tab setting, you'll note both the line measure of each column and the distance between columns.

indent

When in disgrace with fortune and men's eyes, I all alone beweep my outcast state, and trouble deaf heaven with my bootless cries, and look upon myself, and curse my fate; wishing me like to one more rich in hope; featured like him, like him with friends possessed; desiring this man's art and that man's scope, with what I most enjoy contented least; yet in these thoughts myself almost despising, haply I think on thee—and then

hanging indent

When in disgrace with fortune and men's eyes, I all alone beweep my outcast state, and trouble deaf heaven with my bootless cries, and look upon myself, and curse my fate; wishing me like to one more rich in hope; featured like

up cap

When in disgrace with fortune and men's eyes, I all alone beweep my outcast state, and trouble deaf heaven with my bootless cries, and look upon myself, and curse my fate; wishing me like to one more rich in hope; featured like him,

drop cap

When in disgrace with fortune and men's eyes, I all alone beweep my outcast state, and trouble deaf heaven with my bootless cries, and look upon myself, and curse my fate; wishing me like to one more rich in hope;

contoured drop cap

When in disgrace with fortune and men's eyes, I all alone beweep my outcast state, and trouble deaf heaven with my bootless cries, and look upon myself, and curse my fate; wishing me like to one more rich in hope;

Vincentio	Leroy Logan
Angelo	Ethan Taubes
Escalus	Steven Samuels
Lucio	Steve Keffer
A provost	John Garretson
Pompey	Clarke Jordan

Wade Boggs

yr	club	G	AB	R	H	HR	RBI	SLG	BB	SO	AVG
82	Red Sox	104	338	51	118	5	44	.441	35	21	.349
83	Red Sox	153	582	100	210	5	74	.486	92	36	.361
84	Red Sox	158	625	109	203	6	55	.416	89	44	.325
85	Red Sox	161	653	107	240	8	78	.478	96	61	.368
86	Red Sox	149	580	107	207	8	71	.486	105	44	.357
87	Red Sox	147	551	108	200	24	89	.588	105	48	.363
88	Red Sox	155	584	128	214	5	58	.490	125	34	.366
Major league totals		1027	3913	710	1392	61	469	.485	647	288	.356

Legibility

Legibility is a property of a type design, while readability is a quality of typography or the use of type. Though the ongoing efforts of type designers are much to be celebrated, no new typeface design can be substantially *more* legible than such mainstays as Times Roman, Century Schoolbook, or Univers. Legibility, after all, is based on the reading skills of the populace. Since he can't reinvent reading, the type designer pursuing legibility seeks to emphasize the elements of letters that contribute to rapid recognition. In essence, legibility is a fixed property that type designs orbit around, some in better trajectories than others.

A typeface must be quite legible when its chief applications include text typesetting, but everyone with a catalog of dry transfer types knows that there is an abundance of highly idiosyncratic type styles. These faces cover such a range of moods that they literally offer something for everyone. The availability of such a diversity of type designs is a boon, but legibility is often sacrificed by such novel designs.

Type with a prominent personality, like the examples shown here, often achieves its tone by exaggerating letterforms or deploying unusual lines, weights, or flourishes. Beyond this, the designer may construct letters out of surprising raw materials, like the dots of Astra, or play a trick with perspective, as in the three-dimensional Stack, or simply decide on a radical set of rules for lines, like those in Roco and Traffic. The definition of a novel type design might well be that it begs the reader to ask, "Can you really make the *whole* alphabet this way?" When a question like that arises, we know that legibility is on the wane. There are styles that are obviously on the borderline of legibility, but it's sometimes harder to spot type that, while legible enough, will not make reading easy. The main offense a graphic designer may commit in a headline is against someone's taste; in lengthy text, he might sin against readability by selecting type with limited legibility.

It would be convenient if some blunders with type made words indecipherable, but the fact is we can read almost anything if we try. However, there are some standards for high legibility. When legibility itself is the goal, the typographer will want to consider type with these general properties:

large, open counters

The counter in an *e* must clearly distinguish it from its dangerously close relatives, the *c* and *o*. In general, the counter opens up space around a letter, defining its outline emphatically, and this tends to enhance recognition. A condensed font's *n* may look like anything from an *r* to an *i*; small counters in any type set in a small size may fill in with ink when printed, diminishing legibility. A large counter usually means high x-height, another property that improves legibility.

ample x-height

The distance of greatest significance in a line of type is between the baseline and the mean line, or the height of a lowercase *x*. Though all measurements interact, the typographer is given an x-height and must

These typefaces, available in dry transfer sheets from Letraset, can be used for display work, such as headlines and logotypes. But because they sacrifice everything for novelty, legibility is low in ornamented or oddly constructed types like these.

Notice the relative size of the counters, particularly in the e, in these six typefaces.

serve it properly through leading, point size, and line length. X-height, in short, is a more forceful dimension in text typesetting than point size. Still, the graphic designer will want to avoid extremely high x-height. Avant Garde, for example, flirts with danger if improperly used, for its *h* is virtually an *n*, and its *d* an *a*.

restrained serifs

All serifs are not created equal. As valuable as these little marks can be in aiding legibility, there are extremes that defy easy reading. Tiffany's fierce points and Egiziano's powerful slabs are not quiet on the page, and Bodoni's delicate hairlines make for dangerous contrast in text and may even confound reproduction. In short, the rules of legibility loudly proclaim, "Nothing in excess." For a vivid demonstration of the fact that serifs aren't inherently beneficial, look at any computer monitor using the character display standard to IBM and other PCs.

unambiguous character shapes

Only the novel or decorative type styles tend to cause true double-takes from the reader, but there are some letters that by nature are difficult to distinguish. When considering a type's legibility, the graphic designer will want to pay special attention to the *c, e, i, l, n,* and *u*. These letters have inherently lower legibility, and in some styles the one-storied *a* and single-looped *g* will join them. Letters of high legibility are *k, m, p, q, w, x,* and *z*, plus all the capitals in most any font, with the occasional exception of the *I*, which is often happy to masquerade as a lowercase *l*. Note also that drastic kerning can make *olive* read as *dive* in as steadfastly legible a style as Futura.

zusammensetzung

Words themselves have an effect on legibility. Here's a nomination for the most illegible combination of letters. This German word has a single ascender and a lonely last descender, giving it little more contour than a word set in capitals. Of course, that also makes it stand out among words with more varied shapes. Zusammensetzung means "combination."

The toughest letters to distinguish, and the easiest: the top row shows the characters that present the greatest challenge to legibility, and the bottom row presents those of greatest inherent legibility.

c e i l n u
k m p q w x z

moderate thick/thin contrast

Again, the heart of legibility is the avoidance of extremes, and fonts with pronounced contrast make reading difficult. P.T. Barnum's charming Old West flavor is achieved by fat horizontal serifs that summon up a railroad image—so much so that the reader sees the rails themselves. The shimmering Modern No. 20 is based on handsome, legible letter shapes, but these represent the only bulwark against the threat to legibility of drastic thick/thin contrast. On the other hand, pure monoweight designs may appear a bit arid in long text, and it's instructive to note the odd little spots the thickness changes in such otherwise monotone styles as Gill Sans and Univers.

moderate weight

Preserving legibility is clearly an exercise in steering to the middle of the road. We can lean on a semiscientific rule regarding stroke weight, as legibility studies have established that the ideal thickness is roughly 20 percent of x-height. Designers often have several weights from which to choose in a single family and are wise to keep the demi bolds, bolds, ultra bolds, and lights in reserve for short blocks of emphasis only. A bolder weight fattens up to shrink counters and sometimes to distort shapes overall, two serious blows against legibility.

Using a highly legible type is not always important. Almost every headline type will fail at least one of the standards listed above. Perhaps more significant, many short text settings are set in type that breaks these rules, and should. The graphic designer would want little but Century Schoolbook in his shop if maximum legibility were his only goal. In short, thousands of typefaces are thoroughly legible; when reading conditions argue for it, optimum legibility is available in far fewer. But once a type is selected, it's up to the designer to make it readable. If he fails to use it well, the most legible face will be of little help to the reader.

Readability

Legibility determines whether we can read text or not; readability tends to determine whether we want to. The typographer's brilliance in handling type is the basis for readability.

There are two reasons why you won't encounter a tidy set of rules for optimum typographic treatment. First, aesthetic norms vary from designer to designer and from period to period, making most advice on this subject idiosyncratic at best. Second, the sheer number of interacting variables makes a set of guidelines a study in qualifying conditions. Dozens of conditions bear on what appears to be a simple type treatment. With these difficulties in mind, we'll examine all the variables, pause from time to time to link a few of them, and emerge with an understanding of what the rules would have to encompass, could such rules neatly exist. The premise beneath this approach is that good design judgment comes from an understanding of typographic variables, and that those (and only those) can be described.

Instead of describing what reading is, I'll ask you to do some:

> But at this point Turovtsyn suddenly and unexpectedly broke into the conversation, addressing Aleksey Aleksandrovich.
>
> "You heard, perhaps, about Pryachnikov?" said Turovtsyn, warmed up by the champagne he had drunk, and long waiting for an opportunity to break the silence that weighed on him. "Vasya Pryachnikov," he said, with a good-natured smile on his damp, red lips, addressing himself principally to the most important guest, Aleksey Aleksandrovich. "They told me today he fought a duel with Kvytsky at Tver, and killed him."

That passage from *Anna Karenina* demonstrates something about the nature of reading. Unless you're particularly well acquainted with Russian names, you were forced to read words like "Pryachnikov"

almost one letter at a time because, unlike all the other words in the excerpt, you have no mental map of their shape as letter groups. Poor typography makes readers struggle this way with words they know perfectly well. We have a huge array of letter patterns in memory and recognize words by general contours. In fact, we can read whole words as quickly as we can single letters. Type style plays only a small role in hindering or enhancing this pattern recognition ability, for it's a highly abstracted mental map we call upon. Typographic treatment, however, has a large effect.

If the spacing, size, and overall treatment of type is awkwardly designed, a reader won't swiftly match the words to his remembered patterns. He may not grope through a letter at a time, but his reading will be slowed, and perhaps his comprehension will be impaired. Short of that, typography may still contain little flaws that tire or irritate a reader, often without his conscious understanding of the annoyance.

Typographic variables

There are sixteen variables in a type specification, and they're classified here roughly by the principal source that influences them.

Factors influencing type specifications

page size, design, subject matter	type selection
line measure	x-height
reading distance	thick/thin contrast
margins, paragraph spacing	stroke weight
number of type styles used	stress

composition parameters	typographer
word spacing	leading
quality of hyphenation	type size
frequency of hyphenation	paragraph indents
letterspacing	case

Frozen sections of kidney and liver were studied by direct immunoperoxidase and immunofluorescence for kappa and lambda light chains utilizing monospecific peroxidase-conjugated anti-human kappa and anti-human

Content itself can affect typographic quality. Here, a medical journal excerpt shows the word spacing woes the typographer faces with exceptionally long words. Only a few word spaces are availabe in each line to accept the adjustments of justification.

In addition to the variables above, there are four considerations that may have an impact on typographic choices. These are paper surface and color, the audience's reading habits, the application of the content, and the average word length in the text. Common sense will tell you that a telephone directory had better not be typeset with a long line measure and that it's a poor gamble to print 8-point Bodoni on textured paper. Thinking about the printed project in use will guide you in making many typographic choices. You can set a dictionary's type as small as 6 point since readers will examine only a few lines at a time, yet you'll have to give a direct mail brochure every chance to attract attention, and that may mean large type. Further, setting a directory or similar reference book in relatively large type may actually hurt its utility, as the reader scans a larger area for the material he's seeking. Finally, the typographer should consider the average word length in the text. The longer the words, the fewer word spaces on each line for

expansion and contraction in justification. After taking these practical matters into consideration, you can tackle the intricate combinations of typographic variables.

Each of these variables contributes to readability, but x-height, line measure, word spacing, and leading are easily the most important of them all. You'll note that each of them is influenced by a different source, suggesting the balancing act the typographer must perform.

x-height

Type designers, sometimes intentionally, sometimes subconsciously, have advanced different ideas for x-height. Current type design trends strongly favor high x-heights, with lowercase letters drawn toward a rectangle distinctly higher than it is wide. There are a great number of fonts, contemporary and older, that veer toward neither extreme; most Transitional styles, for example, strike a balance here. But in a type like Bembo, x-height is so shallow that 10-point Bembo looks about as small as 8-point Bookman. Set with identical specifications, the lines of a low x-height font will appear much further apart than those of a high x-height style.

Because x-height varies so greatly, the typographer must choose a type size by anticipating the effect of its x-height. If you're making even rough sketches for a design, include an accurate suggestion of x-height; showing point size with the tick marks from a type gauge does little to indicate the type's actual appearance.

Leading and x-height always have an important relationship. With a shallow x-height, you can set solid or reduce leading from the norm. Strictly speaking, one would want to increase leading a bit as x-height rises, but this can also be overcompensation. It is still dangerous to reduce leading from normal dimensions with a high x-height type.

drew the glove from his shapely white hand, made a sign with it to his marshals, and gave the order for the action to begin. A few minutes later the main forces of the French army were rapidly moving toward those Pratzen heights which were being steadily evacuated by the Russian troops descending into the valley to the left.

drew the glove from his shapely white hand, made a sign with it to his marshals, and gave the order for the action to begin. A few minutes later the main forces of the French army were rapidly moving toward those Pratzen heights which were being evacuated by the Russian troops descending into the valley to the left.

drew the glove from his shapely white hand, made a sign with it to his marshals, and gave the order for the action to begin. A few minutes later the main forces of the French army were rapidly moving toward those Pratzen heights which were being steadily evacuated by the Russian troops descending into the valley to the left.

drew the glove from his shapely white hand, made a sign with it to his marshals, and gave the order for the action to begin. A few minutes later the main forces of the French army were rapidly moving toward those Pratzen heights which were being evacuated by the Russian troops descending into the valley to the left.

X-height and leading combined determine the density of a type block and the overall readability of text. At left, the settings are 10/11, and at right, 10/14. The typeface in the top row is Bembo, an extremely shallow x-height design, and in the bottom row is Goudy, a face with moderate x-height. Note the apparent smaller size of the Bembo setting. Though Bembo handles excess leading with some grace, in a long text setting it will defeat the reader's orientation line by line. On the other hand, the shallow lines are such strong horizontals that extra leading for short blocks of text can appear very handsome. Note that Goudy simply looks wrong with excess leading, for the balance between x-height, ascenders, and leading is a poor one.

X-height and readership: on the left, the 11/12 Times Roman used in Modern Maturity; *on the right, the 10/10½ Cochin used in* Rolling Stone. *The latter type conserves space and permits tight leading, but it might well be too dense for readers with even minor vision problems. Times Roman, by contrast, is exceptionally legible in the smallest settings, but here in larger text it's a particularly wise choice for older readers.*

judging left-side clearance of a right-hand-drive car—comes in subtle ambush. Just as you think you've mastered the whole driving caper, you forget there's a lot of car over there in an unfamiliar place. I saw a

College. He interned that summer for South Carolina's Senator Strom Thurmond, the former Dixiecrat segregationist whose crossover to the Republican party in 1964 is a perfect symbol of the way the South has evolved into solidly GOP territo-

A shallow x-height type in a small point size can look rather forbidding in long text blocks. Even when it sets with the same number of characters in width as another style, the reader will assume the block contains more text than that in a high x-height style. The corollary is that shallow x-height types convince the reader he is getting more per page; sometimes this is a desirable deception.

Generally, shallow x-height type designs are older than high ones. Design values have changed significantly, and type companies like ITC are busy redrawing classic fonts with higher x-height to suit the temper of the times.

line measure

Both legibility and practicality are affected by line measure. A very short line measure will lead to line-ending problems, as the compositor must add or subtract space to fill a measure that holds very few characters. This problem is compounded with type in large point sizes. In a short line, spaces between words and letters can be added or subtracted from very few positions, making each adjustment noticeable. In general, because of the need for measure-filling space, an entire column of a short line measure will actually hold less than half the characters that fit in a line measure of exactly double width. It will take about twenty lines in an 8-pica measure to hold as much text as nine lines in a 16-pica measure.

Line measure, sadly, is often pulled out of the typographer's control very early in the design process, for page dimensions and the number of columns tend to set this variable even before type selection begins. In effect, the typographer must often suit his type to a line measure.

Reading, from a purely mechanical standpoint, consists of scanning clusters of words and locating each new line with a sweep of the eyes to the left margin. Try reading this passage as quickly as you can while still understanding it:

During the vacations Fred had naturally required more amusements than he had ready money for, and Mr. Bambridge had been accommodating enough not only trust him for the hire of horses and the accidental expense of ruining at fine hunter but also to make a a small advance by which he might be able to meet some losses at billiards. The total debt was a hundred and sixty pounds. Bambridge was in no alarm about his money, being sure that young Vincy had backers, but he had required something to show for it, and Fred had had at first given a bill with his own signature. Three months later he had renewed this bill with signature of Caleb Garth. On both occasions Fred had felt confident that he should meet the bill himself, having ample funds at his disposal in his own hopefulness. You will hardly demmand that his confidence should have basis in external facts; such confidence, we know, is is something less coarse and materialistic: it it is a comfortable disposition leading us to expect that the wisdom of providence or the folly of our friends, the mysteries of luck or the the still greater mystery our high individual value in the universe, will bring about agreeable issues such as are consistent with our good taste in costume and our general preference for the best style of thing. Fred felt sure that he should have a present from his his uncle, that he should have a run of luck, that by dint of "swapping" he should gradually metamorphose a horse worth forty pounds into a horse that that would fetch a hundred at any moment—"judgement" being always equivalent to an unspecified sum in hard cash.

You probably noticed a few errors, but there's a good chance that at a brisk reading speed you did not find all the mistakes. Some words were repeated, some were dropped, and one word was hyphenated incorrectly. You missed some of these errors because the doubled word appeared at the end of one line and again at the beginning of the next; others slipped by because you were reading in clusters of words. Readers economize their efforts, and as soon as a phrase makes sense, the eyes move promptly onward. But just as this example won't yield the same results with every reader, efficient reading is no license for typographical errors. This presentation is only designed to help you notice the clustering that typography must assist.

We're typesetting in characters and measuring them in picas, but readers read words. A reader clusters three to five words together and can best handle three or four of these clusters per line. Accordingly, a line should rarely hold more than fifteen words, or fewer than nine. An ideal line consists of ten to twelve words. Type size plus line length dictate the ease with which a reader will scan these clusters.

(You read) (clusters of words,) (not letters)

Line measure may have to change based on the nature of text: a scholarly or technical journal will read in harsh staccato if only five or six of its longer words fit on a line. In addition, the line-ending problems are quite severe for long words on short measures, for only a few word spaces are available to bear the brunt of justification.

The larger the type, the longer the tolerable line measure, but even with very large type, a measure over 40 picas is very risky if the reader must examine more than four lines. Line measure, along with leading, must make the scanning process as easy as possible.

Below, a demonstration of the effect of type size on acceptable line measure. The long measure simply will not tolerate 8 point, but the same size looks fine in a 13-pica line. To use longer line measures, keep the type size in proportion, like the 12 point shown here on 29 picas. The type font is Galliard.

This is the Court of Chancery, which has its decaying houses and its blighted lands in every shire, which has its worn-out lunatic in every madhouse and its dead in every churchyard, which has its ruined suitor with his slipshod heels and threadbare dress borrowing and begging through the round of every man's acquaintance, which gives to monied might the means abundantly of wearying out the right, which so exhausts finances, patience, courage, hope, so overthrows the brain and breaks the heart, that there is not an honourable man among its practitioners who would not give—who does not often give—the warning, "Suffer any wrong that can be done you rather than come here!"

8/9 x 43½

This is the Court of Chancery, which has its decaying houses and its blighted lands in every shire, which has its worn-out lunatic in every madhouse and its dead in every churchyard, which has its ruined suitor with his slipshod heels and threadbare dress borrowing and begging through the round of every man's acquaintance, which gives to monied might the means abundantly of wearying out the right, which so exhausts finances, patience, courage, hope, so overthrows the brain and breaks the heart, that there is not an honourable man among its practitioners who would not give—who does not often give—the warning, "Suffer any wrong that can be done you rather

8/9 x 13

This is the Court of Chancery, which has its decaying houses and its blighted lands in every shire, which has its worn-out lunatic in every madhouse and its dead in every churchyard, which has its ruined suitor with his slipshod heels and threadbare dress borrowing and begging through the round of every man's acquaintance, which gives to monied might the means abundantly of wearying out the right, which so exhausts finances, patience, courage, hope, so overthrows the brain and breaks the heart, that there is not an honourable man among its practitioners who would not give—who does not often give—the warning, "Suffer any wrong that can be done you rather than come

12/14 x 29

Reading distance also affects line measure, and this distance tends to be established by page size and format. A hardcover book is held further from the eyes than a pocket paperback, and can support a longer line measure. Holding still, you can see about 2 degrees to each side; the further away the text, the more of it falls within this range of vision. We read billboards with the same muscular effort we use for a telephone book. Line measure should allow the reader to move his eyes alone, not his head, and should place type well inside his central range of vision. If a legal document lists scores of provisions in 6-point type, you're forced to keep your eyes so close to the page that line measures of 30 picas or more are tantamount to trickery.

word spacing

The best argument for learning a little about composition methods prior to phototypesetting is that you'll become better acquainted with the nature of word spacing. Because word spacing is now handled by computerized composition, the typographer may not even realize how much he can control this variable. System defaults may not always yield desirable results, but it's simple to change these parameters.

Word spacing directly influences the efficiency with which a reader will recognize word outlines and scan clusters of words. The space around words on all sides should allow the reader to distinguish words swiftly and without ambiguity. Word spacing, therefore, has a strong relationship with leading. If the space above and below words is significantly different from the space between them, the reader will tire or become uncertain. Clear word spacing is based on proportion: too much of it hinders the clustering action and too little works against word pattern recognition.

Note the effect of these variations in word spacing on typographic color and reading comprehension. The typeface is Goudy; it looks quite weak with the extra word spacing in the center top version, and has no need of the reduction in word spacing in the top right treatment. A slight increase in word spacing balances the longer measure and greater leading at bottom.

"He must be done something with, brother Ned," said the other, warmly; "we must disregard his old scruples; they can't be tolerated or borne. He must be made a partner, brother Ned; and if he won't submit to it peaceably, we must have recourse to violence."

"Quite right," replied brother Ned, nodding his head as a man thoroughly determined; "quite right, my dear brother. If he won't listen to reason, we must do it against his will, and show him that we are determined to exert our authority. We must quarrel with him, brother Charles."

normal word spacing

"He must be done something with, brother Ned," said the other, warmly; "we must disregard his old scruples; they can't be tolerated or borne. He must be made a partner, brother Ned; and if he won't submit to it peaceably, we must have recourse to violence."

"Quite right," replied brother Ned, nodding his head as a man thoroughly determined; "quite right, my dear brother. If he won't listen to reason, we must do it against his will, and show him that we are determined to exert our authority. We must quarrel with him, brother Charles."

increased word spacing, no letterspacing

"He must be done something with, brother Ned," said the other, warmly; "we must disregard his old scruples; they can't be tolerated or borne. He must be made a partner, brother Ned; and if he won't submit to it peaceably, we must have recourse to violence."

"Quite right," replied brother Ned, nodding his head as a man thoroughly determined; "quite right, my dear brother. If he won't listen to reason, we must do it against his will, and show him that we are determined to exert our authority. We must quarrel with him, brother Charles."

decreased word spacing, no letterspacing

"He must be done something with, brother Ned," said the other, warmly; "we must disregard his old scruples; they can't be tolerated or borne. He must be made a partner, brother Ned; and if he won't submit to it peaceably, we must have recourse to violence."

"Quite right," replied brother Ned, nodding his head as a man thoroughly determined; "quite right, my dear brother. If he won't listen to reason, we must do it against his will, and show him that we are determined to exert our authority. We must quarrel with him, brother Charles."

slightly increased word spacing, no letterspacing; increased leading

As line measures grow wider, the reader will not only tolerate but welcome slightly greater word spacing. A type font with high x-height or a wide overall design also calls for generous word spacing. Finally, the greater the leading, the greater the appropriate word space. In all these instances, we're trying to balance word space with the apparent size and density of characters and lines. In the end, a rule does emerge: the space between words must relate to all other spaces in a block of text. As those spaces enlarge, so must word spacing. And when the type itself begins to crowd the space through its x-height or set width, word space must act in parallel to keep pace with the greater size.

There is nothing complicated about such a principle until individual aesthetic choices emerge as we apply it. Some designers gravitate toward denser text blocks, and others like a lighter page. Neither is wrong until he reaches an extreme that compromises readability. Both are right when, above all, the type is consistent in its gray tone. When word spacing is out of balance with other elements, it commits the only real sin in page design: it makes itself known to the reader.

leading

There are some conventions for leading, but type specifiers should not be enticed into believing that a single standard for spacing will always produce legible, attractive typesetting. Choosing a leading specification requires attention to overall point size and the relative x-height of a font.

In general, text type in sizes ranging from 6 point to 9 point is usually given one point of lead, for specs of 6/7, 7/8, and so forth. From 10 to 12 point, two points of leading is standard. As type increases in point size, more leading is required to maintain the proportional effects of

Each of the examples below is set with appropriate leading. Note that Garamond's normal x-height suits the conventional leading of 9/10, while Bookman, a typeface with wider set width and greater x-height, requires 9/11. Futura condensed has both shallow x-height and narrow set width, requiring 9/10 leading, but Futura roman can appear properly set with 9/11 leading, to grant the long ascenders extra room. The shallow Bodoni looks fine with excess leading because it has such emphatic horizontals, and can be set solid without impairing readability.

Between this half-wooded and half-naked hill, and the vague still horizon that its summit indistinctly commanded, was a mysterious sheet of fathomless shade—the sounds from which suggested that what it concealed bore some reduced resemblance to features here. The thin grasses, more or less coating the hill, were touched by the wind in breezes of differing powers, and almost of differing natures—one rubbing the blades heavily, another raking them piercingly, another

9/10 Garamond

Between this half-wooded and half-naked hill, and the vague still horizon that its summit indistinctly commanded, was a mysterious sheet of fathomless shade—the sounds from which suggested that what it concealed bore some reduced resemblance to features here. The thin grasses, more or less coating the hill, were touched by the wind in breezes of differing powers, and almost of differing natures—one rubbing the blades heavily, another raking them piercingly, another brushing them like a soft broom. The instinctive act of humankind was to stand and listen, and learn how the trees on the right and the trees on the left wailed or chaunted to

9/10 Futura condensed

Between this half-wooded and half-naked hill, and the vague still horizon that its summit indistinctly commanded, was a mysterious sheet of fathomless shade—the sounds from which suggested that what it concealed bore some reduced resemblance to features here. The thin grasses, more or less coating the hill, were touched by the wind in breezes of differing powers, and

9/12 Bodoni

Between this half-wooded and half-naked hill, and the vague still horizon that its summit indistinctly commanded, was a mysterious sheet of fathomless shade—the sounds from which suggested that what it concealed bore some reduced resemblance to features here. The thin grasses, more or less coating the hill, were touched by the wind in breezes of differing powers, and almost of differing

9/11 Bookman

Between this half-wooded and half-naked hill, and the vague still horizon that its summit indistinctly commanded, was a mysterious sheet of fathomless shade—the sounds from which suggested that what it concealed bore some reduced resemblance to features here. The thin grasses, more or less coating the hill, were touched by the wind in breezes of differing powers, and almost of differing natures—one rubbing the blades heavily, another raking them piercingly, another

9/11 Futura

Between this half-wooded and half-naked hill, and the vague still horizon that its summit indistinctly commanded, was a mysterious sheet of fathomless shade—the sounds from which suggested that what it concealed bore some reduced resemblance to features here. The thin grasses, more or less coating the hill, were touched by the wind in breezes of differing powers, and almost of differing natures—one rubbing the blades heavily, another raking them piercingly,

10/10 Bodoni

interline spacing. For example, one point of lead is one-sixth the depth of 6-point type, but only one-fourteenth of 14 point.

Leading for headlines and subheads follows even looser guidelines. A 32-point headline would be set 32/37 if the specifier were trying to preserve the same one-sixth of point size relationship, but because display type usually occupies only a few lines, it's generally set much tighter than text type. Scanning headlines is different from reading, so leading doesn't follow a proportional spacing system. In addition, because designers often use display type in strong visual blocks, leading may be tight, solid, or negative to preserve a large shape of two or three lines. The example below compares Clarendon set solid and Helvetica set with minus leading.

Fielding Flubs
Drub Cubs
24/24 Clarendon

Fielding Flubs
Drub Cubs
24/22 Helvetica

Variations in x-height are the major reason that hard-and-fast leading rules lead type specifiers astray. A type with shallow x-height can readily be set solid in text since it offers so much space between the baseline above and the mean line. On the other hand, those tall ascenders permit the typographer to use excess leading in proportion to the spaciousness of the type design itself. In contrast, high x-height can make normal leading look claustrophobic, as lowercase descenders flirt with the full height of ascenders. Though leading is a specification that positions baselines, the reader anchors his eyes around the baseline and mean line. Take this into consideration when choosing leading for type at either extreme of x-height.

The space between lines affects the reader's ability to pick up each new line at the left margin, and in a subtle way governs his reading pace. Too much leading makes it difficult for the reader to hold his place, and he'll swing over to the left margin and begin reading the same line twice. Too little leading makes the page dark and forbidding and will cause the reader to skip a line or overcompensate and start the same line twice. In both cases, reading rhythm is disrupted.

In blocks of a few lines, you're free to use extra leading to create a visual effect. The amount of white space can be three or four times the density of the type and the reader will still have no trouble scanning a short passage, but such pyrotechnics can't be sustained for long.

On the other hand, there are almost no occasions when too little leading is tolerable. If lines are jammed so close together that the interword spacing is greater than interline spacing, the entire scanning process of reading is frustrated. It might be interesting to see the woven texture of type with inadequate leading, but it won't be readable.

It would be more accurate to think of interline spacing as the combination of leading and x-height. The typographer is trying to balance type density and white space, and he must use leading to parallel x-height or to correct any problems it poses.

The type density demonstration on the facing page will give you an idea of the overall effect of different type contrast, weight, and x-height. When selecting a typeface, consider the density at a specific size and leading. These examples are all 9/10 ½

Type density demonstration

This is the Court of Chancery, which has its decaying houses and its blighted lands in every shire, which has its worn-out lunatic in every madhouse and its dead in every churchyard, which has its ruined suitor with his slipshod heels and threadbare dress borrowing and begging through the round of every man's acquaintance, which gives to monied might the means abundantly of wearying out the right, which so exhausts finances, patience, courage, hope, so overthrows the brain and breaks the heart, that there is not

Eras Light

This is the Court of Chancery, which has its decaying houses and its blighted lands in every shire, which has its worn-out lunatic in every madhouse and its dead in every churchyard, which has its ruined suitor with his slipshod heels and threadbare dress borrowing and begging through the round of every man's acquaintance, which gives to monied might the means abundantly of wearying out the right, which so exhausts finances, patience, courage, hope, so overthrows the brain and breaks the heart, that

Galliard

This is the Court of Chancery, which has its decaying houses and its blighted lands in every shire, which has its worn-out lunatic in every madhouse and its dead in every churchyard, which has its ruined suitor with his slipshod heels and threadbare dress borrowing and begging through the round of every man's acquaintance, which gives to monied might the means abundantly of wearying out the right, which so exhausts finances, patience, courage, hope, so overthrows the brain and breaks the heart that

Bodoni

This is the Court of Chancery, which has its decaying houses and its blighted lands in every shire, which has its worn-out lunatic in every madhouse and its dead in every churchyard, which has its ruined suitor with his slipshod heels and threadbare dress borrowing and begging through the round of every man's acquaintance, which gives to monied might the means abundantly of wearying out the right, which so exhausts finances, patience,

Clarendon

This is the Court of Chancery, which has its decaying houses and its blighted lands in every shire, which has its worn-out lunatic in every madhouse and its dead in every churchyard, which has its ruined suitor with his slipshod heels and threadbare dress borrowing and begging through the round of every man's acquaintance, which gives to monied might the means abundantly of wearying out the right, which so overthrows the brain and breaks the heart that there is not an

Goudy

This is the Court of Chancery, which has its decaying houses and its blighted lands in every shire, which has its worn-out lunatic in every madhouse and its dead in every churchyard, which has its ruined suitor with his slipshod heels and threadbare dress borrowing and begging through the round of every man's acquaintance, which gives to monied might the means abundantly of wearying out the right, which so exhausts finances, patience, courage, hope, so overthrows the brain and breaks the heart that

ITC Garamond

This is the Court of Chancery, which has its decaying houses and its blighted lands in every shire, which has its worn-out lunatic in every madhouse and its dead in every churchyard, which has its ruined suitor with his slipshod heels and threadbare dress borrowing and begging through the round of every man's acquaintance, which gives to monied might the means abundantly of wearying out the right, which so exhausts finances, patience,

Bookman

This is the Court of Chancery, which has its decaying houses and its blighted lands in every shire, which has its worn-out lunatic in every madhouse and its dead in every churchyard, which has its ruined suitor with his slipshod heels and threadbare dress borrowing and begging through the round of every man's acquaintance, which gives to monied might the means abundantly of wearying out the right, which so exhausts finances, patience, courage,

Franklin Gothic Heavy

This is the Court of Chancery, which has its decaying houses and its blighted lands in every shire, which has its worn-out lunatic in every madhouse and its dead in every churchyard, which has its ruined suitor with his slipshod heels and threadbare dress borrowing and begging through the round of every man's acquaintance, which gives to monied might the means abundantly of wearying out the right, which so exhausts finances, patience, courage, hope, so overthrows the brain and breaks the heart, that there is not

Futura Light

This is the Court of Chancery, which has its decaying houses and its blighted lands in every shire, which has its worn-out lunatic in every madhouse and its dead in every churchyard, which has its ruined suitor with his slipshod heels and threadbare dress borrowing and begging through the round of every man's acquaintance, which gives to monied might the means abundantly of wearying out the right, which so exhausts finances, patience, courage, hope, so overthrows the brain

Trump Medieval

This is the Court of Chancery, which has its decaying houses and its blighted lands in every shire, which has its worn-out lunatic in every madhouse and its dead in every churchyard, which has its ruined suitor with his slipshod heels and threadbare dress borrowing and begging through the round of every man's acquaintance, which gives to monied might the means abundantly of wearying out the right, which so exhausts finances, patience, courage, hope, so overthrows the brain and breaks

Helvetica

This is the Court of Chancery, which has its decaying houses and its blighted lands in every shire, which has its worn-out lunatic in every madhouse and its dead in every churchyard, which has its ruined suitor with his slipshod heels and threadbare dress borrowing and begging through the round of every man's acquaintance, which gives to monied might the means abun-

Futura Extra Bold

Typographic norms and variations

Most of the norms listed below are rather realistic limits, but the typographer should break with them when he can clearly visualize the need to produce a particular effect. The best way to use this chart is to note how many of the conditions described under variations are true: if you're using a condensed face, set solid, with tight tracking, you've created a situation that absolutely insists on a reduction in word spacing from the norm. On the other hand, if your condensed type is an ultra bold, you have two conditions that are in opposition on the matter of word spacing, and you should probably split the difference and use the norm.

This chart stops short of stating how much you can veer from a norm, and it's here that your own sensitivity to type color and aesthetics must come into play. The "range outside the norm" listed for each variable indicates how much free play you have in the size of your variations.

word spacing

norm: 3 to the em
2/3 of the width of an "o"
the width of a "t"

contemporary norm: 4 to the em

range outside the norm: very small

reduce word spacing when using
condensed or tightly fitted type fonts
tight tracking
extreme kerning, as in a headline
type with small x-height
large point size
solid or reduced leading
sans serif type
upper- and lowercase instead of all caps

increase word spacing when using
type with heavy stroke weight, particularly
ultra bold
wide line measure
reverse type, drop shadows, or other special effects
expanded type

line measure

norm: length of lowercase alphabet times 1.5
point size times 2
10 to 12 words per line
40 to 60 characters per line; never more
than 70

range outside the norm: small in text, extensive in headlines

shorter line measures are permissible when
using sans serif type
using leader characters
text is reference material, catalog, or directory

longer line measures are permissible when
text is technical, including numerous long words
frequent hyphenation is considered undesirable
using large point sizes
using type with high x-height
copy blocks consist of very few lines, with white
space or illustration intervening often

Table of line measures in picas

type point size	6	7	8	9	10	11	12	14
minimum	8	8	9	10	13	13	14	18
optimum	10	11	13	14	16	18	21	24
maximum	12	14	16	18	20	22	24	28

text type size

norm: 10 point

contemporary norm: 9 point
note: reading distance is roughly point size times
1.5, as inches

range outside the norm: large

use smaller point sizes when
type has large x-height
line measure is narrow
frequent hyphenation is considered undesirable
text is reference material, catalog, or directory
conserving space or implying text density is
important
a darker, denser page is desirable

use larger point sizes when
readers are old or young
reading conditions will be poor
font is condensed, bold, or italic
font's thick/thin contrast is extreme
page size is larger, requiring greater
reading distance

leading

norm: text sizes: x-height in points times 2
display sizes: x-height in points times 2.25
for wide lines, at least 1/30 line measure
120 percent of point size

range outside the norm: moderate

use less leading when
stroke weight is light
x-height is shallow
(The norm attempts to handle this by definition,
but if using leading calculated any other way,
adjust for x-height.)
line length is narrow
using all caps
material is read very few lines at a time,
as in a directory

use more leading when
stroke weight is very heavy
a light page density is desirable
type is sans serif

calculating leading for mixed point sizes

To determine minimum leading between lines of
different point sizes, use the table to find the
descender value of the largest size in the first line and
the ascender value of the largest size in the next line.
Add these values together. To this minimum leading
total, you may wish to add additional points for looser
leading.

Example: headline in 60 point, followed by
subhead in 36 point.

60 point		36 point	
descender	+	ascender	
12	+	29	= 41 minimum leading

point size of type	point size of ascender	point size of descender	point size of type	point size of ascender	point size of descender
5	4	1	14	11	3
5.5	4.5	1	18	14.5	3.5
6	5	1	24	19	5
7	5.5	1.5	30	24	6
8	6.5	1.5	36	29	7
9	7	2	48	38.5	9.5
10	8	2	60	49	12
11	9	2	72	57.5	14.5
12	9.5	2.5			

mode

norm: justified or ragged right

use justified or ragged right when
copy is long
an even, balanced page is desired
content, not appearance, is important
setting in text type sizes

use ragged right when
setting on short measures
preserving even typographic color

use centered or ragged left when
setting headlines
impaired readability is acceptable
(Readers cannot consistently pick up the next line
when scanning ragged left or centered type.
Use these modes only when the shape of a short
text block permits it.)

type font

norm: serif typeface, moderate x-height, in upper-
and lowercase

range outside the norm: very wide

use a sans serif typeface when
a spare, geometric appearance is desired
text is technical, a directory, or form

use all caps when
setting only a name or phrase
(Words set in capitals lack the outline readers use to
comprehend text, and therefore are extremely
low in legibility and readability.)

use shallow x-height typefaces when
balancing the extreme with appropriate leading
the strong, low horizontals add appropriate density
to the page

use italics when
emphasizing only words or phrases

indents

point size	indent
0-18	1 em
19-23	1½ ems
24-30	2 ems

range outside the norm: very wide

Combining the variables

Readability rests on balancing the light and dark in type. This facilitates the pattern recognition we use to read words and the clustering action that we use to read sentences. The space around words and between lines must be in harmony. A good typographer seeks the same lightness between words as between lines. He'll need to use the line measure to permit proper word spacing and an easy scanning motion from line to line. Then he'll balance x-height with leading to provide the proper contrast with the density of the type. Though there is no numerical rule to help him achieve this effect every time, the goal remains clear, simple, and challenging to pursue.

O devoted lovers of well-formed letters,

would God that some noble heart would occupy itself in establishing & ordering by rule our French language! By this means thousands of men would strive often to make use of good, honest words. If it be not so established and ordered, we shall find that from fifty years to fifty years the French language will be in large part changed for the worse....

Wherefore, I pray you, let us all enhearten one another, and bestir ourselves to purify it. All things have had a beginning. When one shall have treated of the letters, and another of the vowels, a third will appear, who will explain the words, & then will come still another, who will set in order the fine discourse.

Thus we shall find that, little by little, we shall traverse the long road, and shall come to the vast fields of poesy and rhetoric, full of fair and wholesome and sweet-smelling flowers of speech, & can say downrightly and easily whatsoever we wish.

Geoffrey Tory
Champ Fleury
1526

The television news anchorman stumbles on a word now and then, and the disk jockey occasionally flubs a music segue, but even though millions of people might be listening, these mistakes don't seem very serious. Typographical errors appear to be the equivalent of the newsman's blunders until you recall that they are permanent blemishes. What's worse, they have been in place for hours, days, perhaps months, and have been overlooked by the very people who are expected to be most concerned about the work. When a reader sees one, he has every right to wonder if he is the first person to think carefully about the text he's reading.

We forgive the TV sports director for making a bad camera choice in the middle of the action, but we wouldn't excuse a film editor for compiling a disjointed summary of the game. In short, if you can prevent mistakes, you are obligated to do so. You aren't expected not to make them, and it's actually dangerous to think that you won't. Copy production work, as a whole, looks for mistakes and for occasions when mistakes could arise. These efforts make it possible for everyone in the enterprise to behave like mortals: to make errors, and then have the errors caught in time.

The five copy production tasks are manuscript preparation, copy editing, proofreading, copy fitting, and copy handling. These jobs require patience and concentration, and all too often they are the booby prizes of the publishing world. To those who understand what it takes to do them well, these jobs are challenging because they require skill, devotion, and intelligence in equal measure.

Manuscript preparation

Before Mark Twain sent his publisher the first typewritten book manuscript in 1883, the printing trade was accustomed to setting type from handwritten copy, with all its imperfections. The standards have changed, and the computer word processor's role will soon make mere typed manuscript appear hopelessly sloppy. Right now we're on the borderline: capable of giving a typesetter a perfect manuscript, but not yet morally obligated to do so. What we are expected to submit is meticulously prepared copy.

It may seem tedious or unnecessary to retype manuscript that fails to meet clean copy standards until you consider the effects of submitting careless copy. The typesetting operator will not be able to work at optimum speed, and therefore work priced on an hourly basis will increase in cost. Since the inclusive hourly price for typesetting exceeds any typist's hourly wage, one can afford a good deal of extra secretarial work on a manuscript. In many cases, one retyping plus typesetting will cost less than the error-ridden typesetting of a sloppy manuscript.

Don't underestimate the effect of bad copy on typesetting errors. Between the operator's fatigue from struggling through the manuscript and the potential for missing changes, there are special opportunities for errors to arise. In the end, poorly prepared copy virtually begs the typesetter not to care about a job well done, since the manuscript itself reveals that it has received little attention from its editors.

Think of the questions that the copy may pose to a typesetter. Your copy preparation efforts should answer these questions, and the clarity of your reply is more important than its style. When you have any doubt how proofreading marks will be interpreted, spell out the instruction.

Copy editing and fact checking are tasks performed on manuscripts, not typeset galleys. Before releasing manuscript to a typesetter, you'll want to proofread it one last time. In theory, the manuscript you give a typesetter could be printed as is, with no intervening changes. Unfortunately, that theoretical disengagement with the text rarely seems to take place at the stage everyone expects it should. Nevertheless, you can save considerable time and money if you keep your implied promise to be satisfied with the manuscript you first deliver to a typesetter.

Electronic manuscript preparation

Typesetting equipment now relies on computer software to compose text, and it's logical to try to feed that computer the manuscript in the most direct way. Faster by far than retyping it at a new keyboard, you can supply the manuscript in electronic form. Many composition programs have translation tables that allow specific word processing formats to travel from computer to typesetter. Failing that, most computers can decipher the generic ASCII (American Standard Code for Information Interchange) text format. The goal is to have the

This typewritten manuscript includes some correction but is clean enough to submit to typesetting. Adding more corrections or inserting additional text will compel the author to retype the page.

unnecessary elements deleted from the file and the necessary codes translated to drive the computer's composition program.

The particulars of data translation are too application-specific to be described here, but the general concept is important. At best, you'd like to convey five elements from your electronic manuscript to a composition program:

- the characters themselves, including special characters outside the usual keyboard set
- format information, such as type style and typesetting mode
- attribute information, such as bold and italic
- positional information, such as indents and tabs
- conditional placement information, such as footnote locations and table of contents numbering

Manuscript preparation

These are the properties of a clean manuscript, properly prepared for typesetting.

Typing

Common sense will guide you to prepare a clean, consistent manuscript. Ample margins and double-spacing make the manuscript easy for the typesetter to follow, while a consistent number of lines per page facilitates character counting. The typing should be clean, requiring no more than three or four handwritten corrections per page. When corrections are more frequent, retype the page.

Typesetting operators prefer pica type because the characters are larger. A monospaced typewriter is better than a proportionally spaced one because it's easier to count characters of equal width. If your manuscript is hard copy from the word processor, turn off any pseudojustification feature so that true character counts are visible. (Pseudojustification pads word spaces in monospaced typewriter copy to make uniform line lengths, but undermines all our copy fitting efforts.)

When a manuscript is the final product, typing conventions include some formatting choices designed for legibility and comprehension. However, when the manuscript is only at an interim stage in production, these attributes can hinder more than help. You'll want to format the manuscript based exclusively on the need to make it readable for additional typing. For example, don't single-space a quotation or excerpt that's to be set in a smaller type font. Maintain double-spacing throughout, but indent the excerpt and include typesetting instructions.

Markings

Leave at least a quarter of the first page blank to provide room for marking typesetting specifications. Identify the manuscript by title, author, or slug on every page. The newspaper term slug refers to a short, one-word title for a story used throughout its production. It's helpful to mark the last page as "end" or to use the pound sign to signal the end of copy.

Changes and corrections

To add corrections to typewritten manuscript, think carefully about making your intentions understood. Use standard proofreading marks to correct the manuscript, but if there's any doubt in your mind whether you'll be understood, write out the revision in detail.

Make your changes and instructions clear by writing them in a color other than the black of the typewriter ribbon. Write above the line in question, if possible, and never write a correction or addition on the back of a page.

Circle any instructions that might be construed as copy to be typeset. This distinguishes them as a comment to the typesetter. Don't make redundant markings, such as writing "caps" by a word typed in caps; typesetters will follow the manuscript unless told not to.

Typeset originals

If the original has already been typeset, it may be difficult to read when retyping, particularly if the type is smaller than 10 point. Sometimes, the difference in hourly cost between a typesetter and a typist will motivate you to have the text retyped to make the typesetter's work go faster. Remember, the typesetter's hourly fee includes equipment costs and the wages of an operator generally more highly trained than a secretary.

When working from a reprint printed on two sides, convert it to a single-sided manuscript for the typesetter. Tape each page to plain white 8½ x 11 inch bond, using two copies of the original to make up the manuscript. This avoids any confusion about the order of material.

It's not possible to carry all five types of information from a word processing application to a typesetter, but the first four can be maintained with planning, and the computer can be tricked into using some of the fifth. Sometimes, carrying over information is actually an impediment because it requires that the typist or author place it there. Typesetting commands to change fonts, number footnotes, or perform other tasks may best be entered by a typesetter, not an author. On the other hand, it's disturbing to lose the efforts of a manuscript typist because the material won't translate. Losing every paragraph indentation in translation, for example, means that the task must be done twice. Let's look at each of these kinds of information in detail.

characters

Almost all computer software is comfortable with characters presented in their ASCII form. ASCII is a numeric format for representing characters in which, for example, the capital *A* is symbolized by the number 65. An electronic manuscript in ASCII form can be converted back into characters by most composition software.

There are two typical problems with straight character translation. First, the standard keyboard doesn't include many characters necessary for typesetting. The usual set of 95 typewriter characters is only a fraction of the 256 ASCII values available. Though an ASCII number is reserved for each of these special characters, you can't strike a key that represents it. To obtain an accented character, foreign punctuation, or other special marks, the typist needs to enter an ASCII value directly instead of relying on the computer to translate the keystrokes. Most word processing software programs permit this. In turn, many composition programs allow you to enter special commands in your original electronic manuscript to obtain access to the extended ASCII character set.

The second conversion problem involves characters that didn't find a place among the 256 ASCII values. Symbols such as the copyright mark and typesetting elements such as the em dash don't have ASCII equivalents. There are two basic solutions to this problem, and the one you select will depend on your working conditions and specific computer software.

First, you can rely on a typesetting operator to add these special characters. You would produce hard copy for the typesetter and mark the special character location. Let your type supplier advise you on the most efficient way to indicate the necessary special characters.

Second, you can use composition software that allows you to embed special commands in your word processing file. The Ventura Publisher desktop publishing program, for example, accepts commands typed in a word processing program and set inside brackets, and therefore permits a typist to call for symbols and other special characters within the manuscript. Because many keystrokes may be necessary for some commands, it's often most efficient to use a word processor's search-and-replace function to substitute embedded commands for conventional characters. Again, advance planning is important. Not only do some composition programs fail to provide such internal translations, those that do may accept very different commands.

Special characters

typeset character	Macintosh	Windows	Ventura
Ç	option shift c	0199	128
Ñ	option n N	0209	165
Å	option shift a	0197	143
Á	option shift y	0193	199
Â	option shift r	0194	200
À	option ' A	0192	182
Ù	option shift x	0217	213
Ë	option shift u	0203	203
Ê	option shift t	0202	202
É	option e E	0201	144
È	option shift i	0200	201
ç	option c	0231	135
ñ	option n n	0241	164
å	option a	0229	134
á	option e a	0225	160
â	option i a	0226	131
à	option ' a	0224	133
ù	option ' u	0249	151
ë	option u e	0235	137
ê	option i e	0234	136
é	option e e	0233	130
è	option e	0232	138
ß	option s	0223	217
Æ	option shift '	0198	146
æ	option '	0230	145
¼		0188	
½		0189	
¾		0190	
¶	option 7	0182	188
§	option 6	0167	185
®	option r	0174	190
©	option g	0169	189
£	option 3	0163	156
¢	option 4	0162	155

A partial listing of the characters available in Adobe font sets for desktop publishing programs. To obtain the typeset character shown, type the option key with the keys shown for the Macintosh, or hold down the alt key while typing the numbers shown for Ventura and Windows applications. Check your type font documentation for additional characters in each font. Ventura, by the way, uses the actual ASCII value for special characters, but Windows has its own system.

Several characters have to be converted to a slightly different typeset equivalent. A type font has opening and closing quotes, while a typewriter has only the inch mark. Many conversion routines examine the context and substitute opening and closing quotes when they see a pair. The apostrophe, tabs, and other pi characters all have similar conversion quirks. Typists must comply with conversion logic as well. For example, the manuscript must maintain the difference between a zero and a capital *O*.

The great drawback of submitting text entirely in ASCII format is that virtually everything but the characters is lost. Pure ASCII doesn't preserve tabs, centering, and a host of other formatting elements. Further, an ASCII file is a record of the characters as they appear on the screen. This means that a carriage return appears at the end of every line, an indication we generally only want at the end of paragraphs. The conditional line breaks of word wrapping become absolute in ASCII. Some typesetting conversion programs ignore or strip away these carriage returns and honor only a double return or some other special marker. Plan on coping with these limitations or outwitting them with a special conversion routine.

Don't confuse pure ASCII with a word processing format that includes character data in ASCII form. You may find a typesetting conversion for any number of word processing formats, which will preserve information above and beyond the ASCII character values.

format

The commands for type style changes and typesetting modes, such as justified or flush right, are usually best introduced in the composition program itself. It's generally safer if the typesetting operator knows what you want, through your written instruction, than if he lets the machine follow instructions you send electronically. The consequences of some format commands are difficult to foresee before composition. It's virtually impossible for the novice to set tabular matter without examining a screen display or set galley for guidance. Normally, it's wiser to mark up a manuscript than to try to embed format commands.

But there are some situations in which it's more efficient to include such commands in the electronic manuscript. Throughout the writing, typing, and composing process, a chain of people make choices. Some decisions must be repeated over and over. For example, an author decides to set a quotation in a different typeface, an editor reviews the idea and agrees, a designer selects the particular font, a markup copy editor puts the instructions on the manuscript, and a typesetter finally gives the command to the computer. In this case, the font change command belongs in a position better understood by the author than anyone else, and consists of a specific command best issued by the designer. If all the people involved in the decision could store their work within the manuscript, they can save time and ensure greater accuracy.

Note that an electronic manuscript has some special preparation requirements. For example, don't use a double space between sentences. In typesetting, no extra space is necessary. Make certain that you use a tab for indents, not several spaces. A space has an elastic value in typesetting, while tabs represent fixed positions. Finally, make sure

hard hyphens only where you wish to retain the mark in compound words or other terms.

attributes

An attribute change, such as switching from roman to italic type, is sometimes directed by a designer who sets up a style for captions and heads and sometimes by an author who knows that a book's title should be set in italics. When an attribute change is based on the internal sense of a manuscript, you'll want to preserve it through translation to your composition program. If it's based on a spatial or positional requirement, it can be found again by the typesetting operator, making direct translation less critical, though still of great value.

Typewritten manuscript style uses underlining to represent italics. Some manuscript typists are lavish in bestowing underlining, using it as emphasis and to compensate for the lack of different type sizes. With planning, you can arrange with your type supplier to convert underlining to italic, either through a translation program or by making changes in the word processing file itself. In the latter instance, a search-and-replace routine would change the underline command to an attribute command that the composition software can read. But remember that the wholesale conversion of underlines to italic might not be what you want. Before translation, check the manuscript to make sure that underlining has been used only to represent italics.

Some desktop publishing (DTP) software has special provisions for translating attributes. And some word processing programs make attributes for bold and italics available. These attributes can usually be translated for conventional typesetting and for DTP software.

An example of an attribute you might not want to translate directly is the superscript command. In a manuscript, superscript is used for footnote numbering and scientific equations. True superscript is nothing more than moving up the baseline of a character in the main text font. However, a footnote number is generally set much smaller than body text and with a different baseline. If you can include the additional format information, you'll want to convert a superscript to a font change plus a baseline change. If not, the typesetting operator will have to locate all the superscript characters and change their size and position. Consider this only one example of the need to think carefully about your attribute translations.

This discussion has concentrated on preparing text for conversion routines, but there are instances when it's best to place true typesetting codes in a manuscript. Some conversion is still implicit here, but the command string itself will set typesetting parameters. A typical format would consist of a precedence code that signaled the system to receive a command, the command itself, and the specific value in the command. For example, to set a line measure of 26½ picas, the code might read "store LL ^LL 2606." A complete set of type specs might be rendered in a string with mnemonic commands, such as "^LL 1800 ^FT 1 ^SZ 080 ^PL 090." That example would set a line measure of 18 picas, call for font 1 in 8 point and 9 points of primary leading.

positional controls

Positional commands, such as indents and tabs, are difficult to translate with

positional controls

Positional commands, such as indents and tabs, are difficult to translate with real accuracy. Though you may want to preserve the fact that each paragraph should be indented, setting the amount of indent may require fine-tuning in the composition program. In effect, a positional command has two elements: its nature and its degree. Translating the nature of these commands is far more important than capturing their measurements. And what author could plan precise tab stops in advance for a complicated table? Translating the tabs themselves and then assigning them positions in the composition software is usually the smoothest course of action.

Traditional typesetting calls for paragraph indents to be specified in ems, not picas or inches. When translating an electronic manuscript's indents, you are most likely converting the indent to a tab and then giving the tab a position measured in picas and points. The results can be quite satisfactory, but you will deviate from conventional typesetting markup terminology.

conditional placement

With each passing day, word processing programs endow typists with greater powers to format documents. Among these features are conditional placement routines that orient footnotes at the bottom of the pages calling out the references. On a simpler level, word processing programs can number pages and repeat headers and footers. Needless to say, all these handy capabilities mean nothing when positions and page numbers are changed as text is typeset.

Any composition program or intermediate translation software will ignore commands to produce such conditional placements. For the most part, this is no great loss. But we will miss one very sophisticated feature of some word processing programs. Some programs can generate indices and tables of contents, based on the page numbers of the manuscript. Of course, the manuscript page numbers have nothing in common with the typeset pagination of the text, but we can harness the word processor's talents nevertheless. After page layout is complete, you repaginate the word processing version of the manuscript in accordance. The page numbers it generates for an index and table of contents are now correct.

We can anticipate composition software that includes some of these word processing features. Some high-level programs do already, and we can expect new mainstream products to offer the benefits of such organizational features.

Copy editing

If an editor has tools like a hammer and pliers, copy editors are those working with nothing but sandpaper. Copy editing is the perfecting of the text in matters of grammar and style. Style in this instance is not a literary tone, but a standard for spelling, punctuation, abbreviation, and other mechanical details of presentation. It's up to the copy editor to locate every point in the manuscript that requires a ruling on style, make the proper judgment, and keep all such decisions consistent.

Style in itself has no worth. Rather, style is a guardian of other values in good writing: clarity, organization, and unambiguous meaning. Overzealous copy editors sometimes need reminding that style is not an end in itself. You might think of editing for style as testing for efficiency in expression, while editing for content is examining what is expressed. Efficiency in this sense includes lack of ambiguity and the preservation of real distinctions among words. The conventional sense of efficiency applies also, for a reader should be able to make his way through text with appropriate speed, unimpeded by faulty grammar, redundancy, or inconsistency.

Strictly speaking, there's little creativity in copy editing, but there is a need for great insight and intelligence. There is also a very stiff job requirement: a passion for correct usage of English. This is the kind of devotion that makes others smirk and misquote Emerson. He said, "A foolish consistency is the hobgoblin of small minds," but those who insult diligent copy editors always seem to omit the adjective.

Consistency, above all, might be the copy editor's rallying cry. Accuracy here isn't always black and white, for on many points of style there are options. Some options are legitimate alternatives that any dictionary or stylebook would include, and others are not correct but nevertheless manage to convey the right meaning to the reader. As a copy editor, you may have a secondary mission at times in persuading the author that you're entitled to steer him onto the only correct path. When there are two correct alternatives, your job is to pick one and stay with it.

Style

The author of a textbook may be a good and diligent writer, but if his book is to be part of a publishing company's series, the copy editor will doubtless bring the manuscript into conformance with house style. Magazine contributors similarly will have little claim on setting the mechanical style of their articles. In these instances, the copy editor is not only achieving consistency within a work, but also within the larger publishing enterprise. Naturally, the internal consistency of each manuscript is most important, whether it's part of a larger program or standing on its own.

There will be enormous pressure to veer from certain style choices, but the greatest of these pressures is plain forgetfulness. To set a standard and maintain it, a stylebook records choices and stands by for ready reference. Along with it, you'll often use a style sheet of your own to spell out the unique style issues of a particular publishing program or manuscript.

Stylebooks

If copy editing were merely a matter of consistency, one could freely formulate new rules and force readers to live under them. Such neglect or ignorance of style conventions, however, would be fatal to communication. The definitive text on the matter is the *Chicago Manual of Style*, a book that treats everything from punctuation to the difference between "that" and "which." Another useful book is *Words into Type*. Both books include a discussion of manuscript preparation and general production issues as well.

Stylebooks provide rules for the use of abbreviations, capitalization, symbols, numbers, italics, punctuation, and compound words. They also include a grammar section and information on conventions for typographical presentation. Style is generally black and white: capitalize the full geological name *Early Devonian*, but write *early Pliocene* with a lowercase adjective because the U.S. Geological Survey does not recognize the latter as an official term. However, on some points of style there are shades of gray. Usage of the comma alone probably accounts for disproportionate share of editorial ruminations and stylebook commentary. When in doubt, a good copy editor will recall that a specific comma usage ruling may have to give way to the higher principle of using the comma to clarify meaning.

All of the useful material in a stylebook is worthless to a copy editor who doesn't realize that a style point has been raised by the text. It's easy to spot grammatical errors at their most flagrant, but a copy editor must be able to evaluate all the questions raised in usage. No one would curl up with a style manual and attempt to read it, but a copy editor should master its table of contents and index well enough to recognize the issues it treats.

Style sheets

Published style manuals resolve universal usage questions, while a house style sheet handles the particular conventions of a company or publishing house. Publishers develop style sheets that editors use to determine, for example, whether the term "Deep South" is capitalized, or whether Ohio is to be written "Ohio," "Oh," or "OH." There's a general rule of grammar that answers the first question (capitalize popular appellations for regions and localities), but the second question is a matter of house style. Since there is no one right answer, a preference must be determined and recorded for all editors to use.

A newspaper's house style is likely to differ from a magazine's, and the style used in a work of fiction may be different from that in a technical work. *Time* magazine is known for its fashion of capitalizing any occupational title. *Time* would say "On the street, Panhandler Dave Smith begged for quarters," while almost any newspaper would write "Dave Smith, a panhandler, begged for quarters." The UPI stylebook, which follows *Webster's New World Dictionary* on nearly all spellings, makes an exception by favoring "rock 'n' roll" over "rock-and-roll." These examples show that many style decisions are individual and have no inherent correctness.

A style sheet is particularly important for corporate publications. Companies invariably have unique terms and abbreviations that re-

quire idiosyncratic style choices. For example, is the hospital's new facility the Magnetic Resonance Center, the MRC, the M.R.C., or the M.R. center? Business publications are notorious for suspending rules of style in an attempt to add greater glory to the company's products or services. Be watchful of excessive capitalization or other overzealous typographical treatments.

Style sheets are always evolving documents, because they treat style points that arise in the course of writing and editing. A computer magazine, for example, might originally decide to print software commands in caps, as they are written on the screen. But as issue after issue is published, the editors see that caps are making a dark, jumbled pattern in each column of type. They're also reducing the number of characters per line, requiring more hyphenation or poorer word spacing, and generally compromising the typography of the magazine. Wisely, the editors change to small caps to show program commands. Someday, when computer interfaces change a bit, the editors may need to use a new convention to distinguish commands, such as a different typeface altogether.

Style log

When working on a book manuscript, copy editors should construct a style log to record the decisions made throughout the text. There is nothing more agonizing than deciding, as of chapter twelve, that *U.S.* should be written as *US*. For terms that are particularly likely to be reviewed and changed, the copy editor records the usage and the page numbers of the manuscript where they arise. This facilitates correction and also serves as a memory aid to the copy editor who may be working on several projects with differing styles simultaneously.

Though this procedure is obviously necessary for copy editing a book, it may appear excessive for work on a shorter manuscript. The concept is valuable for any copy editing project. When a copy editor doesn't keep the style log on paper, he's implicitly keeping it in his memory. It's always better to trust a log than a recollection.

Copy editing may take place before or after substantive editing. It's usually helpful to copy edit first, so that mechanical problems don't clutter the manuscript. Editing for content includes rewriting, revising the organization of material, and structuring the manuscript for a specific audience and application. After substantive editing and fact checking, the manuscript is ready for copy fitting and markup.

J	K	L
judgment (no e)		letterforms letterpress letterspace (1 word) logotype lowercase
M markup (n) medieval	N neoclassical non nonjustified nonprinting	O on = line off = line
P pseudo pseudojustification pseudo italics paste = up (n) proofread PostScript (1 word)	Q/R	S subhead
T typeface type foundry typecast	U/V uppercase	W/X word space (2 words) x = height (lc roman)
Y/Z	PUNCTUATION series comma lc after colon periods after initials	

An excerpt from the style log for this book. Note that letterspacing *is a single word, but* word spacing *is two. Style points like this are logged as the copy editor encounters usage in the text.*

Proofreading

Proofreading is a little like driving a car cross-country: there isn't much to say about it, but it will still occupy a great deal of time. It's the kind of job that most people believe they can do well if they really have to (though some dislike it so much they may even admit they shouldn't be asked to try). Common sense and experience are both necessary, and, again like driving, success comes from vigilance and concentration.

Proofreading is a particular skill, and though it requires concentration, it does not consist merely of close attention. The assumption that anyone can proofread is a dangerous one. Anyone can spot a typo like "calssical" for "classical," but not everyone will pause to wonder if "Classical Greece" should be capitalized or if "classical design" should be "classic design." Those questions are properly the copy editor's, but the proofreader should also be able to contribute to the perfecting of the text. In addition, a proofreader must be able to make and interpret standard proofreader's marks, a sign language that takes experience to use well. Finally, the proofreader has to be aware of style points to keep the text in conformance. A good proofreader can be told that the house style uses the serial comma, while a novice might not even see a consistent pattern in punctuation.

Proofreading conditions

Proofreading is obviously one of those tasks that makes high demands for quiet and concentration. Perhaps as important, proofreading is best done in a single session, or in long blocks if the material itself is too lengthy to complete in one sitting. This allows you to notice inconsistencies in style. For example, if one page refers to "X-Rays" and another to "x-rays," you will be more likely to notice the variation if the prior reference is fresh in your mind.

Long, concentrated proofreading sessions are good for developing an overview of the material, but can also rob the proofreader of alertness. When concentration slips for a few minutes, a cluster of errors may be left in the galley. However, it isn't the proofreader alone who may briefly lapse—typesetters are prone to the very same intervals of inattention. Knowing this, a good proofreader always looks for typos in little flocks. And the proofreader needs to be particularly diligent here, because the act of spotting an error can easily move attention away from other mistakes.

Comparison

A proofreader compares an original manuscript with a typeset version. If you examine a galley alone, you'll only notice obvious errors, like transposed letters. Proofreaders must also check for dropped words and confirm that requested corrections have been made properly.

One of the best systems for proofreading is the reader/listener approach, in which two people proofread together. One reads aloud from the typeset galley while the other looks at the original copy, following along to see that the two versions correspond. This technique is recommended for proofreading technical material, long lists, and text with many numbers or unusual terms.

THE

TRAGEDY

OF

HAMLET

RPINCE of DENMARK.

Shakespeare's Fourth Folio, published in 1685, contains this vintage typo on the title page. Proofreading attempts to spare us these, and readers are right to offer little forgiveness.

Standard proofreading marks

delete, insert, and spacing marks

#	insert space	He sent the‿copy.
ℓ̂	insert characters	He s^nt the copy.
⌒	close up	He s⌒ent the copy.
ℐ	delete	He sent the cop̸py.
ℬ	delete and close up	He s̸ent the copy.
eq#	equalize spacing	He˅sent the˅copy.
⌷	indent 1 em	⌷ He sent the copy.
⊞	indent 2 ems	⊞ He sent the copy.
⸢	move left	⸢ He sent the copy.
⸣	move right	⸣ He sent the copy.
⌐	raise	He sent the copy.
⌎	lower	He sent the copy.
ld >	add leading	He sent the copy.

paragraph and position marks

¶	begin a paragraph	read.˅He sent the copy.
no¶	no paragraph	read.⌐ He sent the copy.
tr	transpose letters	He s^net the copy.
tr	transpose words	He/the sent/copy.

punctuation marks

⊙	period	He sent the copy⊙
⌃	comma	He sent the copy˄then
;/	semicolon	He sent the copy˄
:/	colon	First˄he sent the copy.
˅	apostrophe	It is the author˅s copy.
ˇˇ ˅˅	open and close quotes	He said,˅Send the copy.˅
!/	exclamation	Send the copy˄
?/	question mark	Did he send the copy˄

=/	hyphen	He was copy˄editing.
/-/	en dash	Copy, 17, 22, 248˄8
⌶/M	em dash	We went˄with copy.
(/)	parentheses	It˄the copy˄was sent.
[/]	brackets	He send˄sic˄the copy.
⌄3	superior figure	xy3˄
⌃2	inferior figure	H2O˄

styles of type

lc	lowercase	He sent the ¢opy.
caps	capitals	he sent the copy.
sm caps	small capitals	He sent ASCII copy.
caps & s.c.	capitals and small capitals	he sent the copy.
u & lc	upper and lowercase	he sent the copy.
rom	roman	He sent the copy.
ital	italic	He sent the copy.
bf	boldface	He sent the copy.
bf ital	boldface italic	He sent the copy.

marks of instruction

ℓ̸	delete	He sent h̸is copy.
STET	let it stand	He sent the copy.
SP	spell out	He sent (12) copies.
‖	straighten lines	‖He sent the copy. She received it today.
wf	wrong font	He sent the copy.
⊗	broken letter	He sent the copy.
her/?	query	He named her Dave.
ℓ/ℓ	multiple corrections	He sent it's cop̸py.

responses to queries

OK	correct as set	He sent 2 copies. SP/?
OK w/c	OK with corrections	He sent 2 copies. SP/?

Proofreading cautions

Be particularly careful when proofreading headlines and opening sentences. There's a tendency to glance at these before settling down with full concentration, even though a mistake here would be especially mortifying. Oddly, large headline type seems to convince proofreaders that errors would stand out nicely, but typos are no more obvious here.

In this age of computer spelling checkers, proofreaders are the last bastion against inadvertent nonsense. A spelling checker admits any genuine word, whether it's the intended one or not, and never checks that all necessary words are there. Proofreading is still necessary.

A poor speller may actually make a better proofreader than someone certain of spelling aptitude. It's always better to be skeptical than overconfident. Whatever your spelling aptitude, second-guess yourself often. The only way to be certain that a word is spelled correctly is to look it up.

Proofreaders are looking for more than typographical errors. They must also examine the quality of the typesetting, looking for bad breaks and loose lines.

Bad breaks are inappropriate hyphenation points. Computerized hyphenation will provide incorrect breaks ranging from the amusing (def-roster) to the puzzling (powert-rain) to the bizarre (le-groom) as these samples from a car ad's vocabulary demonstrate.

Loose lines are those airy rows of characters that fail to use the desired word spacing or letterspacing values. Only a proofreader can correct some of them, either by supplying a hyphenation point the typesetting program missed, rewriting the text, or overruling another standard, such as the number of consecutive hyphens.

Marking corrections

Proofreading involves two skills: catching the errors and marking the errors so that the typesetter understands what should be changed. Here are examples of the principal proofreading corrections, shown with the double-entry marking system. For every change, a mark is made at the appropriate point in text and in the right margin to signal the typesetter and confirm the intention.

take out text

Draw a line through the letters or words to be deleted, ending in the delete sign.

the long ~~and winding~~ road

add characters

Mark the spot with the pointer sign and print the new characters in the margin above a second pointer sign.

We're pleased to announce our grand opening.

transpose letters

Draw a curved line twisting through the letters and write tr in a circle in the margin.

The faster I type, the more I transpose.

transpose words

Make a U around the word to be moved from the right to the left and end the left side of the U in an arrow to show the spot the word is to occupy.

 Better to have lost and loved

add or subtract paragraph breaks

Place a paragraph sign where the new paragraph is to begin. To eliminate a paragraph break, draw a line from the end of the first paragraph to the first line of the next, and put an arrow at the end of the line. The typesetter will connect the two sentences without a paragraph break between them. This is called running in.

 ever since time began.
 Yet most people still believe that fire can't

abbreviate words or terms

Draw a line through the text that should be abbreviated and write the abbreviation in the margin. Note that you won't end this line in a deletion mark. Abbreviations are not always standard, so indicate the particular style you'd like.

20% It was a ~~twenty percent~~ increase in enrollment.

replace an abbreviation with a whole word

Circle the word or symbol you'd like to spell out in full, and write sp in a circle in the margin. The typesetter will understand the full spelling for common terms, but if the word is unfamiliar, write out the replacement in the margin.

SP We expect to open in Oct '92.

change type style or case

Circle the word and write the mark for the style or case needed in the margin.

CAP Corroborate comes from the latin word for oak.

give the typesetter instructions

Circle your instructions to indicate they're not to be set. Several proofreading marks, such as tr, are always circled to distinguish them from corrected characters.

make multiple corrections

Separate your marks in the margin with slashes.

 It was a fair cry from finished, but he still had times.

correct a mark you made by mistake

Put dots beneath the mark you'd like the typesetter to ignore and write the word "stet" in a circle in the margin. Stet means "let it stand" in Latin.

STET He double checked the work to be certain.

hedges and other shapes to leeward then caught the note, lowering it to the tenderest sob; and how the hurrying gust then plunged into the south, to be heard no more.

The marooned word at the end of the paragraph above is a widow. These are unacceptable between paragraphs, and proofreaders must watch for them and revise the copy or type specifications to eliminate them. A short line at the top of a page, called an orphan, is also unsatisfactory.

Origins of author's alterations

The many steps in print production virtually beg you to change your mind about your copy. You're offered so many opportunities to correct it that it never seems necessary to get it right the first time. Despite the many safety nets of future correction loops, an efficient editor will only give a typesetter a manuscript that's accurate and publishable from the outset. The remaining proofreading stages will be confined to correcting the errors introduced in typesetting.

An author's alteration, by definition, is a change in text as opposed to a correction in typesetting. A mistake in composition is called a PE, for printer's error. Some AAs are inevitable, since they arise to resolve problems that could not have been foreseen before composition. Eliminating widows and orphans may require such unavoidable AAs. Widows are lone words at the ends of paragraphs, and orphans are short lines at the tops of pages. Both can only be corrected when typesetting makes them visible.

Even the most professional authors are prone to rediscovering their work upon completion of typesetting. They may only notice the need to make some changes when the text is arrayed as a handsome stream of type. Words in this state tend to remind writers that the text is on its way to an audience and is about to be fixed in place permanently. That seems to be enough to inspire any author to change his mind a few times. Plan for ample correction time.

AAs may also arise because no one has devoted enough time to research or copy editing before submitting the manuscript for typesetting. The copy production staff has an incentive to keep such revisions to a minimum.

This approach is not merely a matter of honor. Corrections made later in the production cycle are more costly. Though all PEs are corrected at no charge, the changes add time to the job. And AAs have a high price tag.

The cost of AAs climbs during production. To proofread a page of copy and retype it with some changes might amount to a half hour's work. If the manuscript is electronic, the changes made at the computer might involve three or four minutes. At every stage, the proofreading will take the same amount of time, while making the corrections may take from two to ten times as long. What's worse, the corrections must be made on materials and equipment that become progressively more costly than paper and typewriters. The cost of changes in type generally doubles at each production stage. The cost of correcting an error when plates are on press is far greater, since idle press time may be included in the charge.

This logistical and economic reality has given everyone in the production process a reason to cultivate the best of intentions. To ensure that you can act on those good intentions, devote ample time to the copy editing phase of production.

Copy fitting

Copy fitting is projecting the typeset length of a given manuscript, and it's the one editing task that DTP technology might actually make obsolete. The ability to calculate the space text will occupy when set becomes a moot point when the writer himself can set it. Nevertheless, basic copy fitting skills are not outdated yet. Many fit questions are better answered by calculating than by testing. And as you'll see, there are some design strategies open to you only when you can forecast the space required by typeset text.

The term copy fitting implies that text is altered to accommodate the space available, but this is only one of three fitting tactics that the technique supports. More correctly, copy fitting is calculating the space text will occupy when typeset with a specific measure, leading, and point size. The result of that calculation will allow you to see how much you need to change any of the three boundaries: the length of text, the type specs, or the space allowed.

It's possible to project the space text will require with great precision, but simpler copy fitting calculations can be useful for rough estimates. The two systems presented here represent the range of accuracy possible. Select the method that suits the fitting question you have to answer.

Character counts

All copy fitting methods use character count as a basis for projecting typeset length. Editors and writers often think in word counts, and may even estimate typeset space for their particular publications based on words or manuscript pages. Such estimates are simplified versions of the first copy fitting method presented below and only work because the type specifications are so well known that they needn't be represented as raw numbers. (You'll see this very effect after reading about the average line fitting method.) Nevertheless, word-count based estimates are not good shortcuts for production planning on new projects. These estimates only tell you how much space the manuscript will occupy; they don't answer other interesting questions, like how small the type would have to be to make the manuscript fit a certain depth.

characters per pica

A manuscript's character count is converted to an estimate of typeset length, using the type font's particular *characters per pica* value. Even though type is proportional, such an average value works well. It represents characters as a width value and, along with the leading value to establish depth, becomes an efficient tool for estimating typeset space. Here's a sample chart of values for a few fonts.

style	8 point	9 point	10 point	11 point
Bookman	3.0	2.7	2.4	2.2
Century Old Style	3.1	2.8	2.5	2.3
ITC Garamond	3.5	3.1	2.8	2.5
Goudy	3.4	3.1	2.7	2.5
Helvetica	3.1	2.7	2.5	2.2

An italic style is somewhere between a design in its own right and a variation on a family parent. In fact, the notion of relating an italic to a roman did not arise until the 16th century, when coordinated families of capitals, small capitals, lowercase, italic, and bold types were created. Prior to these efforts, italics were discrete designs, and were always used in lowercase, with upright capitals pulled from another font.

Even within a family, an italic usually plays by different design rules than its roman counterpart. Most lefthand serifs are dropped, and many serifs are replaced by short tails. These adjustments suggest the influence of the chancery hand on italic designs, giving italics both the slope and cursive qualities of handwriting. Some italics preserve a hint of original typographic conventions by utilizing a stronger rightward slant in lowercase than in capitals; this evokes the use of a roman font for capitals. Most significant, italics generally are lighter in density and higher in contrast than their companion romans.

Though italics are immediately distinguished by their slant, a roman letter cannot easily be made into a successful italic merely by canting it to the right. Letters given a purely mechanical angle are called obliques. With digital type imaging or camera modification, such pseudo-italics are simple to produce,

This manuscript page shows the average line and the results of calculations for the characters per page. When multiplied by the number of pages, the result is the number of characters to be typeset and the basis for estimating typeset depth.

The characters per pica value is supplied by the typesetting vendor. This number varies not only with type size and typeface, but, to a certain degree, with each typesetting system's version of a font. This irregularity is generally only significant for precision copy fitting, but it's still good practice to have the vendor-specific value for the font.

When a characters per pica value isn't available, you can reckon it with reasonable accuracy yourself. Measure the length in picas of the lowercase alphabet of the size in question from a type sample book. Then divide the number 29 by the length to find the characters per pica. Though there are 26 letters in the alphabet, the thinner characters appear more frequently, making 29 a better calculation point.

The characters per pica value is multiplied by the line measure to project the number of typeset characters per line. Of course, the characters per pica for body text are such small numbers that the difference between 3.2 and 3.4 characters per pica looks trivial at first glance. But these small numbers are going to be multiplied several times: for a 21-pica measure the first value offers 67 characters per line, and the second provides 71 characters. Over a page of text, in two columns, there might be around 120 lines, and the net difference between those two values would be 480 characters, or a third of a typical manuscript page.

When calculating typeset characters per line, round the number downward. Type can be stretched more than it can be squeezed, since word space adjustments are the real tools for filling out lines. Thus a 67.8 calculation should be rendered as 67 whole characters.

To copy fit, you need a ruler, a type gauge, and a calculator, plus the manuscript itself and the characters per pica information for the fonts involved. Despite the fact that several calculations are involved, each of them leads to the next as long as you keep the central system in mind: reduce both manuscript and type to a common denominator of characters. The methods differ in the precision of character counting, but not in procedure.

average line method

useful for books, magazines

For a rough estimate, the character counting is done about the way nails are sold—you pour a few scoops of them onto a scale and pay by the pound. Nails aren't a very precious commodity, and neither are characters in this method.

- Take a page of manuscript and determine whether the typewriter is pica or elite. Pica type runs 10 characters per inch, while elite runs 12 to the inch.
- Determine the length of the average manuscript line in inches.
- Multiply the line length times 10 for pica type or 12 for elite. The result is the *average characters per line.*
- Count the *lines per page.*
- Multiply lines per page times characters per line. The result is the *average characters per page.*
- Multiply characters per page times the number of manuscript pages. The result is the rough *characters per manuscript.*

Before converting the total characters into a typeset space estimate, let's consider some of the potential flaws in the averages above. You may need to make adjustments if your manuscript will be affected by these distortions.

Extensive copy editing makes it difficult to use averages based on the typewritten manuscript. To correct for this, make some judgments about whether the dominant changes were additions or subtractions to text. Or, if necessary, perform localized character counts to develop a more precise measurement. If you are only seeking a rough estimate, a slight adjustment in the average characters per page may be enough to answer your fit questions, but remember that your estimates are primitive under these conditions.

Irregular lines per page is a typical problem. In a long manuscript, writers will often add space before section breaks. Many typists aren't consistent about top and bottom margins. Finally, copy editing has the effect of changing lines per page. To adjust for this, count the actual lines on each page and maintain a cumulative total.

Inconsistent line length was, of course, the very thing we ignored by averaging. Aside from the obvious errors introduced there, you may discover that in the course of several pages a typist will change line length a great deal. If the manuscript seems to vary widely on this point, you may need to adjust for the deviations. For example, you might develop several averages, and multiply them times the number of pages they're in effect.

Pseudojustification, surely the bane of any reader's existence, makes it impossible to determine the average line length, since all lines are artificially made equal by the word processor's calculations. Most microjustification routines can only add space between words, not reduce it. Therefore, the outer margin will always have the greatest possible number of characters, but not the average. Select your average line based on how tight the pseudojustification appears, moving inward from the right margin.

With the manuscript's character count in hand, we turn to the calculations for type specifications.

- Obtain the characters per pica value for the font in question and multiply it by the line measure. The result is the *typeset characters per line*.
- With a type gauge or the designer's specs, determine the number of lines per column. This number is based on the leading, not the point size.
- Multiply typeset characters per line by the number of lines per column. The result is *typeset characters per column*.
- Multiply the typeset characters per column times the number of columns per page. The result is typeset characters per page.
- Divide the characters in the manuscript by the typeset characters per page. The result is the *number of typeset pages*.

manuscript calculations

typewriter	pica, 10 characters/inch
average line	6.1"
characters/line	6.1 x 10 = 61
lines/page	26
characters/page	26 x 61 = 1586
total pages	538
total characters	853,268

typeset calculations

characters/pica	2.5 (10 pt Century OS)
line length	21.5
characters/line	21.5 x 2.5 = 54
lines/page	36 (one column format)
characters/page	36 x 54 = 1944
pages required	853,268 / 1944 = 439

This chart summarizes the calculations used on the sample copy shown on the facing page.

three shortcuts

When working with a standard typeset format on magazines, news-letters, or other items with consistent typesetting specifications, the entire second half of the copy fitting calculation consists of a single reckoning. Since the typeset characters per page are consistent, the manuscript character count is simply divided by a standard value.

Newspaper and magazine editors may use a simplified copy fitting calculation based on word count as a coarse guide. Most word processing programs can count words. Unless your copy is highly technical, it probably averages five or six characters per word. Examine a few lines to see. When in doubt, round upward, for you also need to account for word spaces and punctuation. Then multiply the word count by, say, 6 to obtain a character count.

The handiest shortcut of all takes the burden off the copy editor and puts it on the typewriter itself. If you establish a standard margin for typewritten copy, you can make text virtually count itself. A magazine with a three-column format might typeset 40 characters per line. If all contributors set their margins at 40 characters, the copy editor need only count the lines, which will be the same typeset or typewritten.

vertical line method

useful for brochures, newsletters, advertising

If we were buying nails before, now we're purchasing caviar—we might pay by the pound, but we certainly make our measurement accurate to the ounce. To make an accurate copy fitting estimate, you need to count the actual characters and account for the short lines at the ends of paragraphs. There's a special kind of tedium to this method, since you will examine every line of the manuscript.

- Draw a vertical line on each manuscript page representing the length of the average line. The line must be perpendicular to the typewritten text. Count the characters in it and remember your choice; this is your *base characters per line.*
- Beside each line, note the number of characters short or long of the vertical line. When the line equals the average, make no mark.
- Reckon each *characters per paragraph* subtotal:
- Multiply the base characters per line by the number of full lines in the paragraph.
- Add or subtract the net characters long or short of the vertical line.
- Add the characters comprising the final short line of the paragraph.
- Add all your paragraph subtotals for a grand total of *characters per manuscript.*

The conversion to a typeset characters estimate is the same as the average line method. Now let's consider the inaccuracies possible in even this conscientious approach. Adjust for these problems if your manuscript has such symptoms.

Excessive initial indents can distort the calculation. If the typist indented more than three or four characters, you have some additional

```
You must be sure of two things: you must    5
love your work, and not be always looking over  6
the edge it, wanting your play to begin. And  4
the other is, you must not be ashamed of your  5
work and think it would be more honorable to  4
you to be doing something else. You must have  5
a pride in your own work and in learning to do  6
it well, and not be always saying there's this  6
and there's that -- if I had this or that to  4
do, I might make something of it.    -7
```

$$\begin{array}{r}45\\ 7\\\hline 38\end{array}$$

$$10 \times 40 = \dfrac{400}{\begin{array}{r}38\\\hline 438\end{array}}$$

The vertical line copy fitting method requires a line-by-line character count, and is much more accurate than the average line system. The base characters per line times the number of lines is summed with the characters over or under the base for a precise total.

shortfall to subtract for initial lines of paragraphs. Or, if your typesetting spec uses a dramatically deep indent, you may need to account for it by padding the character count for first lines. For reference, a 4-character typewriter indent roughly equals a 2-em typeset indent in text sizes.

All copy editing foils the character counter unless you specifically count the true, edited line in question. If the manuscript has a great deal of editing, you will need to make extensive line-by-line adjustments to your character count.

Line-ending hyphens in the manuscript shouldn't be counted, since they don't represent final hyphenation points.

Text with numerous capitals will not be accurately reflected in the final space estimate because the characters per pica value was based on a lowercase alphabet. It is unlikely that this will mislead you except in extremely tight copy fitting work.

Typeset paragraph-ending lines aren't accounted for. In going to such an effort to keep the manuscript's short lines from distorting the total, we've ignored the fact that typeset text isn't packed into consistent lines either. This problem becomes more severe for long line measures, where much space is lost on paragraph-ending lines.

a shortcut

After you've determined the number of typeset characters per line, you might want to use that value to establish your vertical line. Since you have to count characters over the vertical line, why not make the measure itself equal a typeset line? The individual counts of short and long characters can be summed and rendered as additional lines. Since every manuscript line is counted, you'll need to subtract the shortfall on paragraph-ending lines: count the blank spaces and debit the total. The lines in the manuscript are already equivalent to typeset lines, so no additional math is necessary. Here's an example:

manuscript calculations

total characters	438

typeset calculations

characters/pica	3.1 (8-pt Helvetica)
line length	13 picas
characters/line	13 x 3.1 = 40
lines required	438 ÷ 40 = 10.95 = 11 lines

This chart summarizes the calculations used in the vertical line copy fitting example shown on the facing page.

```
It is often simply from want of the creative       6

spirit that we do not go to the full extent of     8

suffering. And the most terrible reality           2

brings us, with our suffering, the joy of a        5

great discovery, because it merely gives a new     8

and clear form to what we have long been ru-       5
                                                  ──
minating without suspecting it.    -7              34
                                                   -7
                                                  ──
                                                   27
```

GARAMOND
14/16 X 20
1.9 CHAR/PICA
X 20 = 38 CHAR/LINE

7 LINES
+ 27 CHAR
────────
8 LINES

Other copy fitting problems and solutions

You probably recognized that we multiplied the manuscript measurements over and over to get to the smallest increment and then made a series of divisions to project typeset space. This procedure is involved in all copy fitting systems. But what if the question we want to answer is a little different? Here are some other applications for the technique.

solving for text length

Writing to fit is a subtle skill, but the writer's specific constraints can be determined very easily. When the space and type specs are both known, the project is straightforward.

Determine the typeset characters per line and then the available lines. You might have to measure the available depth in picas and convert that value to points by multiplying by 12. Then divide that total by the leading value desired. Round downward if a fraction results. Then multiply the characters per line by the lines in the layout to obtain the total characters. The author can write to this character count for an accurate fit. If necessary, you might render the character count as a word count to help the writer visualize the space. Divide the character count by 5.5 for a general estimate of words.

solving for type spec

When the manuscript length and available typesetting space are fixed, we can adjust the type spec to fit the text to the space. The manuscript character counting procedure is the same, but then we jump to the type calculations and work them in reverse. We need to make an initial assumption about leading, but we can redo the problem if we don't like the results based on that starting point.

Copy fitting summary

calculating number of typeset lines

used in order to project space manuscript will occupy
known: manuscript size, type specification

$$\text{total lines} = \frac{\text{total manuscript characters}}{(\text{characters/pica x line measure})}$$

calculating manuscript characters

used in order to write to fit
known: type specification, space available

$$\text{total characters} = \text{char/pica x line measure x} \frac{\text{depth of type area}}{\text{leading}}$$

calculating type size

used in order to fit fixed manuscript in fixed space
known: manuscript size, space available

$$\text{char/pica} = \left(\frac{\text{manuscript characters}}{(\text{depth in points / leading})} \right) \div \text{line measure}$$

With the leading determined, we can work out the number of lines available in the typeset area. This number is a fixed boundary. When we divide the manuscript characters by the number of lines, we'll get a value for characters per line. Divided by the line measure, we'll have the acceptable characters per pica value revealed. If the type style has been chosen, you'll simply look for the point size that matches. If you can select any font, you may lean on condensed or expanded type, if appropriate, to achieve the fit.

When working out such a problem, your first effort may produce a characters per pica value that doesn't suit the leading on which you based the example. Use trial and error to balance your leading assumption with an acceptable point size.

fitting headline type

If a newspaper editor wanted to win a bet with a layman, he might wager he could project to the eighth-inch the space any headline will occupy when typeset. If he was any kind of editor, he'd win the bet after a glance at the text in question. This ability owes something to experience, but it's also the product of familiarity with a headline schedule.

For each typeface and size used in headlines, copy editors make up headline schedules to project the width of typeset text. The schedule will account for the set size and the typesetting parameter of flush, centered, or justified. To fit headlines, character counts don't forecast results well. Since few characters appear in a line, a monospaced typewriter is a poor prophet of typeset results. A headline schedule treats the width distinctions in typography by distinguishing thin characters from fat ones.

The true unit system as used in composition systems provides for subtle width differentiations, but we'll be content with a cruder version here. We'll make four categories for width: thin, normal, wide, and huge. For each font, we assign each character a width unit, usually along these lines:

thin / half unit

I J i l f t and often j and r in some fonts
. , : ; " ' ! * () - + / \ and all word spaces

normal / one unit

a b c d e g h k n o p q r s u v x y z
$ % @ ? &

wide / one and one-half units

m w 2 3 4 5 6 7 8 9
A B C D E F G H K L N O P Q R S T U V X Y Z

huge / two units

M W sometimes Q

Examine your specific type font to make adjustments in these values. Some fonts are quite uniform in width and some more extreme than this four-way system can serve. With a condensed style, for example, you might designate only two different width values.

Men and Women both like Ike

Men and Women both like Ike

The demonstration above shows why character counts are little help in fitting headline type. In the typeset version at top, the first line is much longer than the second, but as typewritten they're identical. You fit headline type with a schedule of character widths, letter by letter.

Here's a headline with character units marked based on the sample schedule shown on the previous page. The total is 28 units; for publications with a standard headline allotment of 26 to 30 units, this copy will fit on one line. The units available to you reflect your type size and style, and you must establish the total by setting and counting some dummy headlines.

Next, you'll typeset some dummy headlines to learn the total number of units available in your standard column widths. It doesn't matter which characters you use in the sample to accumulate units; only the grand total is important. The effort you invest in creating a headline schedule is well rewarded if your publication uses consistent headline treatments.

Copy fitting runarounds

A runaround, in which art is mortised into a type area, presents a special copy fitting problem. Sometimes you'll have the opportunity to adjust both type specifications and art size. Invariably, you'll need to set some values, if only on a trial basis, in order to solve fitting questions. In effect, the art size is a second space variable, so we have a total of four with which to work: manuscript size, typeset area, typeset area occupied by art, and type specification.

To copy fit a runaround, you'll divide the typeset area into two different spaces, each with its own line measure and depth. As well as determining how much the art reduces the line measure, you'll find the number of typeset lines affected. Remember to include the gutters around the art—top, bottom, and sides. Sometimes the hardest part about calculating a runaround is finding the line at which the line measure changes. You may need to make an accurate dummy, showing the position of the art within the typeset column against the leading.

You can calculate the characters that will fit in the overall space just as you do any typeset area. Then you'll determine the characters per line and total lines that are squeezed out by the art, and subtract this amount from the total.

In this example, type will run around the contour of the spoon. To determine type size and leading, calculate the characters that will fit in the rectangle defined by line measure and typeset depth, and then subtract the characters that would occupy the shaded area around the spoon. You calculate both rectangles as you would in conventional copy fitting, multiplying the type characters per pica value by the line measure, and multiplying the resulting characters per line by the number of lines your leading permits. In this example, the total is A x B, less C x D.

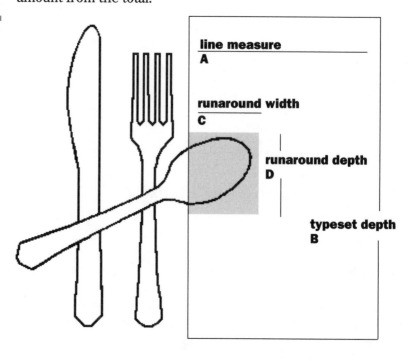

line measure
A

runaround width
C

runaround depth
D

typeset depth
B

Markup

The typesetting instructions written on a manuscript are called markup, and the job of determining them falls to anyone from editor to designer to typesetting operator. There are eight variables in a typesetting specification, and at least five of them must be stated in the markup. The other three have logical default choices and are noted when the defaults are incorrect. The eight items are:

type size	described in points
leading	described in points
line measure	described in picas
type family	such as Garamond or Helvetica
typesetting mode	such as justified or flush left
type font	such as condensed or roman
type style	such as bold or italic
letter style	such as all caps or upper- and lowercase

The last three of these are usually only noted when the obvious norm of a roman font in upper- and lowercase is unwanted. A complete type specification might read:

10/12 bold condensed Univers x 13 picas, U&lc, rag right

There are four common ways of writing the key elements of a type specification, and all are equally clear to typesetters:

$$\frac{8/10 \text{ Optima}}{21} \quad \frac{8 \text{ OPT}}{10 \quad 21} \quad \frac{8/10 \times 21}{\text{Optima}} \quad 8/10 \text{ OPT} \times 20$$

In two of the examples, the type family name was abbreviated, and obviously such shorthand requires advance agreement between you and your typesetter. There are no universal abbreviations for type names, and to complicate matters, many fonts travel under more than one name. For example, the markup above would confuse some typesetters, because Compugraphic uses the name Oracle for its version of Optima, while Varityper calls the same face Chelmsford.

Most typesetters are familiar with the aliases for the fonts they have available, but this name gambit continues to cause confusion. For example, here are the current names for the Melior family: Hanover (Varityper), Ballardvale (Autologic), Mallard (Compugraphic), ME (Itek), Medallion (Harris), Melior (Berthold, Mergenthaler), Uranus (Alphatype), and Ventura (Wang).

A markup editor also states the size of indents at each paragraph. Most typesetters want a value in ems, but some DTP software only copes with absolute dimensions given in points and picas. Finally, the markup editor should note the treatment of paragraphs in general. Among the possible variables are extra leading between paragraphs, hanging indents, and flush paragraphs without indents. The typesetting style for paragraphs is often not evident from manuscript which may have double-spaces between paragraphs purely for clarity.

Markup may also include identifying the final location of a typeset

typesetting specifications

mode specification	copy marking
justified	just.
ragged right	RR
ragged left	RL
centered	CTR
staggered	stagger

position specification	sample marking
runaround	indent R 5 picas, 8 lines
indent left	indent L 2 ems
indent right	indent R 3 ems
indent both sides	indent L&R 1 em
hanging indent	outdent 1 ½em
indent paragraph	1 em
drop cap, contour	3-line cap, 36 pt
drop cap, indent	4-line cap, 48 pt
up cap	36 point up cap
flush left	FL or /—
flush right	FR or —/
quad center	ctr or /—/

The chart above shows typesetting mode specifications and the abbreviations used to mark copy. Sample markings for position specifications will give you an idea of how to mark up copy.

item. Each galley for a publication includes a header that helps the proofreaders and paste-up artists move the story through to the proper page, department, issue, and position. The markup editor supplies these details so the story is aimed in the right direction from the start.

Newspaper editors give each story a slug, or one-word title, to identify it through the production process. With computerized typesetting and page makeup, the slugs have gotten even shorter, now limited to the eight characters of a computer file name. Outside of publishing, an advertising agency may want the galley to identify a client, campaign, or the publication in which the ad is to appear.

After the overall specifications are given, the markup editor plunges into the manuscript to mark all the points where typographic changes and flourishes are needed.

The most dreaded task in markup is planning tabular matter. To examine typescript text and estimate the width required for different columns of typeset characters is often very difficult. Tabs are given in points and picas, and woe to the markup editor who doesn't keep a scratch pad handy to log in the anticipated starting and ending points of the columns. Tab specifications also include defining each tabular column as right-, left-, center-, or decimal-aligning, and calling for leader characters if necessary.

The localized font changes within a manuscript are sometimes clear without additional markup. Almost all typesetting operators read an underline as an instruction to switch to italic. In fact, it's generally cumbersome to add the redundant mark in the margin. However, check with your typesetter before assuming anything. Some will dutifully provide underlined type, following your manuscript to the letter, while others will interpret your intentions as italics.

The markup editor will need to mark bold face and other font changes. He'll also decide whether a phrase in caps in the manuscript should be set in small caps, upper- and lowercase, or true caps. Finally, he'll need to mark all the particular specifications for captions, subheads, footnotes, and all the other special material in the manuscript.

There is a useful shortcut for the markup of particular text elements. For a long manuscript, you might compile the specifications for footnotes, captions, headlines, subheads, and so forth in one master list of specs. Then, assign each text element a letter code. Use this code letter before each element in the manuscript to define it and link it to the master style list. An uncluttered manuscript would have, perhaps, nothing but an *A* in front of each headline, and nothing but a *G* beside each caption.

Electronic markup

Typesetting codes can be embedded in an electronic manuscript and, with the proper translation routine, they can call for font changes and a host of other typesetting commands. In essence, markup need not be penciling in the type specifications, but can even include typing in the commands to achieve the specs.

Let's take a DTP example to examine the process. Many DTP programs include a feature called style sheets. These style sheets are collections of typesetting commands stored under a descriptive name.

Headline might represent the several specifications common to a headline, such as font, point size, leading, and typesetting mode.

A markup editor (who can easily be the editor or writer as well) can type the word *headline* inside angle brackets in an electronic manuscript. This bracketed name will summon the style sheet's stored commands and the text following the command will take on the desired characteristics. Generally, a hard return is used to signal the end of affected text.

In the DTP program itself, the user stores the specifications for all the named styles and also defines the default or body text style. The specifications include all the regular markup elements and may go on to define tabular positions and other fine points. The DTP software includes a provision for copying a style sheet from publication to publication so that one set of specifications can be used consistently for many projects.

One of the great advantages of style sheets is that they permit an editor to define a phrase as a headline and allow a designer to define what a headline should look like in a subsequent stage of production. Any time you wish to change all headlines from Goudy to Garamond, you simply update the style sheet and watch the change go into effect.

But a more significant advantage is the expansion of the editor's role in the composition process. Instead of engaging someone to read a manuscript a second time in order to mark it up, the editor can release the text with overall type specifications plus the situational markup necessary for subheads, captions, and so forth. Of course, this does add to the editor's responsibilities, but a style sheet frees an editor from learning detailed typographic terminology and allows him to use logical names for the type of material at hand.

Electronic markup is only one of several tasks that the computer has altered or assisted. Copy handling, overall, has changed a good deal since manuscripts have become electronic.

Copy handling

Copy handling issues arise because almost all publishing endeavors involve a group of people who contribute to a manuscript. Though each situation is specific, there are some general principles of copy handling that anyone from an ad copywriter to a typesetter must observe. The two central concerns are maintenance of the production schedule and control of the correction cycle.

Copy production schedule

Since most schedules are founded on the time tasks ought to occupy, it's worth reflecting on the conditions that will corrupt such a schedule. Whenever a long chain of tasks is involved, a scheduler runs the risk of allocating time based on ideal circumstances. Though it may be unusual for all jobs to be completed on time, many schedules presume that good fortune will favor the venture. And the more stages in a schedule, the more catastrophic it can be when an early one is delayed.

Production of standard, ongoing projects is easier to schedule than other work, even when the time available may be shorter. For example, work on a weekly magazine is likely to proceed much more smoothly

than on a monthly, and the staff of some quarterly magazines almost find themselves reinventing their work from scratch each issue. In fact, the more frequently a task is performed, the more likely it will stay on schedule because the scheduled time will accurately fit it. If you work on a daily newspaper, you need not ask what to do next, but if your project is completed over a long span, you'll need to rely on a schedule in order to see what's expected of you. The schedule must be a helpful and accurate guide.

Common scheduling errors

When drawing up a schedule in the serene state of planning a job, one can't help feeling confident that the project will go like clockwork. To fuel that atmosphere of optimism, there's a tendency to identify either too many or too few stages on a production schedule.

A scheduler who notes too many stages anticipates more effort for monitoring progress than people are likely to spend. It does no good to identify numerous completion points if no one is there to acknowledge them. Or, if such a schedule is followed, it demands more time accounting for the work than is necessary. The converse mistake leads to missed deadlines because it leaves too many steps unsupervised. A phase of the project may slip through the cracks, falling further and further behind schedule, eventually making the entire endeavor late.

The scheduler will want to consider the use of the schedule as much as the dates themselves. It's important to anticipate the means of updating it, logging in progress, and sharing the information with others involved. For example, a schedule can be posted on a computer network. This allows constant access and constant updating, but unfortunately it doesn't require it. A superior system would use a network and would automatically log, say, the time a page makeup file was closed or a word processing file was sent to an editor.

A schedule must include correction loops at several production stages. Sometimes, it must be honest enough about matters to show two or three correction loops, even though only one is theoretically necessary at certain points.

In the end, schedules often fail to help the copy processing system because they represent what someone thinks ought to happen instead of projecting the likely way it will happen. A good schedule is one that can be kept, not one that proves everyone in the enterprise misses deadlines. Finally, an honest schedule includes time for quality to emerge. Not getting something right the first time is only a problem when there is no second chance. If you consider the printed communication as the real reason for the schedule, you'll build in time for that second chance. The results will be worth it.

Typesetting

MACHINES EXIST; let us then exploit them to create beauty—a modern beauty, while we are about it. For we live in the twentieth century; let us frankly admit it and not pretend that we live in the fifteenth.

The work of backward-looking hand-printers may be excellent in its way; but its way is not the contemporary way. Their books are often beautiful, but with a borrowed beauty expressive of nothing in the world in which we happen to live.

Aldous Huxley
Printing of To-day
1928

Both conceptually and mechanically, a typesetting machine is the personification of the movable aspect of movable type. When type was set by hand, each discrete character was located, arranged in a line, composed in a page, and finally returned to storage when the job was printed. The efforts to automate this process reveal not only ingenuity, but also the significance of quickly disseminating printed information in society.

When you recall that typesetting is always a customized service, unique to the content and job specifications at hand, you'll appreciate the impulse to speed it up. To print each day's *Congressional Record*, for example, involves transcription and typesetting at a brutal pace. The singular nature of each typesetting job motivates inventors to hasten the process, but it also severely restricts automation. Typesetting involves the arrangement of proportional characters in a variety of sizes and positions, but fundamentally, typesetting is the resolution of line endings. How can we direct such a situational process in advance? As you'll see, even before computers could help with the calculations, machines accepted some of the tedious duties of typesetting, but it has been particularly difficult to program computers to make perfect line ending decisions.

This chapter will acquaint you with the essentials of typesetting as a system for executing line endings with hyphenation and justification. Whether you're proofreading type, setting it yourself, or using desktop publishing tools, you need to know how that silent box of type masters and electronics goes about filling out lines with characters. Typesetting has been very much automated now, so much so that an ill-informed user has virtually no control over it. Read about hyphenation and justification in order to judge the merits of specific equipment, evaluate each galley aesthetically, and set the typesetting parameters for your work with a clear understanding of the effects they'll produce. Several aesthetic and quality issues are bound up in the mechanics of typesetting, and that means a typographer must know the tools well.

The unit system

The act of measuring implies that a ruler exists somewhere to set the scale. When the point of reference is a physical scale, the measurement system is an absolute one. Values like points and picas are absolute, and simply by changing the ruler we have in mind, they can be converted into inches, or one into the other.

For a machine to produce set type, however, there is a need for a system of measurement that is relative instead of physically absolute. Typesetting measurements must be made relative to the type size. The space between two words, for example, should be in proportion to character size. In addition, the characters in a font will differ in set width and therefore must be measured individually. To serve the proportional characters of set type and to allocate space between letters and words, typesetting machines use a relative measurement called the unit system.

Units are values with a strict relationship to type design and an ever-changing relationship to inches or points. We could say that an 18-point Bookman *A* is 10 points wide, a 60-point *A* is 32 points wide, and so forth, but all our typesetting calculations would require retrieval of these myriad values. If all Bookman *A*s had a fixed value, and the value represented the design shape of the *A* rather than its space, the mathematics of typesetting would be vastly simplified. In the end, the one thing we really know about the Bookman *A* is that it's about twice as wide as the *J* and three times wider than the *t*. These proportional relationships within the font design are constant and form the core of the measuring calculations in typesetting.

To imagine the unit system in action, consider the specific calculations a typesetting machine performs. As the operator keys in letters, the machine keeps a cumulative count of the character widths. These widths differ, character by character. When the sum approaches the total width available in the line measure, the machine must end the line and begin the next. The unit system allows a typesetting machine to accumulate totals in units through simple addition.

Adding up the widths is only the first stage of composition. If the copy is to be justified, the machine must not only count but also supply even spaces between letters and words to fill out a line measure exactly. Adjusting word spacing is the principal technique for filling a line, but we want the changes to be subtle. To maintain uniformity, we have to use spatial increments that are extremely thin and much beyond the capacity of the eye to discern. And that, after all, is the point: we want each justified line to appear uniformly spaced, even though the number of characters on one line may be much greater than that on the next.

We also want to preserve the smallest distinctions between individual characters. There's going to be a slight distortion of the type

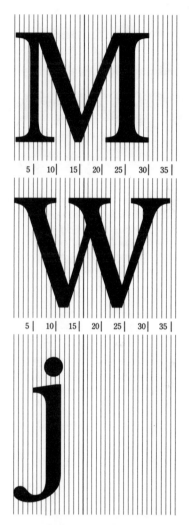

The superimposed grid helps you see the relative unit widths of Bookman. This example shows a 36-unit system, in which the M is 30 units wide, the W 35, and the lower case j only 11½. A character also includes some built-in space on the left and right to ensure proper fit. These spaces are called the side bearings.

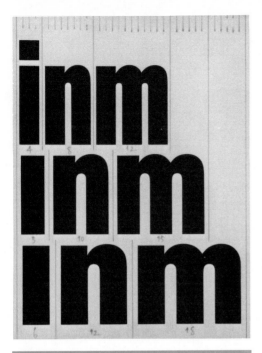

The impact of the unit system on font design is easily seen in these working drawings for Helvetica bold compressed, bold condensed, and bold. The i changes from 4 units, to 5 units, to 6 units, the smallest possible distinction.

design if a *g* must be twice as wide as a *t* instead of 1.8 times as wide. In other words, the thinner the unit space, the more precisely we can position type and maintain the integrity of the type design.

Typesetting machine manufacturers determine a unit value for their equipment that affects the type masters and all the positional controls in the typesetting process. Many machines use 18 units to the em, but higher quality equipment uses 36 or 54 units to the em. For the finest typesetting, there is equipment using 100 and 144 units to the em. The em, of course, is also a relative value that works in harness with the unit system.

To use a particular typeface in a computerized typesetting machine, the system stores the unit widths of all the characters in memory. Any typesetting terminal with calculating ability and access to the width table can calculate line endings. Terminals without calculating software merely store keystrokes and are called dumb terminals; the others are called counting terminals and can perform hyphenation and justification. By the way, desktop publishing is based on using microcomputers as counting terminals, capable of justifying lines.

Justification

A column of type with uniform left and right margins is called justified. Each line is exactly the same width, with subtle adjustments in word spacing made to fill out the measure. This is such a typesetting norm that one must be reminded that there are alternatives in ragged or centered modes. Justification, in fact, seems synonymous with typesetting to those new to the field. Typesetting, specifically, involves making the calculations that permit justifying lines, but these same calculations are used for centered or ragged settings as well.

The copy at right is justified, and at far right is ragged right. A nonjustified setting always requires more depth.

Between this half-wooded and half-naked hill, and the vague still horizon that its summit indistinctly commanded, was a mysterious sheet of fathomless shade—the sounds from which suggested that what it concealed bore some reduced resemblance to features here. The thin grasses, more or less coating the hill, were touched by the wind in breezes of differing powers, and almost of differing natures—one rubbing the blades heavily, another raking them piercingly, another brushing them like a soft broom. The instinctive act of humankind was to stand and listen, and learn how the trees on the right and the trees on the left wailed or chaunted to each other in the regular antiphonies of a cathedral choir; how hedges and other shapes to leeward then caught the note, lowering it to the tenderest sob; and how the hurrying gust then plunged into the south, to be heard no more.

Between this half-wooded and half-naked hill, and the vague still horizon that its summit indistinctly commanded, was a mysterious sheet of fathomless shade—the sounds from which suggested that what it concealed bore some reduced resemblance to features here. The thin grasses, more or less coating the hill, were touched by the wind in breezes of differing powers, and almost of differing natures—one rubbing the blades heavily, another raking them piercingly, another brushing them like a soft broom. The instinctive act of humankind was to stand and listen, and learn how the trees on the right and the trees on the left wailed or chaunted to each other in the regular antiphonies of a cathedral choir; how hedges and other shapes to leeward then caught the note, lowering it to the tenderest sob; and how the hurrying gust then plunged into the south, to be heard no more.

Though there are many tasks that now appear daunting without a computer's support, typesetting certainly seems more difficult than most. To understand justification, you'll want to consider what it was like, before the computer age, to compose foundry type, line by line, with only your eye to judge the results. Though we now consider justification as a process of calculation, think back to the stage when it was trial and error.

Each line of type at a particular measure contains a variable number of characters, since type is designed with different widths for different letter shapes. In contrast, to justify type on a pica typewriter, with a fixed type width of ten characters per inch, is reasonably simple. If you use a 7-inch-wide line measure, you're always asking for 70 characters or word spaces per line.

Type is not as simple to distribute evenly. To compose foundry type, you hold a composing stick and insert the characters one by one. With the line measure marked as a stop on the stick, you fill each line toward that barrier and then make a decision about ending the line with a word or a hyphenated syllable. Because you're looking at the line as set so far and can examine the text to come, you can decide whether the best break will come from spacing the line out further or contracting the space distributed between words already in the stick.

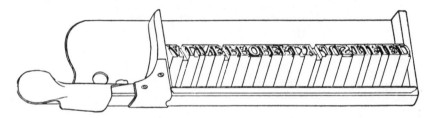

A composing stick with one line typeset. The compositor inserts letters upside down, running left to right.

Between each word you've placed a nonprinting character that's one-third of an em, and usually called a 3-em space. If the line looks just a little short, you'll add thin spacers to each word space. If it's running over the measure, you can replace some or all of the 3-em spaces with smaller increments. Note that you may have to make several tries to fill out the line perfectly, adjusting the word spaces as evenly as your patience and skill permit. You make the decision about how best to end the line without actually calculating with widths of characters but by observing the results and gauging the consequences of the several choices open to you.

Making the line-ending decisions required to justify type is a task in between pure calculation and analysis. People can do it based on judgment when the calculating element is handled implicitly by trial and error. (You could not determine a line break by imagining how the characters would fit or by counting their widths in your head; you must rely on seeing them fall in the composing stick.) A computer can perform the task by straight calculation when the analytical element is handled by logical rules that govern the selection of possible choices.

Computerized typesetting machines approach justification with ideal calculating abilities and somewhat flawed analytical talents. They are perfect at determining when a line-ending decision is due, reasonably skilled at detecting all the possible choices, and occasionally poor

Justification by computer calculation

The calculation component of the justification process itself plays to the computer's strengths. Each font has a table of widths, which the operator loads into the computer's memory. These widths are relative values in the unit system for each letter in the font. The typesetting machine converts the current typesetting parameters into units as well, and then proceeds to count off the characters that begin to fill a line.

Specifically, the machine determines the maximum number of units that will fit on a line and then keeps a cumulative total of character widths. When that cumulative total nears the maximum value for the line, a line ending decision is due. The typesetting machine has no doubt calculated the need for this decision accurately, but it may not fare as well in making the line-ending choice.

The number of units differs by point size and font. Here are two examples of what a measure of 22 picas contains in an 18-unit system:

22 picas
240 points (picas x 12)
393 units ([points / type size] x 18) in 11 point
540 units ([points / type size] x 18) in 8 point

The specifics of the justification calculation involve five steps.

1) Calculate the points in the line measure

22 picas = 264 points (22 x 12)

2) Calculate the ems per line

11-point type = 24 ems per line (264/11)

The ems per line value computation makes use of the fact that the em of any type size is a square, as high as the point size and also as wide. This allows us to convert a height measurement (points) into a width measurement.

3) Calculate the machine-specific units per line

18-unit system = 18 units / em
24 ems per line x 18 units per em = 432 units per line

Each typesetting system has a specific unit system on which its type font unit calculations are based. The predominant systems are 18, 36, and 54 units to the em. In this step, the computer is multiplying a variable (based on line measure) times a constant (the machine-specific units per em value). Results are always rounded up, never down.

4) Count in the units of the characters typed, using the width table values

The sample text below has been counted with the unit values for Garamond.

The computer keeps a running tab of units remaining by progressively subtracting each width value as the character is keyed in. The operator can see a "line measure remaining" value on the screen on most systems.

5) Expand or contract the word spaces to fill the measure

available units in line	= 432
actual units in text	= 427
units short	= 5
word spaces	= 9
excess word space	= 5 / 9 = .55 units
adjusted word space	= 6 + .55 = 6.55 units

In an 18-unit system, a 3-em space is 6 units (18/3). Each word space receives an additional half unit to fill out the line in this example. If the line were overset, the word spaces would be reduced by the excess amount divided evenly among them.

These basic steps govern the calculating process for justification, while a hyphenation routine generally is engaged for determining the word or syllable on which the calculation in the last step is based. The calculation is perfectly handled by computer, but the hyphenation process requires a bit more judgment than the mathematical algorithms can provide. As an alternative, some composition programs hyphenate by dictionary lookup, the retrieval of acceptable hyphenation points from a list of words, prefixes, and suffixes.

Only connect! That was the whole of her sermon. Only
14 10 4 8 6 8 10 10 10 9 8 5 4 6 10 10 8 5 6 13 8 7 6 5 10 9 6 13 10 10 4 9 6 10 5 6 10 9 6 6 7 9 6 10 10 10 4 6 14 10 4 8

total units: 427

at choosing one of them. Of course, they are flawless in calculating the expansion or contraction in word spaces necessary to fill lines. Since type is no longer a collection of unyielding metal elements, it can be positioned now with phenomenal precision, dependent on the mechanics and optics of the type imaging system. Thus, not only are the calculations more precise, the space between words and letters is fastidiously allocated as well.

However, it's the point when machine logic must take over that concerns us. Computers are well suited to calculating tasks, but when the machines are asked to take an action based on these calculations, the final decision is difficult to program through uniform rules. Specifically, a typesetting machine counts the widths of characters as they form a line and adds the total until the sum reaches a value called the justification range. That number is derived from the line measure and parameters the operator sets. When the accumulated characters fall into the justification range, the composition system attempts to end the line by one of four methods:

breaking the line at an allowed point

The composition program looks for a permissible break, such as a word space or hyphen. The hyphenation program supplies hyphens, operating under some limits for, among other things, the number of consecutively hyphenated lines.

An unassuming young man was travelling, in midsummer, from his native city of Hamburg to Davos-Platz in the

adjusting the amount of space between words

Though a 3-em word space might be our target, the composition program must have latitude to adjust word space to fill out each line.

Hans Castorp sat alone in his little grey-upholstered compartment, with his alligator-skin hand-bag, a

adjusting the amount of space between letters

Changing letterspacing is always a last resort, but if word space adjustments are inadequate, the letterspacing can be expanded or contracted to justify the line.

Two days travel separated the youth — he was still too young to have thrust his roots down firmly into life — from his own

combining two or more of the methods

In theory, some characters might fit perfectly and form a natural break at a word space. But this would truly be a matter of luck, and the composition system must almost always tinker with word spacing. If those adjustments are exhausted before the line fits, the system tries to introduce additional break points with hyphenation. Failing this, the machine has to move on to alterations in letterspacing. These three methods are easily ordered in priority, and there is no question about establishing a rule that letterspacing must be the last area to adjust, as changes there are by far the least aesthetically satisfactory. In practice, the typesetting program will often need to combine approaches.

The order in which we should try potential solutions is obvious, but how far we should go with each adjustment before moving on is less clear-cut. Good typography requires a balanced application of the justification tools. For example, the program should consider a very small adjustment in word space preferable to a questionable hyphenation point (such as *a-gain*). It should also combine hyphenation with word spacing to produce the best overall effect rather than accepting

From top to bottom, the three methods for justifying a line: breaking at allowed points; adjusting word spaces; and adjusting letterspaces.

the first hyphen that meets the type parameters. In short, we want the typesetting program to compare several potential solutions and accept the best one. And we want it to act on its own, making choices that would match our own.

For good or ill, true reasoning isn't in the province of any typesetting machine. Instead of asking the machine to compare and select the best justification point, we have to establish inflexible standards for word spacing, letterspacing, and hyphenation. To consider just one reason why rigid instructions might not reflect our own choices, think of the benefits of solving a line break problem by changing the ending of a line above the one in question. When a composition program acts only on a line at a time, it can't consider such adjustments, but many a proofreader will spot the need to add a single syllable to another line to resolve a problem. Some composition systems are capable of examining whole paragraphs to correct poor individual lines, but generally human decisions can encompass and balance many more solutions than machine logic.

It's important to distinguish the difference between the composi-

The demonstration of poor typographic spacing below shows the uneven color that results from unsuitable composition parameters. The example at lower right is by far the worst, with wild variations in spacing. The hyphenation restrictions were also set very loose, allowing three consecutive breaks. These examples are exaggerated, but you can check for the subtle defects in type by turning the copy upside down. If you can distinguish a word shape, the spacing is flawed.

Caedebatur virgis in medio foro Messanae civis Romanus, iudices, cum interea nullus gemitus, nulla vox alia illius miseri inter dolorem crepitumque plagarum audiebatur nisi haec…"Civis Romanus sum." Hac se commemoratione civitatis omnia verbera depulsurum cruciatumque a corpore deiecturum arbitrabatur. Is non modo hoc non perfecit, ut virgarum vim deprecaretur, sed, cum imploraret saepius usurparetque nomen civitatis, crux, crux, inquam, infelici et aerumnoso, qui numquam istam pestem viderat, comparabatur.

too little letterspacing and word spacing

Caedebatur virgis in medio foro Messanae civis Romanus, iudices, cum interea nullus gemitus, nulla vox alia illius miseri inter dolorem crepitumque plagarum audiebatur nisi haec…"Civis Romanus sum." Hac se commemoratione civitatis omnia verbera depulsurum cruciatumque a corpore deiecturum arbitrabatur. Is non modo hoc non perfecit, ut virgarum vim deprecaretur, sed, cum imploraret saepius usurparetque nomen civitatis, crux,

too much word spacing, no letterspacing

Caedebatur virgis in medio foro Messanae civis Romanus, iudices, cum interea nullus gemitus, nulla vox alia illius miseri inter dolorem crepitumque plagarum audiebatur nisi haec…"Civis Romanus sum." Hac se commemoratione civitatis omnia verbera depulsurum cruciatumque a corpore deiecturum arbitrabatur. Is non modo hoc non perfecit, ut virgarum vim deprecaretur,

too much letterspacing, no word spacing

Caedebatur virgis in medio foro Messanae civis Romanus, iudices, cum interea nullus gemitus, nulla vox alia illius miseri inter dolorem crepitumque plagarum audiebatur nisi haec…"Civis Romanus sum." Hac se commemoratione civitatis omnia verbera depulsurum cruciatumque a corpore deiecturum arbitrabatur. Is non modo hoc non perfecit, ut virgarum vim deprecaretur, sed, cum imploraret saepius usurparetque nomen civitatis, crux, crux, inquam, infelici et aerumnoso, qui numquam istam pestem viderat, comparabatur.

too little letterspacing, proper word spacing

Caedebatur virgis in medio foro Messanae civis Romanus, iudices, cum interea nullus gemitus, nulla vox alia illius miseri inter dolorem crepitumque plagarum audiebatur nisi haec…"Civis Romanus sum." Hac se commemoratione civitatis omnia verbera depulsurum cruciatumque a corpore deiecturum arbitrabatur. Is non modo hoc non perfecit, ut virgarum vim deprecaretur, sed, cum imploraret saepius usurparetque nomen civitatis, crux, crux, inquam, infelici et aerumnoso, qui

too much word spacing, proper letterspacing

Caedebatur virgis in medio foro Messanae civis Romanus, iudices, cum interea nullus gemitus, nulla vox alia illius miseri inter dolorem crepitumque plagarum audiebatur nisi haec…"Civis Romanus sum." Hac se commemoratione civitatis omnia verbera depulsurum cruciatumque a corpore deiecturum arbitrabatur. Is non modo hoc non perfecit, ut virgarum vim deprecaretur,

too much word spacing and letterspacing

tion system's overall computer program and the operator's job-specific instructions. Each exerts control over the results, with the program dictating the nature of the balancing act among the spacing and hyphenation tools. The operator, though, is in charge of important controls. He sets the justification range through the minimum and maximum word space and letterspace values. If he makes the variation in word spacing very small, the typesetting machine will move on to adjust letterspacing very early. On the other hand, a wide word spacing value permits more loose lines. As you'll see in the hyphenation section, balancing all these typographic parameters is the most difficult task—for both the typographer and typesetting machine.

Typographic color

Before brooding further on the computer's potential to let us down, let's clarify why poor line endings are worth our concern. In the blocks of text on the facing page are extreme examples of poor typographic spacing. Each excerpt is marginally legible, and might not cause the reader to hurl down the page in disgust. What each will do is hinder the reading process, perhaps only subtly in the case of overtight spacing, but quite harshly in the examples of loose letterspacing. The only reason why typographic standards aren't more fervently maintained is that poor typography is obvious only to the typographically astute. Nevertheless, poor typography affects every reader. The fact that readers sense it only subconsciously is not an excuse for permitting it.

Whether type is set justified or ragged, the end result should be even in color. In typesetting, color refers to an overall tone of gray, and to produce it, the white space around letters and words must be consistent. Margins, column gutters, leading, and the x-height of the type also contribute to the tonal balance of the page. A good designer considers those elements and obtains a comparable density of tone for the type. Type can be set very tight, with limited word spacing, or very loose, with greater white space, but in either case the balance of tone must stay the same, line by line, paragraph by paragraph. Otherwise, a reader senses a diverting pattern in the type.

A reader recognizes words or large letter groups, rather than analyzing type a letter at a time. The boundaries for each word must be emphatic enough for this recognition process to take place without hesitation, and so the word space becomes a crucial element of readability. In addition, the space between letters must support the reader's need to see an entire word as a unit. When letters are too tightly packed, they can fuse into unreadable blobs; when they're too loose, they can distort the overall shape of the word or blur with word spaces.

In an ideal column of type, word and letter spaces would be equal throughout, giving the reader no reason to question which letters belong to which words. This is a fairly simple accomplishment on a line-by-line basis, but within a block of text there may be great variations in the minimum and maximum spacing. Glancing at a page with a wide range of word spacing values, you can see light and dark pockets, where the even gray tone of type is undermined and distracting patterns emerge. Note, for example, the spacing variety in the example in the lower right corner.

percutaneous transluminal coronary angioplasty after successful thrombolytic therapy has reduced the re-infarction rate

A loose line is often the result of a limited number of word spaces within the measure. When long words can't be hyphenated, even the best composition programs may deliver a loose line.

Model of the justification system

A sophisticated justification program should allow the operator to set the following parameters:

- minimum and optimum word space values
- maximum word space before hyphenation utilized
- maximum word space before letterspacing utilized
- minimum letterspacing, to force justify lines
- maximum letterspacing, to expand line

The final hindrance to easy reading is the loose line. All composition systems allow you to set the minimum and maximum word and letter-space values, which restrict the acceptable line endings. The minimum value represents the smallest space you'll tolerate, and the maximum the widest, but as you'll see these limits may become only theoretical.

Whenever permissible word space adjustments are inadequate to end a line, the composition system will either alert the operator and await manual adjustment, or it will simply set the line, adding as much space as necessary. Because so many composition systems process text that is loaded through magnetic media rather than by an operator at a keyboard, almost every system is forced to keep working on its own, allowing loose lines when spacing restrictions cannot be met. Some composition programs helpfully identify the lines that don't match the standard so that proofreaders can consider repairing them.

Note, then, that the finest typographic parameters will simply be ignored when the automated typesetting machine finds no apparent alternative. The computer can fail our standards (by selecting a bad hyphenation point, for example), but it can also fail its own rules and give us a loose line.

Justification controls

The justification range is a span around line length, and its extent is determined by operator settings governing the permissible adjustments to word space and letterspace. If the operator set both to zero, the justification range wouldn't be a range at all but the line length alone. Instead, the settings will allow contraction and expansion of the ideal spacing levels. When the program sifts through its options under the operator's values, we want it to behave as much like a conscientious typographer as possible.

Consistency is a vital component of good composition, but we're now about to defy it by allowing a range of acceptable word space values. The minimum will represent the tightest our line measure, font, and leading will tolerate, and the maximum will hold the other extreme. Shouldn't we make these two values extremely close together?

Certainly—as long as we're willing to let the other two techniques for line ending bear the brunt. The narrower the acceptable word space range, the more the composition program must rely on frequent hyphenation or adjustments to letterspacing to fit lines. A typographer concerned with consistent word spacing is likely to be equally devoted to restricting changes in letterspacing, and so we can envision two aesthetic extremes: designers who value even spacing and will tolerate numerous hyphens to obtain it; and those who dislike the constant interruption of hyphens and will sacrifice variations in spacing to avoid it. The ideal, obviously, is balance, but depending on which side you favor, you'll want the typesetting program to approach justification with a bias toward one side or the other.

Word spacing

Typesetting is so replete with relative relationships that simple rules fail us quickly. Attractive, readable word spacing has nothing to do with fixed distances and everything to do with type size, line length, type

design, and leading. In the relative measurement of the unit system, word spaces are generally between one-fifth and one-third of an em. See the readability section of the typography chapter for more information on word spacing standards.

Systems that allow an optimum word space definition add a valuable control. When possible, the system seeks to allot an optimum space. In essence, it is solving the line-ending problem in an improved order, by looking first for line breaks that offer the optimum word space before it searches for a solution with the minimum or maximum. Since there may be a mathematically correct resolution to a line ending through several possible breaks, the solution the system seeks first may eliminate better ones. A composition program that offers the finest justification routine would compare the success of each solution and select the version closest to desired parameters. That form of comparison, closely following a human intelligence, would consider a hyphen that preserved optimum word space preferable to a straight word break that used the maximum word space, and so forth. Some composition programs perform this kind of complete analysis, while others simply try different approaches in an order that sets their desirability, returning the first solution they encounter. It's up to the operator to visualize the analytical order the system employs to make the best use of it.

setting word space values

Word space values are expressed in either units or fractions of the em space. When setting the values, the compositor should take into account the full situation on a line, such as the number of words between which space can be allocated. On a short line measure, three long words may consume the line, with only two word spaces to absorb excess space. And if the text is technical, it may contain many long words, again reducing the number of interword spaces. In both these cases, conventionally small maximum word space values send the composition system scurrying off to adjust letterspacing, and quite possibly both values are used at their maximum. Under these conditions, we might want to grant slightly greater word spaces to save us from the more distracting effect of wide letterspacing. Or we might want to suspend a hyphenation restriction that disallows three consecutive hyphens. In many cases, the best constructed parameters still beg for diligent proofreaders and typographers to overrule them.

No matter how great or small the desired word space may be, the word space range is the real cornerstone of readable type, for it is wide variations in word spacing that work against an even type tone. However, the shorter the range, the more lines will fail to fit, and the more often the composition system will resort to altering letterspacing or inserting hyphens.

Letterspacing

Letterspace adjustments can go in two directions, to expand a line or to contract it. Generally, letterspacing is added between characters to resolve a justification problem. Contracting intercharacter space, sometimes called force justifying, is a handy adjustment but has limits. Most type designs won't permit much reduction between characters.

Typical justification parameters

This example uses an 18-unit system.

hyphenation restrictions

no more than two consecutive hyphenated lines
no less than three characters before and after a hyphen
hyphenate only words of five characters or more
use preferential hyphen point
do not hyphenate compounds with hard hyphens within
do not hyphenate the last line of a paragraph

word space restrictions

maximum before hyphenation
9 units (1/2 em)
maximum before letterspacing
12 units (2/3 em)
minimum
3 units (1/6 em)
optimum
6 units (1/3 em)

letterspace restrictions

maximum 2 units
minimum 0 units

It was the best of times, it was the worst of times, it was the age of wisdom, it was the age of foolishness, it was the epoch of belief, it was the epoch

Franklin Gothic heavy

It was the best of times, it was the worst of times, it was the age of wisdom, it was the age of foolishness, it was the epoch of belief, it was the epoch of incredulity, it was the sea-

Futura

It was the best of times, it was the worst of times, it was the age of wisdom, it was the age of foolishness, it was the epoch of belief, it was the epoch of incre-

Trump Medieval

Some typefaces tolerate letterspacing better than others. The heavy weight and contrast in Franklin Gothic does not lend itself to loose letterspacing, while Futura's even tone can withstand some. Trump Medieval bold fairly disintegrates when letterspacing becomes visible.

A small amount of negative letterspacing can fill a line without attracting attention, but excessive tightness shows up as increased density and even type distortion. Letterspacing is almost always adding space, not subtracting it.

Letterspace ranges should act in concert with word spacing to produce even, balanced lines. A tight word space range combined with a loose letterspace zone will allow more line-ending solutions through intercharacter adjustment. On the other hand, loose word space values keep the system from resorting to letterspace adjustments. This is the wiser course aesthetically, since we'd like to underutilize letterspacing whenever possible. A newspaper, which faces the deadly combination of a short line measure and potentially long proper names, will have to resort to letterspacing, but good quality composition will permit little adjustment between characters.

Each type design makes some implicit demands on letterspacing. Some fonts can set very loose and still look balanced, while others appear to fall apart with the slightest additional spacing. Look at the counters and the overall contrast in the type design to decide how much letterspacing to permit. Type with very little contrast, reasonably light strokes, and large counters can tolerate more letterspacing. This is because the monochrome quality of such a design is not easily upset by a slight change in spacing. On the other hand, a type with strong contrast will produce the kind of woven pattern on the page that letterspacing can make very uneven. Still, though some fonts can handle letterspacing reasonably well, the adjustment will always be a last resort.

Each typesetting manufacturer's justification system will have its own quirks. As a type buyer, you're concerned with overall type quality and therefore you'll want to select a type vendor whose equipment meets the standards you require. Don't hesitate to discuss these issues with your typesetter. If you're shopping for an in-house typesetting system or trying to evaluate the justification routines in DTP page layout programs, you need to be well acquainted with composition controls, such as the two basic structures for a justification program.

One justification system, called the minimum space routine, puts a priority on getting the maximum number of characters in a line. It looks for the last point before a line exceeds the justification range, called an overset condition. This results in rather tight lines, but it has the disturbing consequence of allowing dramatically light lines every now and then. When the only break point short of overset moves an entire word down to the next line, a very light line results. The minimum space system is fine at getting the most text into each line, but it tends to vary type color a great deal.

An alternative routine sets its priority around maintaining the optimum word space. When a good break is found at the optimum word space, the break is made, but when such an ideal eludes the system, it must branch off and try adjustments. Most programs begin adding space, moving out toward the maximum word space, and if that fails they reduce word space toward the minimum. Another system might find the break that satisfies the maximum word space and the one that fits the minimum, and then choose between the two by finding the adjustment closest to the optimum. In this case, the system might

hyphenate and adjust letterspacing as well, still presuming that optimum word space, however achieved, is the highest goal. To get the most out of such a routine, the user should be able to specify the point at which hyphenation should be tried, and how much letterspacing will be tolerated. Overall, the optimum word space routine will produce average word spaces larger than the minimum, while the minimum space routine will pack the line.

Throughout this discussion of justification, the specter of hyphenation has been hanging above us. In some senses, hyphenation promises to solve all our problems by adding word breaks. Yet it carries some undesirable consequences as well, and the typographer must be alert to both its blessings and its curses.

Typical justification routine

Think of the justification process as a series of nets, each one with a tighter mesh. A line tumbles through until it is caught; if the last and finest weave is the only one to snare it, we may not like the results as much. The composition software stacks the nets in a certain order, and the operator then weaves them by setting the spacing parameters tighter or looser.

These are the stages a typical hyphenation and justification routine employs, presented in the order in which a system will try to dispose of a line. In most programs, a line ending is made as soon as it satisfies a condition, though some advanced composition software will evaluate entire paragraphs for the best overall balance.

1) word break

The program counts the unit widths of the characters, using either the minimum or the optimum word space for the initial total. When this total equals the minimum value in the justification range, the search for a line-ending point begins. If a word break happens to fall precisely at the end of the line, the program ends the line and gives each word space the value it used in counting, either the minimum or the optimum.

2) initial word space adjustment

Now the system checks for a break within the allowed word space adjustments. A refined program allows the user to set a value for word space adjustment before hyphenation is invoked, thus allowing him to set a priority on slight adjustments in space over hyphenation. Because the user determines this initial word space value, he can put as much stress on hyphenation as he likes.

3) check for allowed hyphenation

The system goes on to count the characters that carry it to the maximum value in the justification range. Then it examines its hyphenation restrictions to see if a hyphen, if possible, would be allowed. With controls on the number of consecutively hyphenated lines and the size and placement of words that can be hyphenated, the program may not be permitted to use hyphenation at all, and so it's forced to proceed to the fifth level.

4) hyphenate to create break

If hyphenation is allowed, the system looks for a permissible break that will fit the line. It may use a dictionary to locate acceptable hyphenation points, which may even rank these breaks by desirability. For example, a break after a prefix would be better than one within a word, and "transoceanic" would have its break points graded as follows:

trans	1	oceanic
transo	4	ceanic
transoce	3	anic
transocean	2	ic

Most systems don't use preferential rankings of hyphenation points, and simply insert a hyphen based on a dictionary or algorithm to solve the line ending.

5) word space adjustment

By now, the program's calculations may show that the permissible line breaks, consisting of all hyphenation points, all word breaks, and those characters we'll permit at a line ending, such as a dash, will not equal the line measure precisely. The count revealed the characters falling within the minimum and maximum word space range. Now the system determines what word space value will provide a full line.

If a word space adjustment places the line in the justification zone, the line is broken there. The final word space will be somewhere between the minimum and maximum.

Now the two methods may act together, balancing a hyphenation solution with a word space adjustment. If preferential hyphenation points are distinguished, these are chosen first, with necessary word space adjustment.

Hyphenation

Perhaps the most important tool to even type color is hyphenation, the splitting of words to allow line endings to pertain more to the number of characters than the number of words. Despite its virtues, hyphenation must be used with caution, for overhyphenating can be more distracting to a reader than an occasional loose line. Many hyphens, particularly consecutive ones, will soften the right edge of justified type, and readers will have difficulty piecing together split words. Ultimately, even type color will require hyphenation, but the best automatic hyphenation routines will only provide the right break perhaps 95 percent of the time.

Hyphenation is more accurately called syllabification, because the principle for dividing words is based on pronunciation. For example, there are many words which are hyphenated in different places depending on their meaning: pro-ject (verb) and proj-ect (noun) are pronounced differently and can only be understood if hyphenation preserves their syllables.

With early typesetting machines, hyphenation decisions were made by the person keying in the text. This typist needed information from the typesetting machine, which advised him of the amount of space remaining on a line, based on the character widths. Hyphenation decisions could be made with great precision and accuracy, but they required a lot of the typist's time. Now, almost every typesetting machine offers automatic hyphenation. Though the compositor can, and often should, intervene, the system will provide hyphenation breaks as part of the justification process.

It would be fine to leave the procedure of hyphenation up to a machine if the machine were always right. The English language, and most others, is simply not going to conform to a set of rules for hyphenation, and that's why it's important to understand how automatic hyphenation routines work and to proofread for misplaced hyphens, which are called bad breaks.

Hyphenation programs are usually based on rules of logic that account for the basic patterns of syllabification. The rules, called algorithms, generally deal with combinations of consonants. The simplest algorithms use only suffixes and prefixes to determine hyphenation points. That gives us *paint-ing* but also the bizarre *someth-ing*. A suffix/prefix routine also fails to find a vast number of potential hyphenation points.

A more sophisticated algorithm uses word pairs or word groups. A few typical rules are shown in the sidebar. These algorithms will still be wrong often enough, but they do find many hyphenation points. Because they don't examine whole words, both prefix/suffix and word group algorithms will always fall short of perfect syllabification.

Hyphenation errors range from serious to silly. Some introduce errors in meaning, such as breaking *therapist* as *the-rapist*. Others have the potential to confuse readers by producing two words from the break, such as *of-ten* and *rear-range*. Then there are those strange hyphenation points in which the algorithm produces no syllable at all, such as *thro-ugh*, or very odd syllables, such as *typew-riter* or *repl-ace*.

Given the oddities of pronunciation and spelling in the English language, any set of rules is sometimes going to be wrong, perhaps as often as half the time. The sample rules in the sidebar on the facing page, for example, will permit such bad breaks as *crac-ked, bat-hmat, stryc-hnine, de-stined,* and *heckl-ing.*

Simple hyphenation by algorithm will permit breaks in proper names. Because pronunciation for names may be quite different and readers may have trouble piecing together such unfamiliar words, some hyphenation routines don't allow a break in a word with an initial cap. This, of course, disallows hyphenation of the initial word in a sentence that might well deserve one. Further, many proper names break on syllables quite well. Only proofreading can provide the logical analysis necessary to cope with proper names.

To deal with the oddities of English, most hyphenation programs also have an exception dictionary, which includes hyphenations for commonly used words that defy the rules. The dictionary is searched first, and if the word matches an entry, the stored hyphen is supplied. Most dictionaries are assembled of word roots or stems, and this allows application for numerous prefixes and suffixes and extends the scope of the dictionary greatly. The size of the dictionary in words, therefore, is not the only measure of its usefulness. A sophisticated system must allow the user to add words to the exception dictionary and should be able to handle the many variations on root words that arise in plurals and verb forms. In addition, a good system would allow you to attach a special subject dictionary, covering medical vocabulary, scientific terms, or other lexicons.

The ultimate hyphenation system is the total dictionary approach. The entire hyphenation process consists of applying the breaks stored in a dictionary. Though this method is unrivaled for correctness, the user pays for it with slow composition time and a large computer memory allotment. Merely to approach usefulness, the dictionary must contain at least 100,000 words; English has a base vocabulary of about 500,000 and at least as many technical and scientific terms.

A dictionary program will in effect do what human typesetters used to do before automation, when they keyed every word of text with all potential hyphens in place and waited for the machine to make use of the hyphens it required in a secondary composition stage. Some systems continue the approach and typeset by inserting all hyphens when the text file is loaded, making use of them as needed. This speeds up composition substantially.

A dictionary must be expandable by the user, who will supply, at minimum, proper names, and ultimately terms that the core dictionary hasn't covered. For a further refinement, a dictionary may rank hyphenation points by desirability. In some applications, the user can set the acceptable level of hyphenation, restricting the program to use only the higher-ranked hyphenation points. In others, word spacing would be adjusted before lower-ranked hyphenation points are used.

Though there are endless amusing examples of bad breaks that algorithms and exception dictionaries permit, the other side of the problem is an automatic hyphenation program that is too stingy with its hyphens. The fourth rule in the sidebar on page 126 prevents a break

graveolent
grave-olent
grav-eolent
graveo-lent
gra-veolent

Does it have three syllables or four? To hyphenate this word properly, we need to know if the break between the v *and* e *is permissible. The word is pronounced "gra-ve-o-lent," so that break is allowed. The word means having a strong or offensive smell.*

before *ing* preceded by a *t*, which rescues us from errors like *hitt-ing* but also refuses to give us *hunt-ing*. Thus, when checking for bad breaks a proofreader is also looking for missed opportunities.

Hyphenation controls

Hyphens are conditional when breaking a word to fill a line; if new material is inserted and the line ending changes, the word should lose its hyphen. Compound words include hyphens that must be preserved, like *avant-garde* and *twelve-inch ruler*. A typesetting program needs to distinguish between two types of hyphens. Generally the conditional hyphens are called discretionary or soft hyphens, while the others are called required or hard hyphens. Some typesetters allow the operator to key in soft hyphens which the system will use as a break point if the line requires it, but will ignore if it does not. Almost all computerized composition machines will strip soft hyphens when modifications to the text set up new line breaks.

On the other side of the coin, there are words that the user will not want hyphenated, either because an algorithm supplies an incorrect break or because of the context. A good hyphenation routine will avoid adding a hyphen to a compound, sparing us such awkward displays as *mat-ter-of-fact*. Odd as it may seem, pure computer logic in some programs inserts a hyphen every time an acceptable break is found, which results in hyphens after dashes or even other hard hyphens. Clearly, this is not the work of a polished hyphenation program.

Good hyphenation software will allow the user to insert discretionary hyphens on the fly or to disallow hyphenation for a particular word. It will also let the user establish values for three important hyphenation restrictions. First, a limit is set on the maximum number of consecutively hyphenated lines. Fine typography stops at two; sometimes three are permitted, but this is best allowed only as an exception and not set within the system's parameters. Second, the user should set the minimum length of a word that can be hyphenated. At least five letters is a wise choice, but even at that you'll have a very short syllable on the beginning and end of a line. Third, the user should be able to adjust the minimum number of characters preceding or following a hyphen. When two letters are allowed, you'll see many variations on *love-ly*; three makes for fuller syllables.

Of significance in mathematical and technical text is a setting for permissible line-ending characters. Some hyphenation programs are unreachable on this topic, and this can have serious consequences if you'd like to contradict the program and permit an em dash, slash, fixed space, bullet, or en dash as a line ending. Many routines include some or all of these as accepted points, but when one isn't standard, you'll want the flexibility to include it.

Automatic hyphenation is a valuable feature of computerized composition systems, but the English language evolved without typesetting machines in mind. Our vocabulary defies the most elaborate set of rules. Alternatively, extensive reliance on dictionaries slows down text entry or justification, and requires great reserves of computer memory. Only attentive typists and proofreaders can properly hyphenate text, though automatic systems do give them a good head start.

Nonjustified typesetting

The central struggle in justification is to maintain even type color. Sharp, justified columns look very orderly, but we can also set text with a variable margin, letting the words dictate the line length. This is called ragged typesetting and is specified as rag right, rag left, or rag center depending on the margin we leave open. With nonjustified typesetting, the word spaces will all be equal, and we'll never need to resort to letterspacing. But we will have to be vigilant about the pattern formed by the varying line lengths.

Both justified and ragged text need typographic proofreading. Neither can be set well by surrendering all control to an automatic typesetter. Proper ragged text should never have two successive lines of nearly identical length. It should also never maroon a small word out in the margin where it can be read in isolation. The correct pattern for the margin requires that if the second line is shorter than the first, the third should be longer than the second. All these logical controls on the shape of the text are almost always left to the proofreader to implement, although there are some typesetting programs that regulate some or all of these fine points.

Even at that, proofreading will be difficult. It's much harder to anticipate the best way to correct an unattractive line break in ragged text. Some trial and error is likely to be necessary. Currently, no desktop publishing software offers automatic analysis and control of ragged margins, but the DTP environment is ideal for the operator's trial-and-error resolution of poor breaks. At least one DTP program does allow you to set a different word space and letterspace value for ragged settings, indicating some sensitivity to the matter.

Nonjustified type calls for yet another word space value. Instead of the optimum space that might be about a third of an em, a proper default for ragged text is a bit smaller. In an eighteen-unit system, we might use five units for ragged, but six units for justified.

Handsome ragged text requires hard work to produce but offers real dividends. Since word and letterspacing are equal, the typographic color is perfect. And the ragged margin adds a softness to the page that contrasts nicely with rules and rectangular graphics. All studies indicate that justification has no bearing on reading comprehension, and that most readers aren't actually aware of whether they're looking at ragged or justified text. Still, we have to wonder about that area in between comprehension and interest, the zone in which reading pleasure is enhanced by proper texture and reading efficiency is boosted by consistent spacing. The designer chooses a ragged setting for aesthetics, not because it's proven to be more readable than justified type. Though it requires conscientious control of margins, setting ragged right can make type look its best.

At these times, Mr. Micawber would be transported with grief and mortification, even to the length (as I was once made aware by a scream from his wife) of making motions at himself with a razor, but within half-an-hour afterwards, he would polish up his shoes with extraordinary pains, and go out, humming a tune with a greater air of gentility than ever. Mrs. Micawber was quite as elastic. I have known her to be thrown into fainting fits by the king's taxes at three o'clock, and to eat lamb-chops breaded, and drink warm ale (paid for with two teaspoons that had gone to the pawnbroker's) at four. On one occasion, when an execution had

At these times, Mr. Micawber would be transported with grief *lines* and mortification, even to the *progressively* length (as I was once made *shorten* aware by a scream from his wife) of making motions at himself with *length too* a razor, but within half-an-hour af- *similar* terwards, he would polish up his shoes with extraordinary pains, and go out, humming a tune with a greater air of gentility than ever. *isolated word* Mrs. Micawber was quite as elastic. I have known her to be thrown into fainting fits by the king's taxes at three o'clock, and to eat lamb-chops breaded, and drink warm ale (paid for with two *lines form* teaspoons that had gone to the *pattern* pawnbroker's) at four. On one occasion, when an execution had

Here's a comparison of proper (top) and improper (bottom) ragged right composition. The flaws in the bottom example are noted in the margin.

Typographic spacing

After word spacing and letterspacing are controlled through the justification program, a typesetter will want to manage the intercharacter spacing combinations unique to a type font. Tracking and kerning are the tools for the task.

Tracking

Intercharacter spacing is an important typographic consideration. A type design itself establishes the set width of each character, allotting space around each letter. This dimension is called side bearings, and is part of a font's unit widths. A compositor can alter this space by modifying the position of type, but the font starts out with a spacing norm. When the compositor changes it, he does so by tightening or loosening the type in a global way. This is called tracking. Tracking shouldn't be confused with letterspacing, which controls the variation in intercharacter space tolerated to fill out justified lines.

The lines at right show the progressive effects of increased tracking. Tracking adjustments make global changes in the type's character spacing by modifying the the font's side bearings. You can also use tracking to spread out letters.

The family of Dashwood had been long settled in Sussex.

The family of Dashwood had been long settled in Sussex.

The family of Dashwood had been long settled in Sussex.

The family of Dashwood had been long settled in Sussex.

Tracking is useful for compensating for problems in a font's original set widths, for creating a change in the overall density of a type, or for increasing or decreasing the number of characters that fit in a given space. Perhaps most important, tracking helps deal with yet another flaw introduced by strict proportional size changes. In the master for each font, an ideal intercharacter space is set as a margin around each character. The original intercharacter space is doubtless appropriate for text sizes, but will probably make letters look too tight in small sizes and much too far apart in display sizes. Tracking is a comprehensive adjustment that repairs this problem.

A compositor can set tracking to expand or contract the intercharacter spacing values. Such an adjustment works throughout the entire font and is usually doled out with increasing intensity at point size extremes. When tracking is invoked selectively on a block of text, it's called white space reduction or addition, and it helps the typesetter resolve a localized fit or density problem.

Typographers must be sure of themselves when using tracking to change a type design's set width. After all, that width is a property of the design itself. On the other hand, a good typographer has enough sensitivity to density and proportional sizing to make intelligent tracking adjustments.

Kerning

Tracking changes the overall fit of characters, but there are many occasions when we're confronted with a single pair of letters that look poorly spaced. The type design's set widths attempt to suit every

possible letter combination, but of course these average widths fail from time to time. A word like *LATHE* includes some awkward spaces that affect the balance in density. The void between the *L* and *A* cannot be eliminated, but the space between the *A* and the *T* can be adjusted by bringing those two letters closer together. This selective spatial adjustment is called kerning.

Letters aren't very consistent building blocks. The sharp pyramid of the *A* is reversed in the *V*, and the upper arm of the *T* shelters a large void below. To perfect the shape of words, we often want to adjust the odd gaps formed by certain letter combinations. The designer can do this by calling for selective kerning, or by using typesetting systems that have built-in kerning values. Such equipment examines letter combinations and makes an automatic adjustment between a combination like *AW*.

Take another look at the illustration of *LATHE*. Kerning alone can't resolve character balance. In this instance, the gap between the first two letters and the apparent tightness between the last two makes it difficult to decide how to adjust the *A* and the *T*. The tighter you make them, the worse the first pair looks. The looser you leave them, the odder the last pair appears. With a word like this in large headline type, the thoughtful typographer may want to add space between the *H* and the *E*, and essentially let the extreme combination of the *L* and the *A* dictate the density of the word. Remember that kerning to tighten can unbalance type as easily as it can restore balance.

In photocomposition, the imaging system permits very fine positional adjustments. Typical kerning values work in increments of a quarter of a point or less. The finer the adjustment the better, because we can make distinctions among a variety of character pairs in a variety of fonts.

There are three methods for kerning. Pair kerning uses a table of font-specific values. The user can edit the table; on some systems, it's up to him to create it in the first place though the software is all set to utilize it. The optimum adjustment between *To* in Garamond is different from that in Helvetica condensed, and may be different in roman, bold, and italic in any family. A kerning table uses relative units, just as the character widths do.

An alternative system is sector kerning. This approach attempts to focus on the central predicament that kerning corrects. Each character's overall shape is stored on a grid. The system then compares the adjacent grids when two characters are set, and if the shapes form a gap, the space between the letters is tightened. The degree of adjustment is based on the shape each letter takes within its grid.

Finally, typesetting systems generally allow the user to kern manually. When typesetting a headline, for example, almost all designers want to increase the localized kerning to perfect the word shape. Sometimes a kerning table or sector routine yields inadequate results, and the user wants to override them. To specify manual kerning on a layout, note the adjustment in units or portions of an em, depending on the typesetting equipment.

Kerning brings together letter pairs that are optically too widely spaced.

no kerning

too tight

balanced

Kerning can correct inherently awkward spaces between letters, but it should be used to balance light and dark overall, and not simply to tighten every letter pair to the maximum degree. Note the even space between the T, H, *and* E *in the bottom example.*

Mechanical Alignment Is Not Always Correct. Make Sure Headlines are Optically Flush left.

Mechanical Alignment Is Not Always Correct. Make Sure Headlines are Optically Flush left.

Headlines may require individual adjustment to produce an appearance of optical correctness. Compare the mechanically aligned example (top) with the optically aligned version (bottom). The left margin in the lower example has been altered selectively to align the round characters with the vertical lines of other letters.

Optical alignment

When working with display type, you may need to compensate for the vertical alignment of characters. As the example shows, a *W* above an *I* will appear slightly indented unless you make a manual adjustment. The human eye dictates acceptable alignment, not a typesetting machine's line measure.

A headline with centered type may also need a tweak or two. Punctuation marks are notorious for throwing off optical alignment because they have less visual weight than their size gives them. You needn't accept a centered headline straight from the typesetting machine because it must be mathematically centered. Go ahead and let you eyes determine what looks correctly aligned.

Finally, some punctuation marks are designed to fit beside lowercase letters and look poorly positioned with capitals. Parentheses and hyphens both appear to float too low and must be manually raised when used with caps.

A type design itself has to compensate for some optical illusions. The rounded letters, like *O* and *e*, must fall a little below the baseline to appear optically aligned. Bear this is mind when positioning individual characters by hand.

Hanging punctuation

Almost all punctuation marks are far shallower than a type's x-height, and therefore they have much less density on the page. When they fall at the very beginning or ending of a line, punctuation marks tend to break the crisp edge of the column. To compensate for this, some typesetting systems can push punctuation a little bit outside the line measure to maintain a sharp column of type. To do this, the machine must analyze each line and make an adjustment based on the line-ending character.

This typographical nicety is called hanging punctuation. It's particularly helpful in keeping hyphens from dotting and scalloping the right margin. Some punctuation marks, like the colon, should not hang, but most benefit from the treatment. On the other hand, text with hanging punctuation has a slightly self-conscious look about it, if only because readers encounter it so rarely.

Typesetting machines

Typesetting machines have always had a direct effect on the nature of type design and the appearance of text. The changes in type masters, from casting matrices to photographic masters and now to digital data, have all had consequences. There has been a parallel evolution in the method for positioning type. Metal characters had strict physical boundaries, but phototype is based on beaming light through a master or painting digital dots. This photographic basis for type imaging means that characters can be superimposed, distorted, and positioned with extraordinary precision. Finally, the speed, fidelity, and flexibility of typesetting have all advanced with new digital tools to serve designers and typographers.

If it appears to be stretching the point to consider handsetting type along with more automated methods, reflect on the fact that the initial mechanization of composition was in casting the characters themselves. Typographic traditions begin with handset foundry type, and it's worth a short review.

Foundry type

No matter how peculiar the twentieth century might appear to Gutenberg on every other count, the practice of metal typecasting would be entirely familiar to him. The principle has changed not at all, and the procedure very little. Only with the invention of phototypesetting do we begin to veer from the techniques of the fifteenth century, for metal type has always been cast of virtually the same material and by essentially the same method.

Metal type is cast in a matrix that receives molten metal that will harden in the shape of a printing character. The copper matrix is cut from a punch, a steel impression of the master character. In turn, the punch is first engraved with a counterpunch that carves out the non-printing interior, or counter, of the character. Note that the punch is equivalent to the final metal product and is simply reversed as a matrix, then reversed back in casting. The punch can produce numerous matrices and is the true original of the type. It was many years before the job of cutting punches was distinct from designing a font.

The nature of metal type may seem a topic only for the historically curious, but you will find that typographic norms, terms, and even font designs are all illuminated a bit better for the knowledge of it. In particular, handsetting type requires the compositor to make line-ending decisions without benefit of computer calculation.

setting foundry type

A font of foundry type was sorted into a typecase, a drawer with a set of compartments designed around the frequency with which letters are used. In effect, the typecase is the first keyboard. The terms *uppercase* and *lowercase* come from the use of two separate drawers, one with capital letters set up above the other.

To set type, you place characters and nonprinting spaces one by one in a composing stick. The stick has a stop to mark the line measure, and you justify each line by selecting different size word spaces or hyphen-

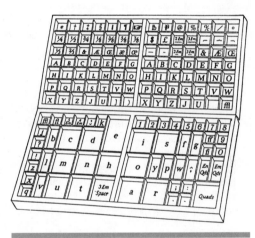

The pair of typecases above is one of several layouts for organizing type. To save space, a more compact version called the California typecase placed all capitals on the right and eliminated many infrequently used characters in order to reduce a working case to a single drawer. They were called California cases because printers heading west wanted to travel light.

Punchcutting and typecasting

The punch cutter in the fifteenth century was also the type designer, executing his drawing in steel. He cut a punch, and as necessary a counterpunch, for every character, in every style, in every size he undertook.

Metal type is cast in a matrix that receives molten metal that will harden in the shape of a printing character. The copper matrix is cut from a punch, a steel impression of the master character. In turn, the punch is first engraved with a steel counterpunch that carves out the nonprinting interior, or counter, of the character. Because it hollows out the punch, its depth was as crucial as its shape. If it was too shallow, the character would fill in with ink. Note that the punch is equivalent to the final metal product and is simply reversed as a matrix, then reversed back in casting. The punch can produce numerous matrices and is the true original of the type. It was many years before the job of cutting punches was distinct from designing a font. The punch itself was cut in a soft steel bar. After the counterpunch hollowed out the interiors of the character, the punchcutter carved away the outside edges, taking care to support thin hairlines with sloping, strong bases. He could check his progress with smoke proofs, made by coating the punch with soot and pressing it against moist paper. When he was satisfied, the punchcutter hardened the punch so it was strong enough to impress copper.

punch

When struck into copper, the punch produced what's called an unjustified matrix, or strike. After it is fitted accurately to a mold, the strike becomes a matrix.

fitting and constructing molds

Casting type is not a simple, foolproof business. To make type of uniform height, the matrix of a sunken letter impressed in copper must be fitted in a mold. The matrix itself contributes only the printing side of the character; the cast height of the type body is controlled by a mold. Though there will be an individual matrix for each character, a single mold is used throughout a font to ensure consistency. Of course, this mold can fix the height of a character easily, but it must be adjustable in width to permit the range of character dimensions.

Fitting the strike into the mold also involves maintaining true parallel between the letter and the top of the mold. Further, the matrix must be in square on all sides to keep the cast character from slanting when composed in a line. The allotment of space on each side of the letter is dictated by the fitting of the matrix to the mold. In cast type, the intercharacter spacing is determined, inflexibly, in the fitting process, when the mold's dimensions are set for the character in question.

mold

The mold itself is an adjustable device of two halves. It can be screwed together, in precise parallel, at different widths to accommodate different matrices. The top is closed by the matrix, while the bottom is open to admit the molten metal.

Gutenberg's specific contribution to printing is not so much movable type but consistent, sharp movable type cast in quantity. The notion of making characters in molds was not original with Gutenberg, but he solved the critical problems in type production necessary to bring quality and dependability to the process. Gutenberg's particular conception of the mold allowed him to maintain consistent type height, and his formula for type metal proved so appropriate that virtually the same blend of lead, tin, and antimony was used during the entire history of cast type.

cast type

typecasting

Hand casting was a delicate process. Much could go wrong: the molten metal might not fill out the matrix evenly, the letter might shrink too much in cooling, and of course the typecaster could be burned. The hand caster poured in metal, gave the mold a proper shake, and then ejected the cast character. It was a slow process in a sense, but it provided type that could be used for many thousands of impressions and truly constitutes an automation of the printing process.

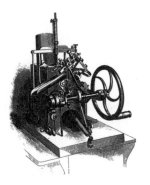

Bruce typecasting machine

Typecasting was done by hand in American foundries up to 1845, but the molds were then fitted to casting machines that automated the process of pouring lead and ejecting cast characters. A casting machine could produce about a hundred characters a minute in a small size.

matrix

ating words. A right-handed person holds the stick in his left, and places the type upside down and left to right in the stick. Between lines, you place nonprinting strips of metal called leads. The thickness of these dictates the interline spacing, and gives us the term leading. To make larger spaces, you might use slugs, which are thicker metal strips. After setting the several lines that fit in the stick, you transfer the type to a metal tray called a galley, the source of the term for composed text that's in the process of proofreading and correction.

Set lines accumulate in the galley tray. To keep the type from moving, you wrap a block of type tightly with several turns of string. Type that flies out of its orderly rows into a chaotic heap is called pied and is probably the definition of lost effort. After all the components of a page are set, you make up the type for proofing. The type arranged for proofing or printing is called a form. After you set the form up on a proofing press, you can pull as many proofs as you like. Then you correct the text by replacing lines with re-set type.

Preparing the final printing form includes positioning all the discrete elements, keeping the text in square, inserting any engravings or cuts that are to print, and filling out all the nonprinting areas with wood or metal that lies below type height. These strips are usually called furniture, suggesting their wooden composition. The finished product is locked up tight to keep the numerous pieces that constitute a page from squirming out of line. Forms are usually locked up with quoins. These are adjustable, stepped blocks of metal that can be tightened with a quoin key.

To distribute type when printing is done, you take up a word or two and read off the letters as you sort them back into the case. Being able to comprehend the words is essential to rapid, accurate distribution. Making sense of letters upside down and reversed requires a special diligence, and minding your ps and qs is literally a job requirement for the hand compositor. One of the standard proofreading marks is the "wrong font" mark, and it was needed often in correcting handset type since one could easily mix up a font when distributing type.

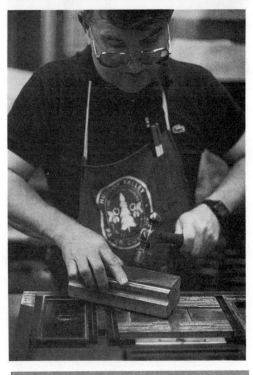

Note that foundry type is an inelastic commodity. You may easily run out of a character or symbol, and sometimes the only way to keep a book project moving is to print a set of pages, distribute the type to put it back in circulation, and compose more pages.

Handsetting type is obviously slow and places all the burden of positioning type and ending each line on the compositor. In one sense, this guarantees that the best choices are made in these highly situational circumstances. As soon as we automate typesetting, we need to preserve the intelligence that went into ending each line and positioning each character to best optical effect.

Linecasting

You cannot help but feel some affection for any machine that reveals its inner workings to you at a glance. The Linotype machine, which took Ottmar Mergenthaler years to perfect, boasts of his genius as soon as you examine it. Its major principles of operation are as visible as those of a door hinge. Cut type into matrices, design a unique key pattern on the body of each matrix that identifies it to a row of notches,

Preparing handset type for printing involves taking the set lines from the galley tray (top) and locking them up in a chase, a metal frame that holds type and engravings in place. The type is secured with a quoin key (center) that moves a wedge tight against the type. The compositor then taps the type to printing height (bottom) to ensure even inking and printing impressions.

let a keyboard summon each matrix to drop into a line, cast a completed line from molten metal, and there you have it. A linecasting machine is at once forbidding in its complexity and reassuring in its clear method of operation.

The Linotype (and a competing machine from Intertype using the same principles) represents an abrupt transition from handset type, yet it yields a similar result. Two central ideas distinguish it from foundry type, and both solve major problems with handsetting. First, rather than assemble cast characters into lines and pages, a Linotype is a supply of type matrices (mats), making each machine a foundry unto itself. With handset type, there is such a thing as running out of *e*s or *Z*s, and the phrase "out of sorts" as used in the composing room refers to such a lack, a sort being the pieces of type of a particular character, font, and size. In contrast, a linecasting machine is a never-ending supply of casting mats. After each line is set and cast, the mats are carried back up into a storage magazine, ready to clatter down again when the keyboard calls for them. Perhaps even more valuable, the pot of molten lead from which each line is cast can become the type's final destination after the page is printed. Foundry type must be returned to its case, letter by letter, in a process nearly as painstaking as the initial setting.

The Linotype's second significant contribution is its use of a keyboard, an innovation easily unnoticed in this age of ubiquitous keyboards and control panels. Not only is pressing a key faster than fetching a piece of type by hand, the letters appear right on the key tops, making training a good deal faster.

Don't expect to pull up a chair and run a linecasting machine based on your mastery of typing, however. The Linotype's keyboard layout will remind you of no other machine's, running six letters deep, with lowercase on the left and uppercase on right. Readers of letterpress newspapers were more familiar with the keyboard than they might have thought, for that cryptic phrase *etaoin shrdlu* they often stumbled across is the first and second column of Linotype keys. When a typesetter realized he'd made an error, he would fill out the line by drawing his hand rapidly down the rows of keys, and then dispatch the completed line when it appeared in the tray of cast slugs. If he failed to dispose of it (sometimes by abandoning another by mistake), the well-known nonsense crept into print.

In this age of digital type, it's difficult to imagine the limitations of purely font-based typesetting. A font of metal or its mats is not only a style but a size. The Linotype mats each have two styles cut into their sides, usually a roman and italic, or a roman and bold. Though a change in sizes or in type families required another full magazine, the typesetter could italicize a word by shifting a lever in the rail, a rack holding the mats of the line in process. The lever raised the mats so that the italic element would be cast, much as the shift key on a typewriter moves a different character on a single bar up against the ribbon and the page. Note that to perform tasks like this, the typesetter was asked to examine the line he was composing; to do so, he read letters painted on the mats on their noncasting side.

For many years, a magazine of type was a heavy, bulky, bronze case filled with mats. Changing magazines meant lifting them overhead and

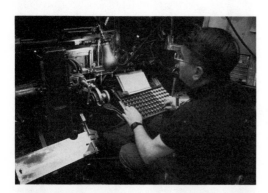

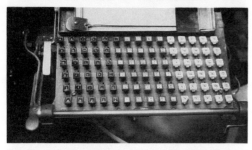

Bobby Ward of Queen City Printers composing on a Linotype, at top. The galley tray, empty at the start of this job, is on the left, and the casting apparatus is directly above it. The keyboard itself, above, is arranged unlike a typewriter's, with the lowercase letters etaoin *running from top to bottom in the leftmost row. Punctuation is in the middle, and capitals on the right.*

onto a Linotype, a task for which women were not well suited. There may be any number of reasons why compositors were generally male, but the job did require some brute strength from time to time. Eventually, magazine cases were made of aluminum, and though they were still necessarily large, their weight became more manageable, and we can expect that even men were grateful for the improvement.

Not that one changed magazines constantly: the Linotype could hold three in place. To shift fonts among the magazines, the operator flipped a lever that closed off one magazine's exit gate against gravity, pushed on another bar that raised or lowered the three-part stack of magazines, and then opened the desired magazine's gate. The wise operator loaded the most common font on the bottom of the stack, and surely dreaded the occasions when he had to change all three.

Perhaps the most ingenious aspect of the Linotype is the spaceband. To savor its clever application, let's set a line of type step by step.

The compositor sets the line measure by fixing a stop in the rail. As he strikes keys, mats tumble down the chutes in the magazine and fall on a moving belt that distributes them on the rail. The belt has the important job of moving each mat in the order in which a key has been struck; the journey to the rail, of course, is shorter for the mats on the left of the magazine.

Between words the compositor presses the space bar, positioned in the upper left of the keyboard. From a supply above the rail, spacebands drop into these positions. Unlike the mats, spacebands are longer pieces of metal, consisting of a frame the size of a mat that holds a long wedge that can slide up within the frame. The more the wedge is pushed upward, the wider it spreads the space between words.

When the line nearly fills the measure, the compositor makes a judgment about ending the line, inserting a hyphen if need be. When he's satisfied the line will set full, he moves a lever to send the rail up and to the left. Here, right before casting, the spacebands are pushed up to an even height (and therefore an identical width) by a bar below. The line is justified by the required expansion of the spacebands.

With handset type, the justification process is neither so tidy nor so swift. The hand compositor uses a certain amount of trial and error to distribute word spaces and lacks the finely adjustable wedge of the spaceband. The Linotype operator must still exercise good judgment on line endings, sensing points where word spacing might be too extreme, but the final size of word spaces is elegantly regulated by mechanical means.

Now the line moves into position for casting. The molten metal is shot through small holes into the mat bodies and then the excess cast metal is shaved off by knives, yielding a solid line of type at an even height. Leading is built into the cast line, and the compositor must set both leading and line length in the caster. Every Linotype operator has stories of burns and sprayed hot metal. Generally, these accidents occur when mats forming a short line are sent to the caster. The molten metal is blasted out over the full measure, and if there's no mat to contain it, it rains down on the floor or, worse, on the operator's leg. You can see why compositors reflexively filled lines to be corrected with *etaoin shrdlus*.

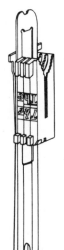

A few mats and a spaceband. The wedge shape of the spaceband is driven upward when the compositor sends the line over for casting. All the spacebands in the line are pushed up to the same height to distribute word spaces evenly.

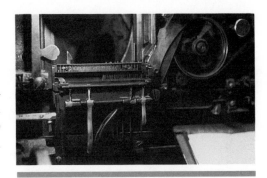

The heart of the Linotype is the rail, where the mats fall into line. It's shown here in the center, with a ruled gauge above in picas. The shift lever, used to set italics, is the thin bar at the right of the rail. The wheel drives a pulley that carries the mats back into the magazine.

The cast slug is pushed out onto a receiving tray, and the mats are lifted up onto the elevator. This bar picks up the mats by their keys, but allows the spacebands to drop away into their special bin. The elevator then carries the mats to the top of the machine and slides them onto a turning distributor bar, laced with notches corresponding to each mat. A mat stays on the bar until its key pattern matches, when it's released into its particular channel in the magazine. Any mat that hasn't fallen during the journey across the magazine is a pi character, and it is finally dropped down a chute to a tray on the operator's right. Pi characters include ampersands, asterisks, symbols, and any other infrequently used character that can't be housed in the magazine. It's up to the operator to draw these from his tray by hand and insert them when required.

All told, the Linotype is an invention bristling with solutions to serious problems. Mergenthaler tackled virtually every woe of the handset compositor, from running out of type to time-consuming sorting of used characters to justification. We can look at the Linotype today as a thoroughly obsolete piece of technology, but only because metal type has been overshadowed by the radically different approach of photocomposition. The Linotype is large, loud, and hot, but it sets metal type as efficiently as the end product permits. And as for its noise, the clatter of mats has a cheerful ring, one that you tend to hear now from a single machine operated in some die-hard print shop. When they were the tool of choice, large newspapers had composing rooms of thirty or more linecasters roaring along, with top operators setting five to seven lines of type a minute. That breakneck pace, which might "hang the elevator" by setting lines faster than the machine could handle them, is utterly dwarfed by current photocomposition output at 40 lines per second.

The Linotype has been eclipsed as a type production tool, but it took more than half a century to improve upon it. The first Linotype was installed at a New York newspaper in 1886, and many surviving machines are thirty years old or more. Photocomposition began to replace metal typesetting in the 1950s but linecasting continued alongside it for many years, and even now the odd, indestructible Linotype rattles on, setting type.

Photocomposition

The linecasting machine dominated typesetting for over sixty years, and for photocomposition to unseat it required a change in printing technology itself. Hot metal type had no shortage of flaws, but there is little doubt that photocomposition would never have shoved it so rapidly aside on its own merits. Printers, after all, had invested in a whole host of equipment that supported metal type. From font libraries to storage systems to special headline casters, a type shop had a large stake in hot metal. Phototype could conquer this devotion only in part because of its superior properties.

Central to the acceptance of the new process was the move toward offset lithography and away from letterpress. Linecasting suited the letterpress method perfectly, but the raised image type had to be converted into a printed proof for use in offset. On the other hand, pho-

tocomposition output consisted of film or paper, ideal for the next photographic step in offset. Both forms of type could be converted into a plate for either process, but the extra step introduced a drop in quality and additional time.

In essence, photocomposition is a technique for making a type image with a light source, type master, and photosensitive material. Photocomposition can be superimposed on a linecasting apparatus, as the first generation machines were, or utilize a digitized type master, as the third generation machines do. Technologically in between these approaches is the equipment using a photographic type master and a flexible imaging system. These second generation machines were inexpensive enough to motivate many companies to bring typesetting in-house, and they exemplify the photographic type imaging process in the clearest way.

First generation photocomposition

Though the principles of photocomposition were impressive in their novelty, it's always asking too much for inventors to fly too far into the future at once. The first photocomposition pioneers seized the central idea that a photographic exposure from a type master could be made at varying enlargements, but they also superimposed this improvement on existing linecasting machines. The cherished matrices, magazines, and spacebands of the linecaster were retained, but the mat now held a photographic master instead of a sunken type image. Only the casting process was really changed, while the keyboard, type transport, distribution, and justification methods remained.

The first machine to leap from cast to photographic type was a painstaking adaptation of the Intertype linecaster. Herman Freund, an Intertype engineer, spent eleven years developing the Fotosetter. In 1948, the public got its first look at it and at a machine launched by Mergenthaler called the Linofilm. Both, of course, sought to produce output in harmony with the rise of offset, but the Mergenthaler device took an even shorter step toward the future. The Linofilm simply arrayed mats of ebonite and photographed them. Though it managed to include a photographic process, it missed the central benefit of sizing type with a lens system. It was hastily packed back to research and development.

These machines have been classified as first generation photocomposition devices. Phototypesetting has several core advances over typecasting, and all of them were advanced in the second generation machines that followed.

Second generation photocomposition

Sixty years after the first Linotype was installed at a newspaper, two French inventors demonstrated a machine based on setting type with photographic masters to potential American investors. Rene Higonnet and Louis Marius Moyroud were able to develop their invention with the backing of Lithomat, a plate-making company. Three years after securing Lithomat's support, the typesetting machine, named the Photon, was shown at the 1949 American Newspaper Publishers

Association conference. Lithomat changed its name to Photon and the company's president, William Garth, Jr., went on to found Compugraphic in 1960.

The Photon was a second generation machine that ushered in a new standard of typesetting speed. It used a stroboscopic lamp to expose the type master. All the early photocomposition machines were burdened by limitations of the photographic chemistry of the time. In fact, it is the speed with which a successfully dense exposure can be made that dictated the top speed of the equipment. Early film and light sources posed a serious constraint here, but the limits were short-lived. Kodak contributed the lens system and kodalith film that were critical to realizing the Photon.

When second generation equipment hit its stride, two dominant approaches to the lens system emerged. One used a lens mounted on a rail that zoomed to various focal lengths, which were effectively the points of magnification of the type master. A zoom system allowed an image at any point size, since the range was as fluid as the zoom action. The other system racked up several lenses of different focal lengths on a turret. When the operator called for 12-point type, the appropriate lens rotated into position. This approach led to slightly better type, for a fixed focal-length lens is always sharper than a zoom. However, it limited the set sizes, and many a type specifier would bemoan the lack of 14 point on certain machines.

The central idea of using a film master to represent type delivered typesetting from the physical problems inherent in casting. Consider the limit on productivity in the linecasting machine, a device with a top speed of 10 newspaper lines per minute. A linecaster was a virtual warehouse of moving parts, and there were strict physical limits on how fast mats could travel and be cast. In contrast, phototype systems were based on spinning disks or strips as type masters. This master had an indexing system by which a keystroke caused the disk to spin to a particular character and stop for the duration of an exposure. Once suitably fast photographic material and suitably bright light sources were brought to bear, second generation machines of the late 1970s could produce about 50 lines per minute.

Photocomposition also conquers some other problems in cast type. A type shop could maintain a much greater range of fonts since a base expenditure for a family of roman, italic, and bold also delivered a large size range. (There are some quality drawbacks to this approach, however. See page 61.) The fonts were easier to store, less expensive to produce, and less susceptible to damage from wear and tear. And even though linecasting was based on tidy magazines of type, there was ample opportunity for mats to become loose and mixed in the wrong magazine. With phototype, this problem was eliminated.

Moreover, the splendid cycle of casting and melting down type was not always appropriate. A metal type shop often had to preserve its galleys for possible future use, pulling the metal out of circulation and requiring a large, bulky storage system. Visit any hot metal typesetter and you'll probably find shelf after shelf of old galleys stored in large racks. The weight of them alone inspires awe.

Casting itself leaves not a little to be desired, of course. Between the

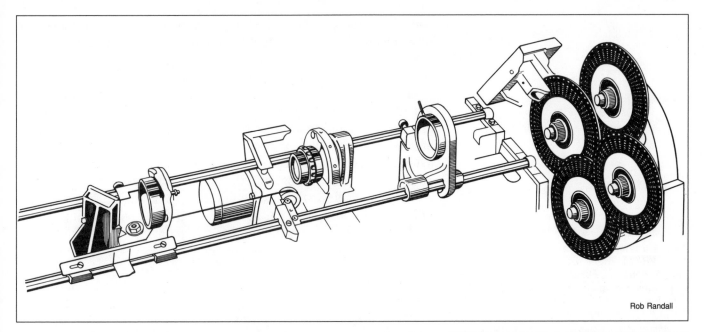

Rob Randall

heat, potential contamination of the metal, and random clogs of the mechanism, the entire process is neither dependable nor elegant. Phototypesetting equipment is quieter, lighter, and, of course, cooler.

But perhaps the most conspicuous advantage to phototype is the move away from physical characters with limited positional freedom. Photocomposition makes hanging punctuation, negative leading, and true selective kerning possible. To make the images, an escapement system moves the writing beam of light from a lens across the paper, and a finely controlled paper advance permits delicate vertical adjustments. Add in the capability of overlapping photographic exposures and you have a near infinite potential for positioning type. Phototype also ends the need to make up two galleys for a ruled or tinted subject, one with the type and the other with brass rules and benday screens. These were printed, in register, to position rules in a chart or place screens behind type. Form design, if nothing else, has changed greatly since phototype cast off those production shackles.

In 1954, a Massachusetts newspaper installed the first commercial Photon. Throughout the '50s and '60s, a slow but certain move toward photocomposition was under way. Kodak spurred the drive along by producing new paper, film, and chemistry that helped unleash the equipment's potential speed. Dymo, Varityper, Harris, Berthold, Mergenthaler, and Compugraphic became key vendors. And the sun set on ATF, the great consortium of type foundries, which managed to release two respectable photocomposition machines, only to be sold to another company, which promptly cut its research budget drastically.

Keyboards

The benefits of phototypesetting were immediately apparent in the late 1940s, but they were somewhat offset by a new host of troubles. Making a correction in metal type was straightforward: lift the incorrect line out and insert a corrected one. With phototype, correcting a line involves a few extra steps, plus the great possibility that the

The lens and type master system used on the Varityper Comp Edit series of second generation typesetters. The four type disks are mounted on a turret that can swing any of them into play. The stroboscopic light mounted above the active type disk locates the character to be set by its unique bar code. Note the rail on which the projection lens is mounted. The machine slides the lens along the rail to produce type at different sizes. The angled block on the left end is the mirror that will project the image of a character onto photo paper.

correction line will squirm out of alignment after paste-up. Further, proofs were then a good deal more complicated to create than they were from raised type. Still, these difficulties pale beside the operator retraining necessary to cope with the new keyboard.

The Linotype keyboard layout makes many concessions to the machine, not the operator. The keys were aligned with the magazine's chutes, and it was important to put the most frequently used characters at one end so that the mat distribution process would move smoothly. These practicalities conspired to place the most constantly used keys all together under the operator's left hand, an imbalanced and awkward arrangement. Nevertheless, as any typist knows, once you learn a keyboard, the knowledge is as deeply ingrained as breathing.

Keyboard layout of the Varityper Comp Edit, with the QWERTY layout for typing and command keys for functions. For this machine, many frequently used functions are given dedicated keys, like the line length setting on the key at top left in the left-hand panel. After striking that key, the operator can enter a measure in picas. Editing keys are on the right, and file maintenance keys on the top.

The new photocomposing machines of the late 1940s had to offer the operator some way of following his work. The cathode ray tube monitor wouldn't appear until 1968, and for two decades typesetting would be done with crude displays. The first of these was supremely logical at the time: an office typewriter was simply drafted into service as the keyboard. The operator could see his work on an otherwise superfluous piece of paper, while the keys closed electric circuits to cue the type master. The Photon machine looked downright reassuring to office workers, and probably looked suspiciously like furniture to Linotype operators.

The typewriter's QWERTY keyboard layout has done its small part to hinder human progress since the first commercially successful machine appeared in 1874. The manual typewriter was a series of levers and bars, and one of the most formidable obstacles to its operation was the propensity for these bars to jam. Anyone could tap the keys faster than the bars could flip up to the paper, strike an image, and fall back down. The typewriter's inventor, Christopher Sholes, sought to prevent these collisions and commissioned his mathematician brother-in-law to devise a keyboard requiring the maximum amount of finger movement, thus slowing down the typist. The QWERTY arrangement succeeds admirably in its mission of peak inefficiency. If we owe the convenience of the typewriter to it, perhaps it's a reasonable price to pay, but the further we move from bars and levers, the more unfortunate the choice appears.

With the advent of photocomposition, the world moves from a keyboard that clusters all the frequently used keys too close together, to a keyboard that was created to restrain typing speed. The burden of retraining linecasting operators was large enough, but converting to yet another unproductive keyboard makes the entire process a dismal

often enough, but now that electronic keyboards are under more fingers than ever, the interest in alternative layouts is rising. The Dvorak keyboard layout is a compelling alternative, designed for maximum efficiency.

Though retraining typists will be a perpetual excuse for keeping QWERTY alive, it's interesting to note that the keyboard layout has more of an effect than the technology beneath it. *The Guinness Book of World Records* notes that the top speed achieved on a manual typewriter was 147 words per minute, in 1923. You will not be impressed to learn that the highest recorded speed on an electric typewriter was 149 words per minute, in 1941. This is a minuscule improvement compared to the speeds attained on alternative keyboards. An average typist works at 125 or more words per minute on ideal keyboards, while the secretarial standard for QWERTY is about half that. Keyboard layouts will always place absolute limits on typesetting productivity.

As photocomposition evolved, the equipment was endowed with more and more features—and generally with more and more keys to summon them. There have been two schools of thought on keyboard interfaces. The dedicated key principle is based on the belief that a discrete, labeled key linked to a function is most efficient. The operator is in no doubt about what a key labeled "directory" will do, and even though the keyboard becomes overpopulated, it's simple to see each key's purpose. The other concept involves the use of precedence keys, and is something of a step beyond the shift key on the conventional typewriter. When the shift key precedes a keystroke, the typist gets a different letter than the unshifted version, thus doubling the number of tasks a set of keys can do. Precedence key systems presume that minimizing the distance the hand must travel is important, and that remembering a few key combinations is just as easy as learning many positions on a keyboard. Typically, a special key called something like "command" is used before a regular key is struck. The manufacturer might design the sequence "command—l s" to precede setting the letter-space value, for example. A keyboard might include several different precedence keys for a very large set of commands.

The dedicated key system offers lack of ambiguity and the smallest number of keystrokes. The precedence key system offers a smaller keyboard and a reduction in the typist's range of movement. Both systems have advantages, but the precedence key approach is now the most widely used. One reason it works well despite the need to learn many key combinations is that typists learn physical patterns for their fingers. It's easiest to learn patterns when your hands stay well oriented and don't travel far.

Third generation photocomposition

The initial principle of photocomposition replaced typecasting with photographic imaging. There was then ample opportunity to improve upon the nature of the type master, and the third generation machines are often called digital typesetters to emphasize the new method of font storage. Instead of using a photographic master, digital typesetters store characters as data that can drive an electronic character genera-

Carol Wigger of Hemmings Motor News *uses a Varityper Comp Edit. This second generation machine featured a screen showing 80 text lines and a preview mode that simulated the size and position of type on the composed page. The preview mode was only available for review, not during input.*

tion process. These machines use a scanning process to make type images, originally as an electron beam painting a cathode ray tube (CRT) and later as a laser scan. The idea of a CRT imaging process does not require digital character storage, and some typesetting machines like the Compugraphic Videosetter used photographic masters to direct the CRT scan. The twin benefits of digital type storage and rapid character generation account for substantial progress in typesetting.

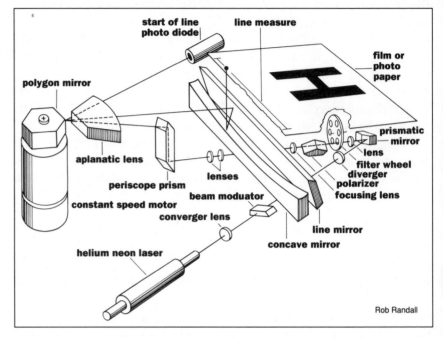

A schematic of laser type imaging. A raster image processor calculates the scan, instructing the laser beam to make marks based on the proper size and position of type. The type itself is stored as outline and fill data that the RIP converts. Note that the image apparatus includes a series of mirrors and lenses that project the scan onto paper, film, or printing plates.

The first digital typesetter was demonstrated in 1965 by Rudolf Hell. The machine was called the Digiset 501T and, like all the early machines, had the kind of stiff price tag and fast output speeds that could only appeal to newspapers and other high-production installations. For many years, digital typesetters were the rare but impressive machines that operated at the high end of the market, while second generation equipment continued to evolve.

By the early 1980s, however, typesetting vendors managed to produce digital equipment appealing to almost any budget and quality requirement. High volume equipment like Autologic's APS-5 could churn out 3,000 newspaper lines per minute, while their economy model, the APS-micro 5, clocked in at 1,000 lpm. Compugraphic and Varityper had already slugged it out for a decade as they sought to bring second generation equipment to every ad agency and publisher in the land. Now they offered digital CRT type at compelling prices. These vendors established the real bridge to the third generation by making it an economic evolution as well as a technological one.

raster image processing

To paint a CRT screen, characters are stored as stroking data. A master data set could produce other sizes by varying the length of stroke segments and by changing the frequency of strokes or the space between them. In addition to type images, the CRT can be painted with halftone dots and any other graphic image, paving the way for a revolution in page assembly. Further, the type image can be distorted

by angling the writing beam. The CRT approach quickly appeared to be an interim step, however. The strokes on a CRT screen were focused by a lens onto photosensitive material. A more advanced method uses a computer-controlled laser scan.

Laser imaging opens up the possibility of entirely nonphotographic typesetting. Laser writing engines similar to those in photocopiers can be used to make type images through the xerographic process. This printing process is based on exposing an electrically charged surface to light. Where the light falls, the charge is neutralized, and when the surface is brought into contact with a positively charged toner, the toner adheres only to the negatively charged areas. The toner is then transferred to paper. Though this process is inadequate for making type images of acceptable quality, it can be used to proof type, and is particularly useful in desktop publishing applications.

Laser imaging in a phototypesetter involves using a laser beam to expose photosensitive material. Because the image on the page originates as digital data, graphics and halftones can be included. But the laser image process requires a raster scan to write the image in horizontal marks, pixel by pixel. This means that the entire page must be in the computer's memory before imaging can begin. There is no way to ask the scanner to pause while retrieving additional data to complete the image. Further, a raster scan output device would normally use a discrete master for each character at each size. A raster image processor (RIP) helps to cope with these problems and to generate the complex images necessary for screen tints, halftones, and other graphics.

A RIP can scale characters from master digital data, performing calculations on a base data set. It's also used to construct a page, providing the raster output device with a complete set of instructions before imaging begins. The infinite range of type sizes, positions, and fonts presents a challenge to any RIP, but as you'll read in the next chapter, the PostScript RIP can print any image and has made desktop publishing possible.

digital advantages

Digital type is distinct from second generation phototype in its method of storage and output, and these changes have more than theoretical repercussions. Among the positive consequences, the digital image cannot wear out, the equipment has the capacity to provide extremely fast output speeds yet operate with very few moving parts, and the imaging system avoids the imperfections inherent in optical lenses. Further, the imaging system can draw rules, graphics, and even half-tone dots as well as type, integrating all components of the page. Though it isn't always practical to digitize every element on the page, the potential is there when computing power and memory warrant.

Digitizing type at Bitstream, a digital type foundry. At top, the letter n *in the Charter typeface is digitized from a master drawing. Above, the outline is complete. This arc and line data will drive a raster image processor to produce type at different sizes.*

There is another potential benefit, not always seized by typesetting manufacturers, of storing the type design as several masters. Most second generation machines work with a single film master and several lenses or magnification settings to scale the characters up in size. This means that a 36-point *e* is simply a gross enlargement of a 6-point *e*. Digital type storage can overcome this problem, and four or five different design masters can be used for the size range.

Type as software opens up many fruitful possibilities, the first of which has been desktop publishing. A corollary of storing type digitally is sharing the data or, more precisely, allowing common software to drive unrelated hardware. A second generation typesetter not only had specific film masters that suited it alone, it also embedded the job of moving the master and calling up the width tables in the electromechanics of the machine itself. Digital type is, in a sense, totally portable. However, the early third generation phototypesetters were based on just as many proprietary systems as their predecessors. The notion of machine-independent fonts didn't arise until 1985.

digital drawbacks

Unfortunately, digital type is not perfect. In fact, it brings with it such a significant flaw that its weakness is even famous: "low resolution" has even become slang for "disappointing." To understand the heartbreak that lies ahead, we have to examine the digitization process itself.

It took the computer's tireless calculating ability to make it practical, but the concept of digital representation itself is as old as Pythagoras. Digital storage and reproduction is based on the conversion of continuous forms, like sound waves or photographic tones, into a series of measurements, expressed numerically. Imprisoned as absolute numeric values, information can be transmitted without distortion and repeated indefinitely. The inherent fidelity of a digital representation is limited only by the precision of the numeric sampling procedure itself, but it's functionally constrained by its necessary re-emergence in the real world of continuous forms. The digital sound recording process, for example, stores sound with great precision, but this "perfect" digital information must drive a set of speakers that produce sound waves in their continuous, or analog, form.

No matter how fine the grid, alignment of strokes in the pixel grid can affect the clarity of curved strokes. A stroke exactly one pixel wide must align with the pixel array, and an arc must fall with its peak aligned to the grid, as it does in the left example here. In the center, the arc is flattened, and at right it's bumped too high.

Metal and photographic type have infinitely varying contours and are analog forms. So is any printed letter. The problem is not so much digitizing type, but getting it back into an analog form for printing. You can think of the digitizing process as imposing a fine lattice over a character and saving the tiny squares that result. The finer you dice the character, the more accurate your image and the more complete your sample. Though you might sample with great frequency, obtaining the type master by scanning at a high resolution, there are many practical limits on output resolution.

The first of these is the memory requirement imposed by the great amount of data you sampled. The direct result of the dicing operation is a mosaic of pixels, and it can be a very, very large number of tiles. A pixel, short for picture element, is a dot produced by digitizing an image. A 12-point character with a resolution of 1200 lines per inch requires 40,000 pixels per em. This is an excessive amount of data for almost any computer memory, and it's even more ponderous for the

computer to process and manipulate. There are some strict economic limits on the cost of high resolution that will remain even as computers become more and more capable.

There is also a shortcut. Instead of saving each and every tile in the mosaic, why not save the outline alone? The interior is all going to be black; all we have to do is tell the laser or CRT when to start painting and when to stop. There are several methods for representing character outlines, from the run-length code that stores the on-off points for a set of vertical lines to the arc-and-vector system that draws a smooth outline from mathematical data.

These methods reduce the data we must store to represent a font, but they don't relieve the demands on computer processing. In fact, the more compact the data, the more calculations are necessary to interpolate it. Though increases in computer processing speed are almost monthly news, we are currently looking at some practical limits on type resolution. It's clearly possible to increase output resolution, and the cost, in processing time, is easy to reckon. As the technology permits, resolution will increase, but it is likely that there will always be a practical boundary here.

sampling

Digital sound recording is based on preserving data that describes sound waves, and then reconstructing the sound waves in a speaker. To store a letterform digitally, we record the spatial frequencies of the shape and reconstruct it with a light source. You can think of spatial frequencies as varying in brightness and in space, while sonic frequencies vary in volume and in time. The more frequently the source is sampled, the more accurate the sonic data; the closer together it's done, the more accurate the spatial data.

In both audio and spatial digitization, the number of samples we take affects the potential for reconstructing it clearly. The worst case is easy to visualize. When a curve on a shallow diagonal is sampled, there is always one point at which the grade changes abruptly. If the gradual change in a curve becomes visibly stepped, the spatial record is compromised. We cannot eliminate the need to make abrupt shifts. That's inherent in digitization. But we can conceal the problem by sampling and reconstructing data in such fine increments that we cannot see the jagged edges.

The output resolution of a digital typesetter is described in lines per inch, but you'll want to recall what that means in relative measurements. For a 24-point letter, resolution of 1200 lines per inch results in 400 lines per em. A 9-point character at the same resolution is drawn from 150 lines per em. This drop in resolution parallels our vision's decline in acuity at smaller sizes. But the real result is that although jagged edges are successfully masked, typographic nuances are lost.

It's not hard to suggest the appearance of type with a collection of pixels. But because the pixels are binary—either on or off, present or absent—they cannot define every possible shape and curve. In the example shown, an extremely coarse grid of pixels does a fine job of revealing what word has been typeset, but it preserves only the similarities between the two type styles, not the differences. They both

Three basic methods for creating a digital image of type. At top, the shape data is rendered as a pixel array that can be edited. This is the Bitstream font editor screen. Center, a run length limited image. The data consists of the points at which the strokes stop and start, not the lines themselves. Bottom, an image constructed from line segments and arcs. The points along the lines are anchors for the calculation of arcs. Top and bottom courtesy Bitstream.

become a generic serif face when digitized at a low resolution. Low resolution type, in short, is a direct threat to the nuances in type design.

Functionally, an output resolution of 1270 lines per inch does an acceptable job of reproducing type, while a resolution of 2540 lines per inch yields type as good or better than second generation output. Of course, output resolution is only half the equation. The type must first be sampled to create the digital data. Resolutions here should be 2000 lines per em or higher to maintain subtle lines and curves. The input resolution must be evaluated on the em, not the inch, because type designers draft at different sizes. We're trying to sample the original at a rate that preserves the thinnest line that can be drawn.

The quality of type images depends on the digital storage method and the output resolution. At left is the pure analog arc of conventional type, and in the center the arc formed by a digital font outline using vectors to define the shape. This curve is greatly enlarged here, but appears smooth at reproduction size. On the right, the stair-step quality of a bit-mapped curve. This shape is not smooth enough even with high-resolution output.

Even at the high resolution of 2540 lines per inch, we're still trying to trick the eye into seeing smooth curves and sharp edges. There are several tactics that digital font designers can use to overcome basic problems. For example, whenever a curve turns into a straight line, the digital transition is so abrupt that the line lacks grace. If the font editor or designer carves out a pixel right before and right after that transition, the subtle notch reduces the harshness of the line. On the other hand, the outermost points on a

This editing screen shows a character with some of the adjustments necessary to suggest a smooth curve. Note the isolated pixels along the outer edges of the letter. These help smooth the appearance of the curve by keeping the arc from looking too flat. On the inside of the letter, some pixels are removed to give the curve a gentle swell. These two editing techniques are called pointing and notching respectively. High quality type design requires editing by hand, not simple scanning and digitization.

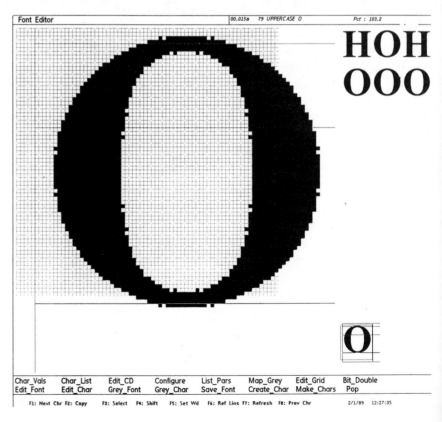

character often look blunt or rounded when a set of pixels comes to a dead halt. The font editor might increase apparent sharpness by adding one pixel at the point to draw the eye along a crisp edge.

Both these examples indicate the need to edit a type font, not simply scan and digitize it. They also suggest that a type design carries with it assumptions about its method of reproduction. The very fine serifs of Bodoni were made possible by improvements in paper, ink, and printing in the eighteenth century; type design changed. The reduced cost of type production in the age of photocomposition made it possible for ITC and others to issue an abundance of new, sometimes very unusual typefaces; type design changed. Recently, with DTP systems using extremely low-resolution office laser printers, type designers are producing fonts with simple curves and stresses; type design is changing again.

Digital type reproduction will continue to improve as computing power and memory permits. Whether type design will play to the strengths of digitization is another question altogether. In many ways, this would be a poor path to follow, for the construction of type from pixels or arcs is contrary to the nature of drawing. However, there is likely to be a fascinating intersection where the hand and computer meet and each can contribute its finest gifts. Beautiful type may result.

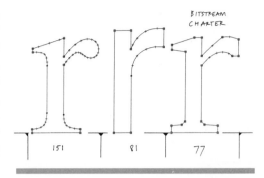

Designing type with low-resolution laser proof printers in mind means basing letterforms on as many straight lines as possible. Matthew Carter created Charter, shown at right, to work well at any resolution. Note the number of data points necessary in Times Roman, at left, and Helvetica, in the center. Charter requires the least information, yet its shape is nearly as complex as Times Roman's.

Here are the four weights of Galliard, designed by Matthew Carter. He began the design in the mid-'60s, and finished it in 1978, using a computer to perfect the design. In the drawing at right, the four weights are superimposed to help you visualize the relationship among them. The Ikarus computer system was used to develop the bold and ultra bold versions.

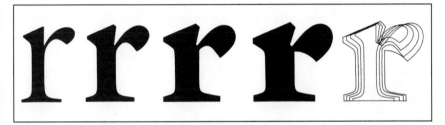

It appears we actually will stop at three generations. Several vendors have attempted to earn the coveted description "fourth generation" with new products, but the marketplace has resisted bestowing the title. If any technology is likely to secure the next number, it may be based on a radical change in image formation, a great increase in output speed, or new methods of combining line and tone images. It appears more likely that the next chapter in this history will retire this numbering scheme and embark with new terminology. "Imagesetting" might be a good place to start; type is, after all, only a part of the printed page.

Setting phototype

With photocomposition equipment, computers began to take on some of the work of setting type. This has many consequences, among them the possibility of turning hyphenation and justification over to a machine. A typist might enter text but not resolve line endings, and so text entry could be separated from composition. However, when compositors format a page typographically, they have some very useful tools.

To start a job on a photocomposition machine, you install, or dress, the machine with the fonts required. For digital equipment, a great number of fonts might be online at all times, but second generation machines use photo masters and generally hold a maximum of four type masters at one time. Then you load the font widths into the machine's

memory to equip the hyphenation and justification (h&j) routine with character values.

Whether the screen helps him visualize the type or not, the compositor types in the typesetting parameters. If he is working blind, he must follow the copy markup closely. If his terminal previews or simulates the set type, he has an easier time confirming that the markup specs are correct. Typing text might be almost all a compositor has to do, but even an automatic h&j system occasionally balks at an overset line and summons the operator to intervene. Except for the earliest, crude displays, the screen shows the typist the line breaks the machine is executing. Most systems also include a status line that shows the line measure remaining so the compositor can establish breaks on his own.

A compositor could load an unformatted text file created on an off-line terminal and apply typesetting specs. He could also bring up a file he composed previously and enter corrections in the body of the text. Sometimes corrections were set as isolated lines and pasted over the errors in the original galley. If the changes were extensive, you might correct and rerun the entire file. This ensured that corrections didn't peel off, slide out of alignment, or vary the thickness of the galley to obstruct the vacuum contact necessary to make a sharp negative or plate. It also saved time, since cutting and pasting correction lines is a tedious business.

courtesy Compugraphic

The Compugraphic Integrator Series combines network operation, microcomputers, and the company's high-resolution digital output imagesetter. A plain paper laser proof printer is shown at right, while the compositors use personal computers with Compugraphic's Powerview monitors to preview type and design.

When you typeset from files on floppy disks, every keystroke is preserved and changes are easy to make. This principle is now obvious to everyone using word processing. The idea of keeping the job fluid, with the possibility of adding material and changing type specs at any time, was once quite new and the source of delight to compositors accustomed to typing, say, every listing in a telephone directory every year. At last resetting was not synonymous with retyping.

Many machines offer a batch processing background mode that composes one file while the operator enters text in another. In any case, most typesetting machines handle h&j as batch processing, which means the operator does not see line endings until calling for a file to compose. Systems with interactive h&j keep the operator informed, but may perform the task sluggishly. A great deal of computing power is necessary

to make h&j take place so smoothly that it appears instant to the operator. The compositor could send batches of lines off to the photo unit for output, or he could accumulate text on floppy disks. The output phase was therefore kept separate from input and formatting.

Each machine's type imaging system is unique, but functionally they all project light in the shape of type onto photosensitive material. It is as easy to expose film negatives as it is positive photo paper, so one can go straight to plate-ready film from the typesetting machine. The photo unit exposes paper or film scrolling out of a continuous roll. When the job is complete, the operator picks up the light-tight photo paper cassette and sets off for the photo processor to develop it.

Processing type

Though each generation of photocomposition equipment uses a different method to make an image of type, they all share a similar means for completing the photographic process. Photosensitive paper or film is exposed by the machine's imaging system and developed in a chemical processor.

Phototype is a high contrast photographic subject. There are no intermediate tones, only a pure black image on white paper. However, a type shop must control precisely how black the type is by monitoring development times and chemical strength. The density, or darkness, of the type must match throughout a job and meet a standard for adequate contrast. If the chemistry is weak or exhausted, the type density will drop towards gray. This may affect the quality of printing negatives or plates. It can also make it impossible to assemble a mechanical of consistent density from several batches of type.

When the density drops significantly from the norm, the type itself will appear light and thin. Type that's too dense will also reproduce poorly. Generally, an extreme change in density is caused by an incorrect exposure in the phototypesetting machine itself. This can be compounded by development problems, such as inconsistent developing times or chemical temperatures. As a type buyer, you need to evaluate the density of the photo paper or film. The quality of the type image can be degraded if the processing is done incorrectly.

Compared to metal linecasting, photocomposition is a great stride forward mechanically. It's quiet, cool, and uses very few moving parts. Sadly, the processor brings at least a few mechanical problems back into the picture. A processor is loaded with moving parts, and while it isn't too loud, its chemicals have a distinct odor.

Plain paper typesetting promises to silence even those objections. The laser printer used to make type proofs in desktop publishing applications gives us a preview of that future. Right now, the writing engine in a laser printer is incapable of the fine resolution we expect of type. A photographic method is still required to maintain a sharp, clear image. But the gap between laser printers and photographic imaging is narrowing, and plain paper type may soon be feasible.

Other typesetting methods

Photodisplay machines are still commonly used to set headlines, particularly when distortions and special effects are sought. These machines use a photographic master to expose a narrow strip of paper. The operator sets the line letter by letter, and on some equipment he's responsible for the spacing between each character as well. Some machines must be used under safelight conditions, but others seal the photo paper against light as the operator adjusts the type master above the imaging area. Drop shadows, compression, screens, and a host of other effects are the principal benefit of using headliner machines.

Dry transfer sheets are a very handy source for instant type or art. These are thin film images that a designer can rub off a backing sheet onto a layout or art board. Using presstype well is not always easy. As you rub down each character, you must maintain baseline alignment, letterspacing, and word spacing. You can correct a mistake by peeling up the poorly positioned character, but of course you destroy the letter in the process. Despite the effort needed to transfer presstype to paper letter by letter, it's a very useful product. If you have a large enough library of sizes and styles, you can use presstype to visualize a headline or logo in type swiftly. Dry transfer sheets of rules, ornament, and symbols are also available.

Typesetting futures

Our present technology is moving toward maintaining text and type in a purely electronic state. The digital data in a word processing file represents the message itself, while the font that will shape the message in print resides in a digital form of its own. These two streams of information are moving closer together and can reside in the same microcomputer. Desktop publishing is one manifestation of the flexibility of digital technology, but it won't be the only application.

Communication itself is becoming more and more electronic, but it doesn't appear that we want to take paper and printing out of the flow of information. Instead, we want to use electronic means to control the image that gets on paper. Messages will begin to carry more and more typographic qualities, at an earlier stage, as individuals are equipped with the means to produce them in type. It is possible that we'll think more graphically when we can move our words so easily through a process that controls their appearance. Desktop publishing gives us the first tools for this next phase of print communication.

Desktop Publishing

```
% !PS-Adobe-2.0
/SS { /Temp save def } bind def
/SetMetrics
2 {.5 add 4 1 roll} repeat
2 {.5 add 4 1 roll} repeat
/y1 exch def /x1 exch def
/y0 exch def /x0 exch def
newpath
x0 y0 moveto
x1 y0 lineto
x1 y1 lineto
x0 y1 lineto
closepath
clip
/reencdict 12 dict def
/IsChar {basefontdict /CharStrings get exch
known} bind def
/MapCh {
dup IsChar not
{pop /bullet} if
newfont /Encoding get 3 1 roll put
{pop pop}
/beta exch 10.0 div def
/alpha exch 10.0 div def
0 dyFromTop mx1 translate alpha mx2 rotate
mxCharToUser concatmatrix pop
/spotfunction
1 add 4 mul cvi
/sm cellsize dup matrix scale def
32 0 0 167 167 0 0 1 /Galliard-Roman /font29
ANSIFonf font
32 2 SJ
1147 519 955 (he practice of) SB
32 0 0 125 125 0 0 1 /Galliard-Roman /font 29
ANSIFont font
1739 649 603 (typography) SB
1739 649 35 (,) SB
32 0 0 58 58 0 0 1 /Galliard-Roman /font 29
ANSIFont font
1 SetBrush
0 setlinecap
0 setline join
```

excerpt from the PostScript file that produced page 25

When small, inexpensive copying machines first appeared, many people wanted these personal copiers for their offices or homes. It is safe to say that these people didn't specifically want to make copies, but wanted the capability to make copies. No one is captivated by this menial task, but we are all likely to be keen on getting our work done with a minimum of outside help. In short, we'd like control and if control brings with it extra work, it may still be a fair trade.

Desktop publishing is quite similar. From its first appearance on the Macintosh in 1985, DTP offered you a chance to write, draw, design, edit, typeset, paste up, and print your work without using any professional suppliers. Emotionally, the idea of self-publishing strikes an important chord in many people. Practically, businesses note that the idea promises savings, direct supervision, and reduced reliance on outside vendors. In both cases, the real issue is control. Control is so desirable that it entices creative and commercial people alike, yet they both must accept the new tasks and new relationships that it brings.

By definition, DTP must be simple. It must be a task people can accept on their way to their real goal of achieving the purest kind of authority over their work. DTP software is indeed properly viewed with awe, for it succeeds in giving the user instinctive mastery of much of the page makeup process. In little ways, DTP reminds the user he's paying for the control he gained by doing the job himself. But in return, the technology gives him exactly what he craves: the ability to control the form and content of his work.

DTP has been handed over to everyone from secretaries to magazine editors to technical writers to graphic designers. It is always worth noting whether or not these users wanted DTP for their work, or were producing work that someone else believed should be completed by them with DTP. Many people, with diverse jobs, find DTP engaging and productive, and many a secretary will become proficient with it. Still, we should recognize that we've reached another stage in the evolution of this technology. The first people using DTP were like people who bought cars in order to go on a trip. The next wave of people, who have been made into DTP production workers, are like chauffeurs. Both types of user care about the horsepower and capabilities of their vehicles, but only the first group may find the driving itself appealing.

Publishing and people

At first, the triumph of equipping a computer to produce typographic communications led us all to overlook the fact that publishing is a group activity. One stand-alone machine may reverberate with potential, but the long cycle of creation, revision, editing, approval, and correction does not suit an isolated computer. This is another way of looking at the control issue, with emphasis on the need to share the product if not to share the labor. Even if a DTP system allows a single person to carry his words through to type, he is likely to want comments and direction from others.

It really does fit on the desktop, but it takes quite a desk to hold the laser printer, computer, and large screen monitor that comprise a typical workstation.

As of this writing, the group nature of publishing is a hot topic among software and hardware vendors. A network alone is not enough, since a network principally allows shared resources and movement of files. For all the aspects of publishing to migrate to microcomputers, every piece of software and hardware must be integrated toward that end. One hint at the future is the recent introduction of document management systems. Such software operates on a network and provides an environment to track progress, retrieve files, and maintain revisions to a project's components. But this is only the first of many products that publishers will need to make DTP feasible for complex projects, large groups, and diverse applications.

DTP and computers

Desktop publishing is probably the most demanding use for a microcomputer yet imagined. It tends to push hardware to its limits and then suggest yet another capability the hardware should address. It tends to emphasize the essence of the user's operation of the computer, focusing our attention on the graphic interface that lies between the machine's operating system and the application program. And it tends to put infinite possibilities at the heart of software design and imaging systems, for DTP by definition must permit any type and any art at any size—an elastic continuum of images far beyond the com-

The Macintosh II, currently the dominant platform for desktop publishing, is shown here with Apple's Laserwriter IINTX printer. This printer uses the Motorola 68020 processing chip, a Canon print engine, and the PostScript page description language that helped make desktop publishing possible.

plexity of a database or spreadsheet. In many ways, DTP pushes the computer industry forward. Some manufacturers sense that clearly: both the first computer from NeXT, Inc. and the current machines from Sun Microsystems make publishing a prime capability. The future may be difficult to predict, but it is evident that DTP is no brief craze. It will mature and merge into applications that are indistinct from traditional composition and page makeup. Maybe it can even lose its "desktop" epithet. And maybe we will soon look back at the typewriter as a very temporary peculiarity in the arc between writing and printing. Type will be everywhere.

Quality and complexity

For the first time in the history of typesetting, the people given the new technology are not the people who used the old. One consequence is that people using DTP literally can't appreciate how these new tools work. It should surprise no one that traditional vendors of type and design at first looked upon DTP with everything from apprehension to open hostility. As some early work proved, amateurs do not make good designers and typographers just because they have access to the tools. Perhaps more irritating still, a DTP novice may dare to complain about how much work it is to do something like set tabular matter. Yet he gets an accurate simulation of the type size and position on a screen, a mouse, menus—all instruments denied the hard-working traditional compositor who finds the DTP user's complaint ridiculous.

DTP is torn between the need to be simple enough for noncompositors to use and complex enough to give a sophisticated user all the nuance he obtained with traditional systems. To add another twist, publishing on the computer is really a finishing operation. The user pulls text files from different word processing programs into a document. Then he collects art from diverse sources, some electronic, some conventional. He uses a page makeup program from one vendor and fonts from another; he makes proofs on a low-resolution laser printer in his office and then calls for final output from a high-resolution

machine at a remote site. DTP is sometimes as much integrating resources as it is setting up a page in type.

The need to make it simple enough to be tolerable has had an effect on typographic capability. Part of simplicity is operating speed, and software developers may avoid including certain features to reduce the program's demands on computing power and memory. Then too, some DTP developers assumed both limited typographic interest and sophistication on the part of users. Of what possible advantage is it to offer tracking to someone who not only hasn't heard the term but hasn't a clue as to how to set the values? Originally, it was fashionable for real typographers to dismiss all DTP products as hopelessly crude, but refinements have put some page makeup programs on a collision course with professional typesetting systems. We can take it for granted that computers, displays, and output devices will offer more and more advancements. There is still a gap between DTP and conventional composition, but it exists primarily to preserve ease of use. There is no reason to assume it will remain. Users can demand it be abolished by becoming educated enough about composition to utilize (and insist on) advanced features. In turn, users will have to accept greater operational complexity, longer training times, and the need to take on more responsibilities.

Simplicity of operation and typographic quality are not mutually exclusive properties, but they do have difficulty converging. The DTP marketplace will probably evolve with some products anchoring the ease-of-use aspect for simple applications and others charting the highest end of sophistication and complexity. Pressing hard on the former are word processing programs that offer font changes, placement of graphics, and general formatting features. Constricting the latter are traditional composition systems that can finally migrate downward to microcomputers or draw users upward toward more powerful workstations. In examining competing systems, you may want to let typographic issues be the decision-making watershed, but you will want to consider operational details as well if you're thoroughly envisioning the system in a work environment.

The discussion of DTP that follows is entirely based on procedures and products that enable you to produce true, high-resolution type. Implicit in this approach is the use of PostScript-equipped, high-resolution output devices, which will be described in detail. Making an image in type on office-grade laser printers is not typesetting by any definition used here, though proofing type on such machines is appropriate. The typographic quality of desktop publishing can be quite high, and it's fitting to focus our examination on the systems that provide the best quality possible.

New relationships

A DTP system proposes that an author become a typesetter, that an editor become a designer, that a secretary become a production manager, and that a designer become a color separator. All these new relationships occur because DTP places the originators of print projects closer to production. For some people, DTP is a natural extension of their abilities, and for others it's extra work for which they're ill-

suited or ill-disposed. Perhaps the greatest initial fear was that DTP would fall into the hands of people with that deadly combination of high graphic interest and low graphic competence. The screen was so enticing and the software so responsive that nondesigners would be swept away and unleash dreadful publications on us all. They would promptly overrate their abilities because they had always known what they liked in the way of graphic design. Producing it themselves, from scratch, was about to be too simple to resist.

This particular fear about the world's safety from bad graphic design was somewhat exaggerated. Though amateur work continues to embarrass us, we've also seen a new wave of interest in the real fine points of design and typography from some enlightened amateurs. If anything, people may now have a better appreciation of design. And the initial luster is wearing off now. The editor who thought he'd take over all the production tasks for his magazine wearied of his duties after the second issue. We're back to sharing the work, recognizing the talents of others, and turning to outside vendors when the need arises.

Desktop publishing is about three years old as of this writing. It stretches no one's memory to look back at its origins, but it continues to stretch everyone's expectations.

DTP origins

The slow and steady evolution of page makeup was pointed toward what we now call desktop publishing for many years. From an early point, the logic of merging typesetting with paste-up was clear. A bit later, the desire to equip the compositor with a preview of his work was realized with display terminals that could show type at size and in place. The wisdom of utilizing electronic manuscripts to eliminate repetitive typing was almost immediately championed, and vendors provided interfaces to make the awkward bridges that would later become shorter and smoother. Of course, this work was taking place on mainframe or minicomputers, for the idea that micros would be powerful enough to handle the tough task of hyphenation and justification, let alone image placement, was laughable.

Desktop publishing was born on the Macintosh computer, and it could have emerged nowhere else. The Mac uses a bit-mapped display, ideally suited to the representation of type and graphics. By contrast, IBM-class computers normally use character-based displays, which limit the images on the screen to letters at a single size in a single design. (See the sidebar on page 160 for a discussion of screen image technology.) Further, the Macintosh was introduced with a laser printer at its side, which was equipped from the outset with the versatile innovation that made DTP possible: PostScript.

PostScript

PostScript is a page description language, capable of printing any image—rules, tints, type, and the bit maps or vectors that comprise graphics. It contains algorithms that scale fonts to any size from raw font outlines. PostScript can handle the three distinct types of images: text characters set in type fonts; vector graphics, which are line segments and the coordinates for their trajectories; and pixel arrays, which

are bit-mapped graphics. Most important, PostScript conceives of text and graphics as the same kind of data. Fonts are stored as outlines, not bit maps, and the scaling algorithm that draws them preserves the high quality of digital type. Further, the type can be rotated into any position as easily as it can be scaled in size.

While PostScript itself is a published language, Adobe, the software company that developed it, has kept the "hints" that adjust type scaling a trade secret. Thus, competing page description languages (PDLs) may be able to implement the PostScript commands and routines, but they must develop their own methods for scaling type and overcoming the difficulties in producing the curves without distortion and jagged edges. Further, other digital foundries must build in their own methods for scaling type cleanly. Pure mathematical scaling produces flawed type in the smaller size ranges. The type outline data must be interpreted over very short spaces, and the information that made a graceful arc in 18 point may produce a stubby curve in 8 point. Scaling hints are adjustments in interpretation to correct such deficiencies.

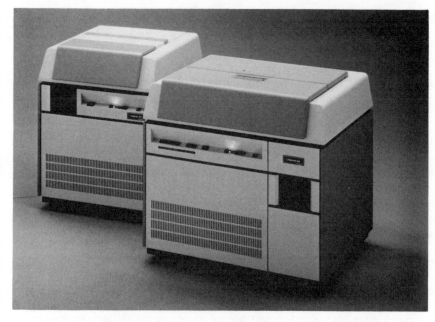

Linotype made the first high-resolution typesetting device employing the PostScript page description language. Shown here are the Linotronic L300 and L500. Photo courtesy Linotype.

PostScript was developed by John Warnock and Charles Geschke, and first appeared on the Apple Laserwriter in 1985. It is licensed to printer manufacturers to make their equipment capable of producing the rich graphics of drawing and page makeup applications. Apple sought out PostScript for the Macintosh because the new computer it was about to launch used bit-mapped graphics for its display that could not be reproduced by daisy-wheel printers. Though Apple could (and did) offer a dot-matrix printer, the company needed to provide letter quality printing as well. Only a laser printer would serve. Apple developed the Laserwriter hardware, and turned to Adobe for a page description language to make the printer print.

device independence

From the outset, PostScript was not constrained to the Laserwriter. It was conceived as a device-independent language, and though it wasn't the first of these, it's the one that has been widely accepted. Its

competition includes Hewlett Packard's PCL language, Xerox's Interpress, and Microsoft's GPI. Device independence means that typesetting and page formatting can be done without regard to a specific printer. You can proof a page on a Laserwriter and then obtain a high-resolution version from a typesetting machine when both output devices are equipped with a PostScript interpreter.

A page description language like PostScript serves as the bridge between composition and output devices. Unlike conventional typesetting systems that use proprietary routines for input, output, and composition, a PostScript-based system uses the language to connect disparate machines, smoothing over their idiosyncracies. The task of composition includes creating a PostScript file that records the state of the page, and the act of printing involves using a PostScript-driven raster image processor (RIP) to make the image. You can think of a PostScript file as instructions for making an image of a page, not the page itself.

Screen and printer fonts

Functionally, all DTP applications rely on supporting the operator's work with a simulation of type and graphics on the page. The benefits are obvious and stimulated efforts by manufacturers of conventional typesetting equipment long before the Macintosh was introduced. When early simulation terminals provided this longed-for benefit, they were dubbed what-you-see-is-what-you-get displays, or WYSIWYG. From the outset, WYSIWYG has deserved an adjective or two: what-you-see-is-fairly-reminiscent-of-what-you'll-get might sum it up. The first simulation terminals of the 1980s provided generic screen fonts and a rather diagrammatic representation of the page. Digitized graphics might be shown only as blocks representing their size. Nevertheless, these displays were a significant advancement.

To understand the difficulties inherent in producing type and graphics on a cathode ray tube (CRT) screen, you'll want to consider the process used to make a screen image and to bear in mind that users always want much more than accurate simulation: they want fast screen response to the changes they make.

Two basic principles can be used to paint a CRT screen, a raster scan or a vector display. In both cases, the appropriate phosphors in the monitor glow when bombarded by electrons. Vector displays draw line segments on the screen, while raster displays charge selected pixels that constitute a grid of lines and columns making up the display.

Display imaging

Vector displays are based on representing characters and graphics as the mathematical functions necessary to describe lines. A vector is a starting point and an ending point for a line, or a starting point, curve anchor points, and ending point for an arc. Vector displays can position elements anywhere in virtually any size because they're not constrained by a pixel grid. They're more accurate and, in the early days of limited computing power, they were far faster in response time. For example, when the operator moved a block of type, a simple mathematical adjustment to the vector data swept the image to the new position. In a raster display, each new pixel coordinate was calculated to make the move. One drawback to vector display images is the limitations on vector data that can be processed quickly enough to refresh the screen. Each letter consists of several bits of vector information, and it's all too easy to exceed the processing power of the computer. A raster image, by contrast, never needs any more data than what's required by the fixed array of pixels. Finally, vector displays are incapable of simulating tones or photographic imagery.

While vector displays were the best early solution to simulating type on CRTs, computing power soon reduced the sluggish response times of raster displays. A raster scan CRT uses an electron beam that sweeps across a series of horizontal lines, called rasters. The beam can change in intensity as it moves from position to position, altering the brightness of the image. This is the method used in television and most computer monitors.

The scanning process must be swift enough to keep the screen from flickering. A beam typically takes one-sixtieth of a second to cover the entire screen, which is fast enough to keep your eyes from noticing the phosphor refresh rate. Changing the electron

type and graphic images

The job of making type images at any size was a daunting prospect. The Adobe developers had to scale type from font outlines, and had to avoid the jagged edges, jittery baseline alignment, and varying stroke widths that would normally mar type generated this way. They succeeded, but they made this aspect of PostScript proprietary and encrypted the refinements of font scaling within the program.

Specifically, PostScript uses character width data called font metrics to position type in a line. A DTP page makeup application also uses font metrics to perform the calculations for composition. Users may obtain fonts from any source they choose and provide these font metrics to their computers. But note that the specific font software used by the output device may not match that in the page composition program. While PostScript forms a sturdy bridge between page makeup and output, the two tasks may not share the same versions of a font. Adobe sells fonts, but so do other software houses, and PostScript does

beam pixel by pixel and line by line could require extensive memory resources, and two methods address this functional problem.

A character generator can free the computer from constructing each letter from pixels. Instead of determining which pixels to charge to represent each letter, the computer uses the ASCII code for a letter to retrieve a predefined pixel array. The character generator is fast, inexpensive, and allows the system to devote very little memory to screen imaging. However, it confines the display to characters of a single size, width, and design, located in predefined columns and rows. It is this limitation that originally made IBM-compatible computers so unsuited to desktop publishing. A computer that relies on a character generator can't make typographic images on screen.

Bit-mapped displays

The alternative method for conserving memory and permitting fast response is bit-mapping characters. Here, the memory is arranged as a pixel grid and the characters or graphics are defined as bit maps that will turn pixels on or off. Now we're utilizing every pixel on the screen instead of a coarser grid one character wide and one character deep. However, to calculate the requirements of each character on a pixel basis will quickly exhaust the computer's processing power. Instead, it retrieves data in the form of bit maps that represent whole characters. The bit maps themselves can be scaled in size to a limited degree by operations that uniformly increase or decrease the number of pixels while retaining the form of the letter. This scaling operation doesn't produce particularly elegant results, so a range of bit

maps for each font are necessary to produce type at different sizes.

A display using bit-mapped fonts is ideally suited to DTP. Bit-map representations of typefaces are reasonably simple for vendors to construct by scanning the original type. These screen fonts can represent true type well enough for most design decisions. The Macintosh uses a bit-mapped display for all applications, and relies on Apple's QuickDraw software to create screen images. QuickDraw makes it simple to supply screen fonts to the computer, but it limits screen images to the conventions Apple implemented. For example, QuickDraw controls the level of color data available to a monitor. Most important, QuickDraw is not PostScript, which means that the screen cannot mirror the printed page. Apple has released a laser printer that uses the QuickDraw screen information to produce pages, ensuring a match between screen and printer. But QuickDraw is not yet a rich enough page description language to rival PostScript for type and graphic output.

For an IBM-compatible computer to work as a DTP platform, the character generator must be shunted aside and a bit-mapped display inserted in its place. Microsoft Windows and Digital Research GEM are both operating environments that permit bit-mapped displays for IBM compatibles. Without them, desktop publishing would not be possible on such machines.

The screen fonts used in any DTP application are not high-resolution type. When you purchase a font package, you receive both screen fonts and printer fonts. The DTP program uses character width information from the printer fonts to compose text, while the screen fonts approximate the results.

not demand Adobe fonts. Type designs and character widths vary, and there is currently no system for policing consistency between composition and output. In short, PostScript cannot actually guarantee that a page will print the same way on any PostScript output device.

Seeing what you set

Anyone in the 1960s who knew what a photocomposition machine did but hadn't seen one in operation probably assumed that the operator was, above all, aware of what the typesetting machine was doing to the words he typed. At the very least, setting type would be like using a typewriter and seeing characters fit on lines. There would be special provisions for correcting mistakes and probably a new kind of display to show the operator what the typeset material looked like. Asked to imagine a machine that turned keystrokes into typeset characters, no one would have buried the entire process inside a machine that moved photographic masters and showed the typist none of the results.

Yet this was precisely the case with all of the early photocomposition machines. Using a typewriter without the ability to review the last line typed or correct a mistake in the paragraph above is an impediment to any secretary or author, but typesetting was considered a job divorced from both authorship and page format design. The compositor's role was very narrow, confined to pure typing with great concentration. As a single element in the assembly line moving text into print, typesetting did not address a manuscript's form or content and did no more than execute a designer's plan for the appearance of the typeset text.

That type of specialization, however, demanded that compositors understand their equipment and its potential extremely well. To make up for the machine's lack of prompts or visual feedback, compositors had to foresee the consequences of all typesetting commands. They defined results; they did not react to their progress and refine it.

Early photocomposition terminals displayed nothing more than the current line, with only those commands for type font, size, or position that happened to be within it. In the 1970s, it was a legitimate triumph when some terminals were endowed with two-line display. This accomplishment was swiftly eclipsed by the arrival of terminals displaying whole pages of text.

At the top of the screen, the Varityper Comp Edit presents the typesetting parameters in effect on a job. It was up to the operator to visualize the results, for the input text appeared as unformatted characters in a standard size and position. WYSIWYG terminals superceded this approach in the 1980s.

The composing process was then subtly divided between data entry and formatting. In addition to the full screen display, text files were stored on floppy disks, which permitted random access. Previously, punched paper tape recorded keystrokes for subsequent output, and though this allowed retrieval of data, it demanded a linear reading of the paper tape and was unsuited to efficient file updating. With full page display screens and the editing capability to roam through an entire

file, a compositor could correct errors, check style throughout a document, and reformat text with new commands before committing the results to photographic output.

This capability allowed compositors to move into the role of editors. They could revise manuscripts based on both typographic commands and stylistic standards, using provisions similar to those of word processing systems. The ability to manipulate text was resident in the system itself; now it remained for compositors to become editors—or vice versa.

It was, indeed, the other way around. Newspaper publishers responded to the potential of typesetting systems with so many editorial applications with an alacrity tempered only by their financial resources. The larger newspapers were the first to install composition systems utilizing a single CPU and output device serving many input terminals. Reporters had always typed stories, but previously these manuscripts were typed all over again in a composing room. If the reporter's initial keystrokes could be preserved and drive a typesetting machine, a redundant and time-consuming step could be eliminated. These composition systems not only gave reporters all the control over their stories they would exercise at a typewriter, they also saved time, permitting later deadlines.

The large typesetting systems that used reporters' original keystrokes did not make reporters into typographers. Though reporters learned to add typesetting codes to text, they were not asked to master the full range of commands and were not, for example, prepared to code and compose the paper's display ads. The compositor's role was still clearly defined.

Even with a full-screen display and the ability to scroll through it at will, a compositor was still missing something that is virtually instinctive to anyone's conception of what typesetting ought to be. In the early 1980s, composition terminals first included visual simulations of typeset material. At its simplest, a typist could now confirm that a paragraph had actually received its indent or that a tabbed table had roughly the visual balance required. The size, position, and relationship of typeset characters were visible for the first time. This set the stage for an entirely new approach to composition: trial and error.

Trial and error

Trial and error is such an ingrained tactic for problem solving that people are generally frustrated, consciously or subconsciously, when deprived of it. Most tasks include hundreds of steps or decisions, and it's easiest to make those decisions in response to the progress of the job itself. Imagine building a cabinet by defining the type of wood, length of cuts, style of joints, and means of assembly. It might be nice to have a machine help out by performing some of these duties, but so many decisions about the job are best made by reacting to the work that carpentry of this type would yield only the blandest of furniture. Visual simulation terminals put typographers in touch with their work in the most fundamental way. Now they could see the consequences of their choices and perfect the appearance of typeset text.

Terminals that simulate type were originally called soft typesetters

The FrameMaker screen display not only shows art and type, but the program lets you examine several components of a document at once. The index and table of contents shown here were generated automatically. The thumbnail view of the document along the left helps you visualize the overall publication.

and displayed a representation of output sharply constrained by the nature of CRT displays. They did, though, display an image based on the fitting characteristics of a specific type style, reporting the results of composition that had previously occurred invisibly.

A compositor could also use a simulation terminal to deploy simple graphics through either keyboard instructions or a lightpen or mouse. Two tasks were directly addressed by these terminals: marking up manuscripts with commands for size and position, and pasting up pages with rules in place and type positioned precisely.

Conventional markup, which demands that one know in advance what the result will be, tends to make people both more skillful at visualizing type and less productive. The smallest adjustment necessary to resolve a fit problem can't be made until text is set, and the feedback that is the logical basis for decisions is separated from the initial markup process. Trial and error takes the form of multiple settings, not rapid reactions to the effects of typesetting commands. The advantages of unifying page makeup, markup, and typesetting are obvious, and the method for linking them must include a display that gives the operator control over the work.

WYSIWYG was the rallying cry of typesetting manufacturers in the early 1980s. The WYSIWYG concept was based on a screen that simulated typeset output. This simulation turns a display terminal into a graphic device in its own right. Painting the screen with pixels representing different sizes of characters is a radically different matter than pumping out the same set of phosphors for every Q the operator strikes. Simulation terminals had to position type and rules on coordinates nearly as finely distinguished as the point system itself and at least hint at the difference between a roman and italic type style.

The overhead in computer memory required for such simulations made the next logical step a difficult one. Ideally, a typographer would type a line and watch all the positional effects immediately. He could correct a command or eliminate a widow as part of the data entry process itself. When all the results of a computer's operations are visible as they're summoned, the operator is working with an interactive machine that allows a typographer to adjust his work in response to specific, ongoing visual cues. Many simulation terminals, including ones used currently, work as type previews, not interactive displays. The typographer can request a simulation with one or two keystrokes, check his work, and then go back to data entry or formatting.

DTP has fulfilled the promise of these early WYSIWYG environments. In so doing, it has changed the nature of compositional problem solving. It has made trial and error a feasible method for fitting type and positioning graphics.

Trial and error is the fundamental technique by which we solve a huge array of problems. Many times, the trials themselves are only imagined, not articulated, but whether we judge tangible or mental results, we build our ultimate solution out of possibilities. In one sense, a desktop page layout system is the most flexible trial-and-error environment imaginable. Here is its deep psychological cachet, particularly for design novices who are convinced that by being able to see all alternatives they will produce beautiful pages.

No matter how much the screen display implies the freedom of trial and error, the user must set up a large number of size, placement, and typographic definitions in order to obtain results. The program will greatly affect the order and nature of these decisions, sometimes in ways which can't fail to stymie the loose, intuitive, and truly global way which human beings tend to reach visual solutions. For example, no matter how sophisticated the software, any page makeup program proceeds to act in a linear way: this page, that page; this block, that block. However, the basis for many layout decisions is quite simultaneous: this issue, this story, this idea. To refine these global ideas, people tackle the details, one by one, but their priorities among the details are not likely to match a computer-based sequence.

The requirement that problem solving proceed along a path that the user didn't create himself and which may not mirror his approach is the reason that the conversion to desktop systems can be uncomfortable. It's also the reason that the user interface is so important. Looked at in this light, the interface is not so much pleasant or unpleasant, but rather an environment that suppresses, as much as possible, the gap between conventional thinking-and-acting and the computer's insatiable need for instructions given in a specific pattern.

DTP system architecture

There's a tendency to think of DTP as a collection of products instead of a process. Buying the components is important, but working with them is the real goal. A DTP system includes, at minimum, a microcomputer and software for word processing and page makeup. Almost every user adds a laser printer to preview type output, and many embellish the system with a large, high-resolution monitor to work swiftly and accurately on each page. In some applications, a scanner feeds the system text or graphics in electronic form. Finally, users can add optional software to their systems, from drawing programs to fonts. Before discussing each of these components, it may be useful to look closely at the centerpiece of the system, the page makeup program.

The blank screen

A computer screen is just as blank as a piece of paper. No one is convinced he can draw because he has a nice pen or a particularly smooth sheet of paper. That blank screen can both entice and frustrate the new user, since all is possible and nothing is fixed in place. This example deals with the page makeup procedure generally, and each specific page makeup program will have its own flourishes and variations on the process.

First, you establish the dimensions and page length of your print project. You'll then get blank pages of the size you specify and with guidelines for the columns and margins you've set. The page will have dotted lines that are equivalent to the non-printing rules found on conventional mechanicals. But these electronic guides do much more than their paper counterparts. They are positional markers with the power to "snap" text or rules to their precise location. This principle is easier to see than to describe, but you can imagine why it's crucial for

```
┌─────────────────────────────────┐
│ File                            │
├─────────────────────────────────┤
│  New...                      ^N │
│  Open...                     ^O │
│  Close                          │
├─────────────────────────────────┤
│  Save                        ^S │
│  Save as...                     │
│  Revert                         │
│  Export...                      │
├─────────────────────────────────┤
│  Place...                    ^D │
├─────────────────────────────────┤
│  Page setup...                  │
│  Print...                    ^P │
│  Printer setup...               │
├─────────────────────────────────┤
│  Exit                           │
└─────────────────────────────────┘
```

PageMaker's file menu greets the operator with options for opening or closing a publication file, loading text (through the Place command), and setting page and printing parameters.

DTP. The screen cannot show with precision where anything is, but the computer can count and measure with great accuracy. By establishing a ruler mark and making the program obey it, a page makeup program can be as accurate as conventional paste-up. Of course, you can also place text without a ruler mark to snap to, but when you want to maintain an even margin or a specific coordinate, you'll use these snap-to guides.

Each program has its own implementation of menus and tools, but all follow the convention of offering you menu selections and allowing you to change your mouse's pointer into different tools. When it's a text tool, for example, you can type corrections or other text directly onto the page. When it's a cropping tool, it can position, resize, and crop graphics. When it's a drawing tool, you can make circles, rules, and squares. In all cases, you use the mouse to define where something should occur and the tool selection to define what should occur.

PageMaker on the Macintosh uses bit-mapped screen fonts to simulate type and gives the page makeup artist a clear suggestion of the composition of the page.

Often, the tool alone isn't enough to make your intentions clear. Each program has a set of menus and modes that you use to issue commands. As an example, you might make the mouse into a type formatting tool, use it to mark a section of text on the page, and then go to a menu to select a type spec to make the text italic. You make some selections by clicking the mouse pointer on a menu listing and others by answering questions the menus pose in dialog boxes. These boxes cascade down when you request something that requires additional specifications.

page makeup tasks

To start a project, the user imports text and art onto the electronic page. Page makeup programs are not well suited to text entry, and they have almost none of the features of word processing programs. For example, the search-and-replace capability that is standard on most word

processing programs is available in none of the mass market page makeup programs. Rather than type in the page makeup program, you summon text from a word processing file. It will pour onto the page following the column guide for line measure. If you've embedded commands in the word processing file, the text emerges with all those typographic aspects. If not, it appears in a default type style and size.

It's at this stage that all the design and planning for the project pay off. It may be tempting to set some columns and margins, bring in some text, and see how it looks. DTP programs don't require that you file a flight plan before taking off. But it's here, when everything is possible and nothing is fixed in place, that the DTP novice becomes discouraged. There are simply too many possibilities. While it may seem logical to try to design by getting the thing itself under way, you will doubtless find that a preliminary sketch or two will focus your efforts. It's probably accurate to say that ten minutes of rudimentary planning will save an hour of roaming around with the mouse.

type specifications

Each page makeup program offers you a particular way of assigning type specifications. More important, they vary in their typographic controls. Some don't provide features like tracking, and others don't give you the control you might like over something like letterspacing. Details aside, the basic job in DTP is assigning type specs and positions to text elements. In a way, this entire process is interactive markup. You select some text, assign a type spec, look at the results on the screen, and revise the spec if necessary. The type becomes a fluid form on the page, rejustifying when you change the line measure by squeezing the column tighter, and repainting the screen in response to font changes.

One of the conventions of electronic page makeup is the maintenance of the order of the text. Unless you specifically delete and move some of it, a text file stays in its original order. Though you may move columns and text blocks all afternoon long, you can't scramble the text by accident (as you can all too easily when piecing together a conventional mechanical). Some page makeup programs use a frame metaphor to control the position of text and others use a more free-form system, but all follow similar schemes for organizing text. This amounts to a structure for filling a space with the file you've called up for placement and, if you make that space too small for the text to fit, giving you some options for continuing the text stream elsewhere.

Further, each application will give you a particular method for establishing space around text blocks and graphics. Sometimes you may want to link this space with the text itself, like the extra leading you'd want between a subhead and text. Other times, the space is a function of design alone and has no intrinsic relationship to text. You'll find there's a real difference between placing an element somewhere on the page and calling for a certain amount of space after a headline or around a graphic. You'll also find spatial relationships should change when text flows forward or backward to make new column or page breaks. One of any program's most beneficial aspects is its support of elastic text boundaries. When you add something, text moves onward to accommodate it. The text behaves exactly as you'd want it to—unless,

of course, a change in position affects the relationship to illustration, the space at the top or bottom of a column, or the general layout of the page. Then you may have to intercede and make some manual corrections and position changes.

graphics

Most projects also include art. If you're using conventional halftones, you'll simply size the art back in the three-dimensional world and transfer the size to the page makeup program by drawing a square to represent the art's position. This keyline is just like a regular mechanical's, and you can specify whether it is to print or to disappear.

If you want to include electronic graphics or scanned halftones, you can import the art just as you did the text. These images can be scaled and cropped right in the page makeup program and help you visualize the completed page. Many users find it's useful to scan photos and illustrations just to create dummy electronic images. These scanned versions aren't used for final printing but are helpful on the screen when designing the project. However, a scanned halftone greatly increases laser printing time, and in some production situations they slow down proofing prohibitively.

Though you'll need an illustration program to produce complex vector-based graphics, you can draw rules, boxes, and ellipses directly in a page makeup application. You are guaranteed that lines will be in square and rules will appear in the precise line weight specified. As any mechanical artist knows, these benefits are not insignificant.

Apple's Laserwriter II printer is one of the most popular PostScript output devices. The 300-dpi output is fine for proofing type, but inadequate for fine printing. Photo courtesy Apple.

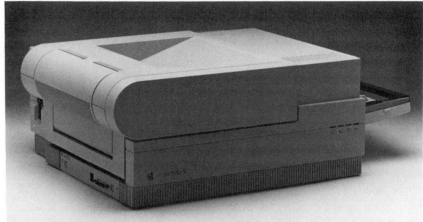

finishing touches

Now there are generally some finishing touches. You may use the program's capability to number pages automatically, and to repeat a footer or header on each page. It's likely that you'll add some rules or boxes you create in the page makeup program. Finally, you'll depend on the great flexibility of the program to solve odd little fit problems, to rewrite a caption to run on three lines exactly, to make the corrections a proofreader calls for, and to move a subhead just a little higher in order to balance two columns of type.

These kinds of finishing tasks take a great deal of time. It's safe to say that fitting and fussing with the page will account for perhaps three-quarters of the time spent on it. While you're most likely to see a

demonstration of a page makeup program in the act of zipping in text and zipping on type specs, you will spend most of your working life moving a text block down a half a pica in order to get rid of a widow in the next column.

Output

You have probably been printing out the page at several stages along the way to finishing it. If you've relied exclusively on the screen, the printed proof you examine now is likely to reveal some areas that need revision. A computer equipped with Display PostScript utilizes the same instructions to paint the screen and to drive the printer. This promises to reduce the disparity between printed output and screen display. However, even Display PostScript will not eliminate all surprises. A laser printer has much greater resolution than a screen, and you'll want to use it for proofs at several stages. Proper kerning, for example, can only be judged with laser proof output.

The steps described here are simple enough, and they stay that way. DTP becomes complex when the user demands intricate fit, extensive typographic control, and other fine points. You may have a project that stretches the page makeup program to its limits, but the approach to each step remains the same.

Hardware

Selecting the computer that will hold your DTP application is a critical decision. The moving target of computer technology resists formal discussion here. At the moment, DTP is principally placed on Macintosh computers or on DOS-based equipment, such as the IBM AT and the many IBM compatibles. More powerful computers from Sun, Apollo, and NeXT will soon be handling mainstream DTP as well. The major distinction among all these computers is their operating system.

Macintosh computers use Apple's proprietary operating system. Among other distinguishing features, the Apple system has a consistent interface that helps a user quickly grasp each new software application since all commands are issued in a similar way. The user interface is graphic, relying on icons to symbolize commands, locations, or files. The Macintosh operating system is largely transparent because the interface allows the user to direct the machine without remembering commands or communicating with the computer in a constricted language.

IBM and compatible computers use the DOS operating system developed by Microsoft. DOS has a reputation as a hostile or at least indifferent operating environment. Broadly speaking, DOS requires the user to issue commands to perform file maintenance tasks or to load application software. Because the command syntax itself is both terse and extremely formal, users must remember that, for example, "MORE<READ.ME" will cause a text file to appear on the screen page by page, but "MORE>READ.ME" will cause the More utility to overwrite and obliterate the Read.Me file. Most important, it's up to the user to initiate commands; there are no menus or prompts to suggest how to proceed. DOS gives the informed user great control over the computer because it makes no assumptions about the approach the

user may have and it allows direct manipulation through commands. By contrast, any operating routine that simplifies, say, program loading makes some assumptions about that task that a user can't control. With DOS, one must know in advance what the computer can do and how to request those actions.

DOS is likely to linger in the computing world, but a new operating system called OS/2 is currently in joint development by Microsoft and IBM. Notable to desktop publishers, OS/2 will use a graphic interface called Presentation Manager, thus borrowing an idea from the Macintosh. In this environment, a user is greeted with menus and icons that prompt actions, reducing the burden of educating the user in the ways of the machine. A precursor of Presentation Manager called Windows, also created by Microsoft, is currently used for the screen display and overall environment in which some DTP applications operate on IBM-class equipment. Machines with DOS use character-based displays, not the bit-mapped images that allow simulation of type and graphics. Windows and other operating environments like GEM make DTP possible on IBM-class equipment because they take over the display and use bit-mapped images.

Sun and Apollo computers use the UNIX operating system, long considered powerful but difficult to use. There are promising indications that a graphic user interface will help mask the cantankerous qualities of UNIX and that DTP will make use of these more advanced work stations. Currently, only highly sophisticated applications are using UNIX-based machines. These programs rival traditional typesetting systems, but are also expensive and make greater demands on their users than mass market DTP products. Recently, the sophisticated page makeup program from Interleaf was ported down from UNIX to the Macintosh and the PC. Applications like Interleaf are typical of the complex document processing programs that work on UNIX platforms.

The NeXT computer uses the UNIX operating system and veils it with the NextStep graphic interface. More significant still, it uses Display PostScript for its screen display. Display PostScript is an implementation of the page description language for dynamic application on a monitor, as opposed to its static use in a printer. When an application program uses the PostScript language to define a page, it can project a faithful copy onto a monitor. Using PostScript to produce a monitor display is far more complicated than using it for output alone, since the display is ever-changing and must respond to the user's freeform revisions in type, size, placement, and so forth. Along with NeXT, IBM and Digital Equipment Corporation are planning to use Display PostScript on future computers.

You have a difficult choice in selecting a computer for DTP. It is hard to say which is moving faster, technology or expectations. There is a tendency to think the wisest course is waiting a little longer for the next breakthrough rather than purchasing equipment that can become obsolete. If you do buy, doubtless you'll have a chance to regret a choice you made if you decide to reflect on the accelerating pace of technology. If nothing else, you can lament how much you had to pay for something last year that's half as expensive today. But such

One of the major conventions of DTP is the use of dialog boxes and control buttons to enter commands. In an operating system like MS-DOS, commands are issued by typing a word or phrase of command syntax after the system's mute drive letter prompt. The Macintosh operating environment, by contrast, uses menus. To implement PageMaker on IBM-compatible machines, Aldus relied on the Microsoft Windows operating environment, and the screen above is from the PC version of PageMaker.

anguish is unnecessary. Every month you wait, you miss a chance to use the tools that are available now. They're going to get better, but they're useful enough even now. Most important, the sooner you begin to use this technology, the easier it will be for you to grow with it.

Page makeup software

You might think of a page makeup program like Quark Xpress or Aldus PageMaker as a system for writing a PostScript file. Your real goal is to produce a set of instructions for a printer that can make images of type and graphics. The best way to make sure that an instruction set is correct is to preview the results on a screen. And the fastest way to select the commands that will be part of that printer file is to work in the rich world of a page makeup program.

If DTP began and ended with PostScript, we would have to become skilled at writing code like "/Caslon-Italic findfont, 36 scale font, setfont...," and so forth. A page makeup program lets us write in the PostScript language by selecting commands from menus, indicating areas of text to which the commands should apply, and placing text and graphics freely with a mouse. You can work using infinite trial and error—changing your mind, moving things left and right, revising a type spec until the text and art fit precisely where you'd like them. You work with great freedom while the program compiles a PostScript file that reflects the state of the page.

Page makeup software is also in charge of composition. Typically, you load fonts from another vendor to give the page makeup software access to the type unit widths, called font metrics, and you also load data the program can use for screen fonts.

Adobe and Bitstream are currently the dominant type font vendors, but they each sell their products slightly differently. Adobe fonts are scaled during output by PostScript, which means that the page can call for any size of type but that output processing time may be lengthy. Mergenthaler, Compugraphic, Varityper, and Monotype all granted Adobe licenses to convert their type libraries for PostScript output. Bitstream type is aptly named Fontware and is sold with an installation kit that generates fonts to size for a specific application. The font becomes a file in computer memory. Bitstream is the first independent digital type foundry and produces new type designs as well as digitizing existing faces. Both Bitstream and Adobe offer screen fonts along with printer fonts to allow you to preview the type.

The page makeup program typesets text using specifications you provide through menu commands, style sheets, or codes embedded in the electronic manuscript. It draws font widths from the type package and applies them based on a specific output device the user assigns.

Choosing page makeup software generally requires evaluating two major aspects: the program's method of operation and its features, primarily its composition capabilities. It's impossible to offer definitive comments on products in the rapidly changing DTP arena. It may be more useful, in any case, to consider the major principles by which any page makeup software can be evaluated.

The page setup screens for the Macintosh and PC implementations of PageMaker. The operator clicks the mouse on control buttons to select options, or enters numbers in option boxes to define the number of pages and other settings.

Page makeup paradigms

All page makeup programs produce pages, and the buyer must examine how they operate, not what they create. Page makeup programs all have been developed with some ideas about what the designer actually does when making up a page. At the heart of the distinction among programs is a paradigm for what design and layout must become when computer based.

The designers of DTP software have to make some difficult decisions about how human beings will best be aided by a tireless but frankly witless machine. Beneath the central approach to any DTP system is the answer to the questions, what do people want to do for themselves and what do they want the computer to do? The related questions are legion: if we presume that a computer is extremely good at repeating tasks and keeping track of things (work that people would like to avoid), to what degree should the software dictate what keeping track of things really means? How do people make choices about what should be on a page, or what type should look like, or what a correction cycle should include—and how can a computer support these choices?

DTP systems can be broadly categorized as either layout oriented or document oriented. The document approach, best exemplified by Xerox Ventura Publisher, is based on one answer to the question of what machines can do for people. It swiftly boils down to two ideas. The first is that typographic specifications work in sweeping, global ways and can best be defined as discrete style tags. These tags are then linked to particular blocks of text, in effect defining something as a headline in a text file and defining what a headline looks like in a style file, with the happy consequence that a single change in the style file affects everything it should. The second principle is that the particular space text occupies is the least of your worries, while the efficiency with which it gets there is a prime concern.

document paradigm

The document paradigm originated to serve what's often called structured text, typified by a technical manual or a parts catalog. In these applications, the user has a standard physical product that must be updated as effortlessly as possible. If material is added, text should flow forward, and whether or not something is on page 13 now is immaterial. What is important is that conditional text, such as a footnote, index, or table of contents, is updated automatically. Further, the paradigm proposes that the editor revising material should not have to review or implement any typographic decisions. This assures consistency in appearance and saves time when styles are to be repeated. Finally, the concept assumes that wholesale style changes may be needed someday, but that the user has invested considerable effort in creating text to which new styles must apply. Therefore, discrete style tags can be changed in a single operation, and they'll proceed to affect all the text to which they're linked.

In general, this DTP concept supports reusable formatting and assumes what the user wants the computer to do is resolve fit problems in a document-specific, not page-specific, manner. Decisions the software makes on your behalf tend to be correct if the document, not the

page, is your core product. These programs rely on the convention of frames that hold text. The user assigns characteristics to frames and defines rules for their placement.

This DTP concept also assumes the user will want text to behave in a standardized way and will want conditional text to be automatically affected by placement changes. Finally, it assumes that a user can define typographic appearance, at least initially, without regard to particular text. In other words, the choice of type size and leading will have nothing to do with filling a particular spot and everything to do with classifying text elements.

As soon as we look at an actual program in use, however, we'll want to qualify at least that last description. Naturally, flexibility must be built into any application as complex as DTP. A document-oriented program offers the user maximum support performing the work described, but of course it's also prepared to serve other tasks. For example, the finest document program can't dwell in the idealized world of documents for long: every publication will have at least some corrections that are intensely localized. The ease with which the paradigm breaks down to accommodate an application that strays from its central mission is one key to its flexibility.

Document-oriented software may fall short of its promise at certain points. For example, the position of illustrations on a page may be related either to adjacent text or to a design principle that places art in particular locations. This is the kind of either/or option that suits human reasoning perfectly and software not at all. So far, no mainstream DTP program provides the user with a choice of linking art to text references or pinning it to relative page locations. No layout-oriented program does this either, but this is more a shortcoming for a document paradigm system. The document paradigm implies that pagination will become virtually automatic, and when it requires intervention the concept breaks down.

layout paradigm

The second major paradigm is usually called layout oriented, and is embodied by programs like PageMaker. At the heart of this approach is the idea that the user wants the computer to mimic very closely the steps a layout artist would take to construct a page. Not everyone will sense the benefit in making the computer's support of page makeup so relentlessly analogous to traditional paste-up, but for many users it's a valuable approach.

The effort to make page layout behave with a close relationship to traditional methods ultimately breaks down, and this makes the page paradigm a little fragile. While the document approach constantly calls attention to the fact that the user is defining things, the page concept keeps trying to let the designer respond to visual trial and error as he always has, even when this is a strain on man and machine. But PageMaker has made this process so graceful and intuitive that it nearly eliminates that strain. It even makes positioning type in a runaround a fluid task, augmenting conventional paste-up with the effortless control of type that designers have dreamed of. A layout-oriented application like PageMaker represents a technological exten-

sion of traditional pasteup, while document-oriented programs reconstitute pasteup to allow the computer to serve it.

After you make peace with some of the frustrations inherent in the layout metaphor, it's possible to find enormous support for design and placement decisions there. The central concept is that a user will position text and illustrations by focusing on a single page at a time. The program supports him by showing the consequences of his choices succinctly and by allowing him to make changes based on that information. Originally, PageMaker was a stern taskmaster and required the user to tack down each column of type individually. Now it's been upgraded with an automatic flow feature that allows the user to speed the basic placement of text and then fine-tune the arrangement, area by area.

The layout-oriented approach is often best for those who want the computer to help them with what they've always done. This means it's simple to learn because the capacities of the program are all known to you already, as you've performed the real-world equivalent of them many times before. A layout-oriented program increases the knowledge you have about the results of tasks you've done before, but it allows you to think about them much as you always have.

A DTP user must make adjustments, from how he thinks of his pages to how he thinks of the work he wants to do on them, but these adjustments can be invigorating. The central adjustment is a conceptual one toward one of these basic paradigms. Several programs are blurring the line now, with happy consequences. PageMaker creeps toward the document approach by offering style sheets and automatic text flow. Ventura loosens up by giving users a free-form method for setting tables. When a program begins embracing elements outside its paradigm, it's becoming more flexible and more valuable. The paradigms may break down so completely that we stop recognizing them, but for now they continue to influence the dominant method of working in a page makeup program.

DTP system components

There's a tendency to define a DTP application simply with a single software package, like Quark XPress or Ventura. These are indeed the heart of a DTP system, but a complete system integrates several other items. For context, a conventional typesetting system fuses many software functions in a single program and serves as both an editorial work station and a composition program. In comparison, page makeup software generally stops short of editing and text entry and gives you a wide range of output possibilities.

There are six aspects of the page creation process that electronic systems now address, and despite the impulse to obtain and integrate all six, publishers are wise to consider these applications as discrete. Though turnkey systems are available, assuring that hardware and software are properly matched, the potential user need not assume that combinations are excessively difficult to construct independently. The components of a DTP system can be clarified as facilities for text editing, text entry, graphics input and editing, composition and page makeup, screen display of page makeup, and output.

Text editing

For DTP, text editing includes both the usual chores of copy editing, fact checking, and editing for style, and the new job of preparing files for page processing and composition. The nitty-gritty of production work includes a generally overlooked procedure by which text files are named and shuttled into the appropriate subdirectory or folder.

The file management tasks for users of a DTP system can be a bit daunting, and desktop publishers are advised to contemplate their operational approach in detail. In general, you'll want to develop a system for identifying the constituent parts of a project and acquainting the page layout artist with the relationship of text, call outs, illustrations, and sidebars. Ventura, for example, offers the capability of linking an illustration with a section of text so that repagination takes into account context relationships. This is a very valuable feature, but your file preparation system must give the designer instructions on what elements should be linked.

The choice of a word processing package can be made with some independence from the DTP composition package. Editors and authors can use different packages, feeding manuscript through ASCII or, if available, through the DTP software's word processing conversion facility. The presence of extensive formatting controls in the word processing package itself can be a moot point.

Text entry

Most word processing packages offer features that exceed what's necessary to make a file that will be formatted in a page makeup program. Capabilities like pseudojustification and multiple columns are meaningless here, since these operations must be turned over to the composition software that works on the text at a later stage.

Though DTP packages have some limits on the word processing formats they'll import directly, all are happy with plain old ASCII, so any word processor that offers ASCII conversion will do the job of bringing text over. ASCII carries some irritating information with it, such as a hard return for each line that the DTP program must strip, but also refuses to convey some information you might like, such as underscores. Since each word processing program handles the attributes for indents, underscore, supershift, and the like differently, a publisher who wants to preserve everything in an original manuscript will benefit from using a word processing program that his DTP program converts completely.

Strict conversion of a word processing package can be inessential or even a hindrance. If you're working with footnotes, for example, you want to apply new typographic attributes to the superscript numbers, and this is best done with the page makeup software. Most page makeup programs include a filter or basic translation table for style commands. These allow you to place codes in your original manuscript that will kick off the appropriate parameter in the page makeup program. The author or editor uses such a code instead of the word processing package's command. (See the text chapter for more information on electronic manuscript preparation.)

Text capture and conversion

Publishers who wish to receive manuscripts in electronic form can use two tools to capture text electronically. A modem allows a properly equipped contributor to file his story over the phone, and a scanner converts printed text to electronic data.

A scanner with Optical Character Recognition (OCR) can translate marks on paper into ASCII blips. Plan on a bit of disappointment here, for OCR is easily foiled by such villains as photocopies, alien typewriters, and dot-matrix print. Your text file will certainly include some misreads, and it can be efficient to pass the file through a spelling checker to locate errors. Even after that, you'll still need to proofread, and scanning is far from the perfect text capture system.

Some scanners include software that flags unread characters, and some can be taught new letterforms. The latter is a tedious proposition, but can be worth the time if you want to read material from the same typewriter many times. The current roster of widely read type styles includes Courier, Prestige Elite, Prestige Pica, and Letter Gothic.

Special characters

Some particularly knotty problems stem from the central dilemma of representing characters–on the keyboard, on a monitor, and on a printer. Since you'll use word processing software to write and edit, you face one kind of screen and one method for communicating the codes that represent characters. Later, the text is formatted in a page makeup application, often with a physically different screen, but certainly with a different method for painting the screen with characters. Along the way, you might proof text in its word processing form as monospaced typewriter characters, and then you might print the formatted pages on a PostScript-equipped laser printer to see its typeset form. Finally, you'll use a high-resolution output device for true typesetting, perhaps with a different vendor's font set. Throughout, your computer's keyboard offers you only 94 different characters through the shifted and unshifted versions of 47 keys. Typesetting machines, needless to say, have always been endowed with many more. It's easy to see that we have two obstacles: the need to extend the number of characters we can type and see on a screen, and the need to have disparate applications agree on these extended codes.

It's no accident that a computer character set includes 256 items. Using 8 computer bits, each of which is either one or zero, to represent each character, there are 256 possible discrete codes (two to the eighth power). In this 8-bit scheme, the letter "A" is a set of on-off voltages in the computer that can be represented as 01000001. This character set is called ASCII, for American Standard Code for Information Interchange, and is pronounced "as-key."

At first glance, 256 characters sounds like a most accommodating number, but it has proved a troublesome limit for typesetting applications. The upper- and lowercase letters, plus numerals and punctuation, require 94 codes. Thirty-four additional codes are reserved for printer command sequences, such as carriage return and line feed. These constitute codes 0 through 127, or the low level set. The remaining 128 codes were first established by IBM, and are correctly called the extended or high level ASCII set. IBM's version includes characters used to produce borders and fill bar charts, of virtually no use to us in typesetting, and a few valuable symbols we will want to employ. Significantly, other suppliers have defined these high level keys quite differently. The Roman 8 character set used on many printers offers accented characters and other symbols. You will probably only notice what's missing when you need a special character, and when you need a special character, a disproportionate amount of time will be spent on getting that one symbol in print. Here's an example of the procedure necessary to represent the pi symbol.

Overcoming the keyboard

First, the word processing file is going to need to include a special code to represent pi. The 256-character limit is based on 8-bit data, but we can overcome this limit by using more bits to make up a single character. If we have two 8-bit segments, for example, we can use the first to signal that a new character set is in effect, and the second to identify the character. This is similar to using the shift key to gain access to a separate, uppercase character set. In traditional typesetting, this is called a supershift approach, or a precedence key system.

Each word processing program will have different

Graphics input and editing

A scanner is also the tool for hauling graphic images into your system electronically. With graphics painting or drawing software, you can create images or edit those retrieved by a scanner or imported from another graphics file format.

Graphics may appear in your page makeup package either as finished line art that a page description language like PostScript can print, or as the electronic equivalent of for-position-only (FPO) stats, showing a halftone image for design and cropping purposes, but not as reproducible art. At the moment, scanners can produce gray scale halftones but the output isn't yet satisfactory for high-quality printing. The scanner can resolve tonal information as pixels, but the 300-dpi limit restricts the outcome from rivaling true halftones. These scanned halftones can be placed during page makeup, but they're of interest chiefly as an aid to designing a page.

routines for permitting access to alternate keys. Some let you use the control, shift, or alternate keys on the IBM-style keyboard, or the option key on a Macintosh. Other have menus that you step through with function keys. Depending on the word processing program, you may either remap the keyboard or selectively call for characters from an alternate character set with commands. The first approach solves your problem permanently, and gives everyone using the revised keyboard a reasonably simple mnemonic if you use, say, control-P to remap the keyboard to represent pi. The second method requires that you remember how to identify pi as a special number or command.

Now the word processing program has new, useful information about the pi symbol, but the monitor does not. Whether the display uses a character generator or bit-maps, it must search for a special image to represent pi. In some cases, the character isn't available, but Greek symbols are a part of many display font sets.

Getting the symbol information to the word processing program and the monitor is only half the battle. To print it as hard copy is yet another challenge. A daisy-wheel printer is clearly constrained in its character set, but at least it reveals them all to you right on the wheel. It's a bit harder to be sure which characters a dot-matrix or laser printer will make available. You may need to test your printer's character set range to locate the character.

Typesetting special characters

Now we have to come up with a code that the typesetter and composition application will acknowledge. The effort we spent tailoring the word processing display is not wasted. Right before releasing the file for page makeup, we can perform a search-and-replace routine to substitute characters that the composition program will accept. Of course, it may not be enthusiastic about much of anything we have to offer. In this example, the pi character is part of a different font than the one in which the balance of the text is to be set. We're asking for a font change rather than for an unusual character within the base font. This means that a style tag won't do the job, but an embedded command will. Page makeup programs that don't accept such commands require that you change the type spec manually. In short, for many special characters, the word processing file cannot contain codes that translate properly.

Finally, the matter of revealing pi on the page makeup screen depends on the screen font in place. The symbol screen font does indeed have pi, but you must make certain that your page makeup program can use it. In Ventura, for example, you might have designated the extension for screen fonts as PSF, to allow Adobe screen fonts to be visible. The symbol font supplied with Ventura has the extension EGA. By renaming the file with the PSF extension, Ventura can use it to make pi visible on screen.

Printing pi on a PostScript-equipped laser printer is fairly simple. For the first time, the printer and the software are in agreement on the specifics of the font change and the character set. However, some special characters differ from font to font, so one last bit of frustration may lie ahead. This long example is as much a tour of DTP components as it is a tip for setting a Greek character. As you get more familiar with which element is in charge of what result, you'll be able to get the most out of your system.

Graphics

Paint and draw programs allow you to originate art at the computer screen. You may first become acquainted with paint programs by using them to clean up art you've scanned. A scanned image is a bit map, and within the paint program you can add or erase pixels and save the corrected image file.

Working in a paint program serves to remind you of the great gulf between your hand and the computer screen. You don't move the mouse as if it were a pen, but rather click to anchor a line, move the mouse, and click to finish the stroke. That's easy enough, but to draw an arc you must define its start point and end point with mouse clicks, and then add a tug or two on the initially straight line to curve it outward. This process is easier to understand at the screen itself than it is to read about.

A paint program allows you to draw shapes, fill them with patterns, and even produce tonal effects reminiscent of airbrushing. Some packages include the option of scaling and rotating type. The type in this instance is a bit map, like all the other data in the artwork. This means it isn't comparable to the quality of type produced from a true font. However, all desktop publishers who need to run photo credit lines on a vertical have at least been tempted to try the paint program's type rotation facility.

The drawing program is converting marks you make into bit maps. You can edit these pixels at any time by enlarging the screen image to inspect pixel arrays clearly. To a degree, these pixel arrays can be resized in a page makeup program and still print well, but resolution will be changing with resizing.

Drawing programs produce object-oriented graphics instead of bit

Optical character recognition

An OCR scanner gets information about a character through a photocell that measures the light the shape reflects. The black areas reflect no light and therefore cause the photo element's voltage to mirror their shapes. When scanning graphics, the process stops here: the analog voltage information is converted into bit maps. When recognizing characters, the process continues, and the shape is examined and converted to its ASCII equivalent.

There are two basic techniques for that conversion: matrix matching and feature extraction. The former seems, at first, to be bulletproof: the scanner's software includes a "map" of each letter in a specific typewriter style and it dutifully compares the scanned image to this roster until it finds a match. Working against its accuracy are random blobs and blemishes on the manuscript and the potential for tilted letters or a page skewed when fed into the scanner. It can also be a slow process, though most scanner manufac-

turers have developed some recognition shortcuts so that the software needn't march through the entire alphabet seeking a match. The shortcuts are based on examination of telltale areas rather than all elements of a letter.

The second approach, feature extraction, implies greater potential for matching a range of type styles. These scanners inspect overall letter arrangements. The panel can be stumped, but because capital H's generally consist of two parallel vertical strokes and a horizontal bar, a feature extraction scanner can make sense of a great number of H's on this basis.

If you receive electronic manuscripts in a variety of word processing formats, you may need text conversion software to bring the material into your own word processing program or over to a page makeup application. Though you can always fall back on ASCII as an intermediate file structure, you may want to preserve the spacing and attributes of the manuscript that ASCII can't translate. Several software products can convert the unique formats of a range of word processing applications.

maps. It's important to recognize the difference between bit-mapped graphics and these vector-based graphics. When the line or tone information for artwork is obtained as a collection of pixels, the data has an inherent size and resolution. For example, when scanning a line drawing of a floor plan, each black line is saved as a row of pixels that are on, and all blank areas are pixels that are off. This will paint a computer screen or produce an image on a PostScript printer, but the image will consist of pixels of a particular dimension in a particular array. To render these pixels as line segments, you can use an illustration program that lets you trace the shape and save it as a vector-based set of line segments, arcs, or circles.

Vector data is entirely different from bit maps. A straight line is defined as a *from* point and a *to* point. Only two data elements are needed to create a line, unlike the large set of discrete pixel locations necessary for a bit-mapped line. An arc can be represented by several conventions. The Bezier function, for example, includes a start point, an end point, and two intermediate control points that bend the curve. Sliding the control points changes the shape of the arc. All vector-based data is significantly more compact than bit-mapped data, requiring less computer storage and permitting faster output. Further, because it is saved as a mathematical function instead of a map, vector graphics can be manipulated in size and scale without loss of detail or line weight.

Composition

In DTP, the PostScript file defining the page may drive a PostScript device, or its instructions may be translated to drive a conventional typesetter. In the latter case, the instructions direct the imaging process just as input from that typesetter's own terminal would. The Linotype 202 uses a code called CORA, for example, which some high-end DTP composition programs can write.

The connection is clean and simple in theory, but it does have some potential pitfalls. The user is responsible for providing both ends of his system with clear font style and width information. If you install one vendor's fonts on your computer and a remote high-resolution typesetter uses the same fonts, things should proceed smoothly. However, if the composition program and the output device use different versions of a type, character widths will differ, and the output will not match.

Connections to conventional typesetters can be difficult, but the results may be worth pursuing. Even the task of acquiring character width data is fraught with inconvenience, for we're now using output fonts that won't match our page makeup program's fonts without modification. Nevertheless, conventional typesetting machines still outnumber PostScript-equipped machines, and many users want to take advantage of equipment they already own. Without a page description language like PostScript, graphic elements are outside the range of the output device, so conventional typesetters stop with producing type and rules alone.

PostScript continues to be the language of choice for DTP today. When relying on it and a set of fonts that matches those on the output device, you can compose pages with an accurate simulation of the results on screen and through a low-resolution PostScript laser printer.

Composition consists of hyphenation and justification, spacing parameters, type style and size selection, and all other aspects of positional control of type. When selecting a DTP package, professional publishers are seeking products that provide a high level of typographic nuance and quality. Features like kerning and tracking, now widely available, tend to be required. The ability to define minimum, maximum, and optimum word spacing is essential for fine typography.

A desktop publishing package's hyphenation system is of major significance. Dictionary-based hyphenation is accurate but slow; algorithm-based hyphenation can be speedy but may err on the side of either missed opportunities or bad breaks. Publishers will also want to evaluate the h&j program's control over successive hyphenated lines and the minimum characters before and after a break. You might want to refer to the typesetting chapter for information on standards for composition quality.

Student Alex Fattoruso works in the Bennington College publications office on a Macintosh preparing the alumni magazine and a weekly bulletin of campus events.

Page makeup

It takes an act of will to divorce page makeup from composition when examining interactive WYSIWYG packages such as mass market DTP products. Ventura, for example, composes a text file the moment you import it by reviewing the text for all potential hyphenation points. Then, with the text on the screen, the user proceeds to move and resize it, finishing the design of the page. Since the hyphenation points are already in place, the h&j process adapts easily to changes in type font and line measure. It's page makeup the user sees and works on; composition takes place invisibly.

Mainstream programs like Quark Xpress and Ready, Set, Go! fit roughly under either the layout or document paradigm discussed above. A third paradigm, represented by some high-end programs, is the direct evolution of conventional typesetting and could be called code-based batch processing. No matter how long you try to keep it from the user, typesetting requires codes, and these applications are honest about it: an editor or page makeup artist has to type out instructions on font size, style, leading, and so forth. To simplify this

routine, a high-end program like MagnaType allows you to designate a set of commands under a single format code that can be named logically. Computer users will recognize this as a macro capability. Editors don't need to type out a long line of code, but can instead say <uf22> to MagnaType, which will use format 22 in response.

From a practical point of view, you'll want to make some operational decisions about how much the editor has to code and how much the page layout artist should get into the act. Editors don't have to fill the file with instructions, but those typographic choices that are context based are best encoded when content is being examined. All these packages are at pains to make the coding task painless, and potential users should not be intimidated by the need for editors to embed at least some codes.

The batch element in here is an elusive characteristic. An interactive WYSIWYG package has to call time out occasionally to recalculate the page's type, but you remain in the middle of your primary task without having to request composition as a special operation. Batch processing is the computer's chance to go off by itself and follow a long set of instructions you've written for it. You don't see the results until the batch file is run. This is the opposite of interactive processing in which, delayed or not, your choices are mirrored on the screen. Code-based programs always have an aura of batch processing around them, but they make up for this by providing a page preview display, which you can toggle on and off.

Input devices

Whatever the page makeup paradigm, the user employs it to perform work he previously accomplished in the three-dimensional world. Aiding him in the transition is the mouse, which is designed to make movement around the screen natural and instinctive. Some page makeup packages don't require a mouse for control of operations, and at least one doesn't even support one; but for the most part, layout artists will benefit from using a mouse.

The mouse is actually a very sophisticated cursor control device that decodes ever-changing XY coordinates. Compared to holding down the left arrow key for five seconds, zipping the mouse around the screen is a pleasure. The movement always seems to mirror your search for a location rather than a cursor's slow journey to a spot you relentlessly chart for it.

Display

Asked to imagine the ideal editorial work station, one would immediately endow it with WYSIWYG at an imaginary zenith. The screen would be the typeset page, with graphics, halftones, rules, and text deployed precisely. In fact, writers would work here, comfortably typing away, watching line endings, positioning sidebars, and making notes about the need to get a certain illustration at a certain size.

What vendors mean by WYSIWYG may not be what your instincts assume it to be. A productive DTP system doesn't put each editor in direct control of his pages, but instead follows the conventional breakdown of tasks by asking editors to prepare manuscripts which

then make their way to a layout artist. At the page makeup stage, a WYSIWYG display allows the user to resolve fit problems by trial and error and to confirm that the work has received the proper type and positional codes. Someday, this environment may be a pleasant one in which to edit text, but only when the computing power necessary to create the display becomes a simple technological feat.

Display PostScript hints at this state. It will show the same type and graphics that the PDL will print. We can expect that computers will be powerful enough to meet its processing overhead and that all applications, from spreadsheets to databases, will be able to drive such a powerful display. For DTP, we're only concerned about endowing word processing and page makeup with such an accurate display.

Throughout the composition process the computer knows everything about the space the type will occupy, but this doesn't mean it can easily let you in on it. A display inherently disappoints the end user because the screen can never refresh fast enough to support your theoretically constant need for visual information. The act of inserting a single dropped character in a line of type can send the display into a paroxysm of rejustification. And the computer never knows where you'll strike next: the screen has to update the entire page, answering hundreds of questions you never even asked.

Monitors

Large-screen, high-resolution displays are usually considered optional equipment, but they enhance your ability to work on the page so greatly that you should probably think of them as required. On a typical 13" low-resolution monitor, you will not be able to read text type on a page shown at full size. To examine characters, you magnify the page and look at only a segment of it. Then you must expend a fair bit of effort moving the enlarged page around in the small window your screen opens onto it. If anything makes screen paste-up feel awkward and sluggish, it's this task of positioning and repositioning the page itself.

A large, high-resolution monitor solves this problem, and offers a clearer vision of the type itself. Resolution is measured in pixels per inch, and smart shoppers must perform several calculations to determine what a vendor's spec sheet really means. The number of pixels used to paint the screen must be placed in the context of the screen dimensions: a 1600 x 1200 pixel display on a 15" monitor is much tighter resolution than the same pixel count on a 19" one.

Output devices

Office-grade laser printers print at 300 dots per inch, a resolution just high enough to tempt many people into calling such a page finished typesetting. The defects in type and tints introduced at low resolution are very visible to anyone pausing to look. A 300-dpi printer is only useful as a proofing device for a quality print job.

There are several mid-resolution devices, printing at 400 and 600 dots per inch. This equipment produces work suitable for casual printing jobs, but it is still far from providing a proper image of type. Output from a 600-dpi device is appropriate for in-house documentation

and manuals, but it is still a step away from high-quality type. Only the high-resolution typesetting machines, such as the Linotronic L300, offer output comparable to traditional typesetting. The L300 has a resolution of 1270 or 2540 dots per inch, and uses the Adobe Saturn raster image processor, or RIP III, as a PostScript interpreter.

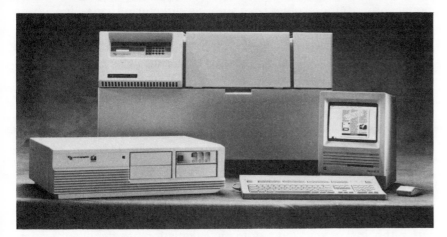

The Compugraphic CG 9400-PS is a laser output device that uses the PostScript raster image processor at 1200 or 2400 dots per inch. It's shown here with a Macintosh SE that can interface directly. Photo courtesy Compugraphic.

The low-resolution laser printer that becomes the proofing device in most DTP installations is a computer itself. It contains a processor chip, at least a megabyte of RAM to hold font data, and the PostScript PDL. There are two principal manufacturers of laser printer engines, Canon and Ricoh. The Canon engine, also appearing in its personal copiers, is large, reasonably fast, very heavy, and tends to produce weak blacks in large solid areas. The Ricoh engine solved the size and weight problem by some interesting imaging engineering, but paid for it with slightly slower operation. Though it produces an extremely rich, even solid black, it will tend to fill in small areas, like the counter of a 9-point *e*.

Laser printers are inexpensive as type-proofing devices and can produce multiple copies of each page. They're small, quiet, and far simpler to maintain than a photo processor.

Page processing

Typesetting is a subcomponent of a large task called composition, or the complete assembly of page elements. DTP is effectively a composition tool that includes all the constituent tasks, like typesetting. For many years, the idea of automating page makeup beckoned technicians and designers alike. Interim triumphs, like moving the photopaper backwards to allow enough reverse leading to position two columns side by side, were page makeup breakthroughs that pale by comparison with DTP. However, there are still some tasks that elude mainstream page makeup programs.

Think about the yellow pages of a phone directory. Listings and advertisements are positioned by categories, and on each page a series of decisions must be made about placement. All the display ads from plumbers must appear adjacent to plumbing directory listings, and one cannot fit the display material without testing its effect on the space available for the directory. Further, each column must be fitted tight,

with no slack at the bottom. This kind of back-and-forth spatial resolution is difficult for humans and machines alike. It clearly requires a high level of conditional problem solving, well suited to computers but quite demanding of their resources.

A database page makeup program can handle the endless situational composition problems of a phone directory. Using algorithms that define placement routines and user preferences, it will position text and ads by computer logic. Such a capability should eventually migrate towards desktop applications. Instead of assembling documents manually, we'll be equipped with tools that handle some of the repetitive chores of page assembly. The conditional routines required to assemble directories represent the highest level of sophistication in page makeup, and set a standard to which DTP applications can aspire.

One of the important tools used by a sophisticated page makeup program is vertical justification. When a column of type and graphics doesn't quite fall to the bottom of the page, a vertical justification routine lightly pads the space between paragraphs to square off the text. This is exactly what a layout artist does to finish off a mechanical, but in this instance it's an automatic calculation. Vertical justification should materialize relatively soon in DTP.

DTP and visual literacy

Some will say that the availability of type to every computer user is the beginning of a new standard in presentation graphics. Others believe it's the opportunity for widespread visual abuse. The truth probably lies in-between. We should bear in mind that saving keystrokes and converting every letter from Prestige Elite to Perpetua is not the same thing as typesetting. Harnessing brute typing ability for bringing text into a page makeup program is a little like getting hydroelectric power from a dam. The river is strong enough to do it, but then again, it doesn't know any better. Our challenge is to give people a chance to become true typographers so that they do, indeed, know what it is these desktop publishing tools help them accomplish. We need to educate them and raise their standards so that visual literacy increases. No one will be helped by making typography artificially simpler than it is, and no one should be tricked into hoping that typographic skill comes easily. It is as hard as it ever was to be sensitive to type, but easier now to express that sensitivity in print.

Bibliography

Bann, David. *The Print Production Handbook*. Cincinnati: North Light Books, 1985.

Beach, Mark, Steve Shepro, and Ken Russon. *Getting It Printed*. Portland, Oregon: Coast to Coast Books, 1986.

Beaumont, Michael. *Type*. Cincinnati: North Light Books, 1987.

Blumenthal, Joseph. *Art of the Printed Book*. Boston: David R. Godine, 1973.

Bove, Tony, Cheryl Rhodes, and Wes Thomas. *The Art of Desktop Publishing*. New York: Bantam Books, 1987.

Bruno, Michael H., ed. *Pocket Pal*. 13th ed. New York: International Paper Company, 1983.

Bunnell, E.H. *Understanding Digital Type*. Arlington, Va.: National Composition Association, 1978.

Click, J. William, and Russell N. Baird. *Magazine Editing and Production*. 4th ed. Dubuque: Wm. C. Brown Publishers, 1986.

Craig, James. *Production for the Graphic Designer*. New York: Watson-Guptill, 1974.

Crow, Wendell C. *Communication Graphics*. Englewood Cliffs, N.J.: Prentice-Hall, 1986.

Dennis, Ervin A., and John D. Jenkins. *Comprehensive Graphic Arts*. Indianapolis: Bobbs-Merrill, 1983.

De Vinne, Theordore Low. *The Practice of Typography*. New York: The Century Co., 1900.

Goudy, Frederic W. *The Alphabet and Elements of Lettering*. New York: Dover Publications, 1963.

Kleper, Michael L. *The Illustrated Handbook of Desktop Publishing and Typesetting*. Blue Ridge Summit, Pa.: Tab Books, 1987.

Lawson, Alexander, and Archie Provan. *100 Type Histories*. Arlington, Va.: National Composition Association, 1983.

Lee, Marshall. *Bookmaking*. 2nd ed. New York: R.R. Bowker Company, 1979.

Nesbitt, Alexander. *The History and Technique of Lettering*. New York: Dover Publications, 1957.

Ogg, Oscar. *The Twenty-six Letters*. New York: Thomas Y. Crowell Company, 1948.

Rogers, Bruce. *Paragraphs on Printing*. New York: Dover Publications, 1979.

Ruggles, Philip Kent. *Printing Estimating: Principles and Practices*. Boston: Breton Publishers, 1979.

Seybold, John, and Fritz Dressler. *Publishing from the Desktop*. New York: Bantam Books, 1987.

Skillin, Marjorie E., and Robert M. Gay. *Words into Type*. 3rd ed. Englewood Cliffs, N.J.: Prentice-Hall, 1974.

Solomon, Martin. *The Art of Typography*. New York: Watson-Guptill, 1986.

Updike, Daniel Berkeley. *Printing Types: Their History, Forms, and Use—A Study in Survivals*. 2nd ed. New York: Dover Publications, 1980.

White, Jan. *Editing by Design: Word and Picture Communication for Editors and Designers*. New York: R.R. Bowker Company, 1974.

Zapf, Hermann. *Manuale Typographicum*. Cambridge, Ma.: The M.I.T. Press, 1954.

Periodicals

American Printer, 29 North Wacker Drive, Chicago, IL 60606.

Communication Arts, Coyne & Blanchard, Inc., 410 Sherman Avenue, Palo Alto, CA 94306.

Electronic Publishing & Printing, Maclean Hunter Publishing Corp., 29 North Wacker Drive, Chicago IL 60606.

Folio: The Magazine for Magazine Management, Hanson Publishing Group, Inc., 6 River Bend, Box 4949, Stamford, CT 06907.

Graphic Design:USA, Kaye Publishing Corporation, 120 East 56th Street, New York, NY 10022.

Graphis, Graphis US Inc., 141 Lexington Avenue, New York, NY 10016.

Magazine Design & Production, South Wind Publishing Co., 8340 Mission Road, Suite 106, Prairie Village, KS 66206.

National Association of Desktop Publishers Journal, NADTP Inc., P.O. Box 508, Kenmore Station, Boston, MA 02215.

Seybold Report on Desktop Publishing, Seybold Publications, Inc., P.O. Box 644, Media, PA 19063.

Typeworld, Typeworld Educational Association, Inc., P.O. Box 170, 35 Pelham Road, Salem, NH 03079.

Personal Publishing, Hitchcock Publishing Company, 191 S. Gary Avenue, Carol Stream, IL 60188.

Print, 104 Fifth Avenue, New York, NY 10011.

Printing History, The Journal of the American Printing History Association, P.O. Box 4922, Grand Central Station, New York, NY 10163.

Publish!, PCW Communications, Inc., 501 Second Street, San Francisco, CA 94107.

U&lc, International Typeface Corporation, 2 Dag Hammarskjold Plaza, New York, NY 10017.

Index

Index to typefaces

The first printed book to include a colophon was a Psalter printed by Peter Schoeffer and Johann Fust. The colophon, translated from the Latin, reads:

> The present volume of the Psalms, adorned with beautiful initial letters and with an abundance of rubrics in red, has been given this form artificially by means of an ingenious contrivance for printing and inscribing without any use of a pen, and laboriously brought to completion for the service of God by Johann Fust, citizen of Mainz, and Peter Schoeffer of Gernsheim in the year of our Lord 1457 on the Eve of the Feast of the Assumption.

The present author feels much as Fust and Schoeffer did: awe for the technology that allowed production of such a typographically complex book on the desktop, and a certain desire to let the reader know it was a difficult task nonetheless. This book would likely not have reached its present form without the interactive quality of page makeup software. Many of the typographic demonstrations would have been daunting if not impossible to construct without such tools. The author wrote, designed, and composed it on an ALR 20386 computer, using principally WordPerfect for word processing and PageMaker for composition. Other hardware included a Sigma Laserview monitor, Microsoft mouse, Panasonic keyboard, Hercules graphics card, and a Texas Instruments Omnilaser. Other software included Hercules Fontman for production of a custom monospaced text font used in word processing, Easy Cad for drawings, and Adobe and Bitstream fonts for screen and printer output. Pages were output on a Linotronic L300 with the Saturn RIP. Color breaks were done manually, and halftones were produced conventionally.

The body text is 11/13 Century Oldstyle.

Cover design by Bob Fillie
Edited by Jennifer Schwartz
Managing Editor, Andrew Hoffer
Production by Hector Campbell
Design consultant, Jay Anning
Type output by Sprintout